Taking It Off,
Putting It On

Women in the Strip Trade

Chris Bruckert

PRESS

Women's Press | Toronto

Taking It Off, Putting It On: Women in the Strip Trade
Chris Bruckert

The first paperback edition published in 2002 by
Women's Press
180 Bloor Street West, Suite 1202
Toronto, Ontario
M5S 2V6

www.womenspress.ca

Every reasonable effort has been made to identify copyright holders. Women's Press would be pleased to have any errors or omissions brought to its attention.

Women's Press gratefully acknowledges financial assistance for our publishing activities from the Ontario Arts Council, the Canada Council for the Arts, and the Government of Canada through the Book Publishing Industry Development Program.

National Library of Canada Cataloguing in Publication Data

Bruckert, Chris, 1960–
 Taking it off, putting it on: women in the strip trade/Chris Bruckert.

Includes bibliographical references.
ISBN 0-88961-405-9

1. Stripteasers. 2. Striptease—Social aspects. I. Title.

PN1949.S7B78 2002 305.43'7927 C2002-902364-5

Cover design by Marijke Friesen
Cover photograph by James Cotier/Getty Images/Stone
Text design and layout by Susan Thomas/Digital Zone
Author photo by Bruno Schlumberger and the *Ottawa Citizen*

02 03 04 05 06 07 08 6 5 4 3 2 1

Printed and bound in Canada by AGMV Marquis Imprimeur Inc.

ONTARIO ARTS COUNCIL
CONSEIL DES ARTS DE L'ONTARIO

THE CANADA COUNCIL | LE CONSEIL DES ARTS
FOR THE ARTS | DU CANADA
SINCE 1957 | DEPUIS 1957

Dedicated to the memory of
David Lloyd Rawlings
1955–1992

Contents

Acknowledgements

I would like to acknowledge the contributions of some of the people without whom this book would never have been completed. Many thanks to:

Heather Jon Maroney for her commitment, wisdom and patience. I will remain forever indebted to her for her academic and personal generosity. To Derek Smith for sharing his thoughtful reflections and rich insights, and for his infectious enthusiasm, which sustained me many times. To Fran Shaver, Janet Siltanen, Eileen Saunders and Rosemary Warskett for their many helpful comments.

Sandy Hitsman and Martian Dufresne for being great friends and academic confederates and for always being there to work through ideas, to encourage, to sympathize and to listen. Robert Gaucher and Lorna Weir for being, each in their own way, truly inspirational teachers who opened my eyes to the many possibilities of academe, and for their assistance during various stages of this project. Sylvie Frigon and Colette Parent for their ongoing confidence and support.

The people at Canadian Scholars' Press and Women's Press for providing the practical support necessary to make the book a reality. In particular a special thanks to Althea Prince for her early and, most especially, her continued enthusiasm.

Simon and Benjamin Bruckert, who were boys when we started this project and are now two very special

young men, for their love and support, even though it meant Mom was far too busy, far too often. David Rawlings for his unselfish act that gave me the opportunity to start this academic journey so many years ago. Gudrun (Gundi) Barbour for her innumerable acts of kindness and her unequivocal acceptance.

The men and women working in strip clubs who took the time to talk to me and patiently responded to all my tedious questions. Last, and most important, my gratitude to Ann, Alex, Debbie, Diane, Judy, Jamie, Josey, Kelly, Kerri, Marie, Rachel, Sarah, Sally and Tina for sharing their lives and stories. Without their generous assistance I would have had nothing to say.

Introduction

To resurrect an old slogan from the days of women's liberation, "the personal is political." This book is certainly both political and personal in ways that prohibit any arbitrary separation between the two. During the late 1970s and early 1980s, between dropping out of high school and attending university, I supported myself and my family with a variety of marginal labour activities including working as a stripper.[1] It was a job that I found alternately, and sometimes simultaneously, boring and exciting, annoying and enjoyable, oppressive and liberating. Certainly it was not particularly problematic. I comfortably reconciled my emerging feminist consciousness with my job, enthusiastically reading *Women in Sexist Society* (1971) in between taking my clothes off for a roomful of intoxicated men.

In 1982 I went with a number of colleagues to a screening of the anti-pornography film *Not a Love Story*. There we learned, in the words of director Bonnie Klein, that we (as strippers) were "part of it, [and]...serve the whole thing." *That* experience was disturbing. The feeling of dis-ease re-emerged years later when I spent many hours in university lecture halls listening to academics speak a (the?) Truth I did not recognize. I wondered why feminists who argued for the need to take women's lives as the central point of departure were at the same time keeping women like me "off the record" (Spender, 1982:14) by failing to listen to and

accept our experiential truths. Frustrated and angry, I was silenced by my lack of academic language and legitimacy; by the lack of space for my experience within the discourses; by the discourses themselves which de-legitimated me and denied my agency. And by my fear.

My experience of being an "outsider within," while hardly unique, was powerful. When you find yourself transformed into an object under the lens of sociological inquiry and silenced by "the unspoken sociological stipulation instructing us to disregard what we know of ourselves as embodied subjects" (Smith, 1987:117) you can either deny yourself or you can be politicized. I embraced the latter.

This book is the result. It is an attempt to redress imbalance by honourably attending to lived realities that do not fit readily into existing conceptual frameworks. This objective cannot be realized by simply adding another set of voices to existing discourses. It requires that theory, methodology and analysis "begin from the standpoint of those outside ruling regimes" (Smith, 1990:631). Such an approach necessitates that we draw on divergent theories to create an analytic space in order to make sense of the contradictions of the nuances, of the grey area where these women live.

My political/personal agenda is not inconsistent with the critical social-scientific imperative of "doing sociology from the bottom up," integrating the perspectives of marginalized individuals and addressing their historic silencing through biography and the documentation of ordinary (unfamous rather than unexceptional) lives. This, in combination with my commitment to making the lives of marginal women visible and audible, to understanding those lives from their own perspectives, and to situate them in the broader social contexts, locates the project firmly within feminist ethnography (Reinharz, 1992:50).

RESEARCH METHODS

It is important for the reader to have a sense of the process through which the following text emerged. The undertaking required that intersecting research techniques be employed. Initially I had assumed that my personal experience already afforded me insight and depth of

understanding. I quickly discovered, however, not only that industry transformations rendered my experience obsolete, but also that as a full participant I had not been a particularly systematic observer. I had little sense of what *happens* in strip clubs today, how they operate and how personal and professional relations are structured. Accordingly, I spent twelve months working full-time as a bartender, and occasionally as a waitress, in a strip club located in a mid-sized southern Ontario city.[2] Standing behind the bar proved to be an effective physical and social location. I was able to become part of the environment and in spite of the fact that the management and staff at the club were apprised of my research interests prior to my entry into the field, I was largely invisible. A series of semi-structured interviews lasting between one and three hours with individuals working in strip clubs as support staff — disc jockeys, waitresses, doormen and managers — helped to flesh out what I was observing and broaden my perspective of the multiple dynamics operating in strip clubs.

Furthermore, in order to locate the industry within the framework of state administration, regulation and broader discourses, archival work was undertaken. A variety of documental sources were analyzed including municipal bylaws, provincial health regulations, corporate registrations, the Canadian Criminal Code, legal judgements and the media. This archival work, like my participant-observation and interviews with support staff, was a secondary method designed to provide context and expand insights. In other words, these were substantiating, rather than substantive, sources.

The most important source of information for this book was the in-depth interviews I conducted with fifteen women aged twenty-one to forty-six who were employed as strippers in Ontario in 1997 and 1998. Each lasting between two and four hours, these interviews were relatively unstructured and flexible. In the interest of protecting the research participants, the names of these women and those of their co-workers, friends and clubs, as well as any distinguishing aspects of their stories, have been changed. All of these women had been working in the industry for a minimum of one year, although most had considerably longer careers. The women were all articulate, insightful individuals. They all had *something to say.*

I hope their voices come through. My concern speaks to interpretive requirements of the research process. Quite obviously, since I collected, edited and analyzed the research material and produced a text in which experiences were transformed into data, I assumed authority over the narratives. This is of course problematic. Can we proclaim that research participants reveal the truth of experience yet claim analytic authority ourselves? The legitimacy of my doing so is, I believe, in part supported by my own experience. As a consciously feminist stripper, I was certainly able to understand the industry, but lacked the theoretical tools necessary for a sociological analysis. A related concern was the potential that my political commitment and desire to expand the parameters of the debate would blind me to the very reality I was attempting to validate. In my desire to resolve these dilemmas, I turned back to the literature on inductive methods and opted for grounded theory with a feminist consciousness.

Practically speaking, ensuring that I was *facilitating* without *imposing* meant starting with very careful transcriptions and spending many days reading and rereading the transcripts before allowing themes and patterns to emerge. Field notes, support-staff interviews and archival work were then considered in relation to these themes. As I started to develop analytic frameworks, the transcripts were again reviewed, this time to look for inconsistencies. It was only when my analysis fit all the data and I could reconcile apparent contradictions that it was related back to the sociological literature. Throughout, I continually challenged myself: was I being as rigorous and faithful to the data as possible, or was I imposing meanings? The process opened up a space that held the promise of discovery. It was reassuring when, in order to "make sense," I was forced to abandon some concepts, embrace others and continually rethink my own assumptions.

Ultimately the process left me clinging to an admittedly modernist faith in "doing sociology." If poststructuralism has made us circumspect about truth claims, then the problematics that permeate the research process confirm the need to be vigilant. We cannot seek *the truth*; we can, however, strive to reveal *the truths* grounded in the experiences of marginal women's everyday lives.

Unlike the reassuring (though erroneous) truth claims of empiricism, these truths are plural, fluid and subjective; they "jar us from our complacent security outside: (Personal Narratives Group, 1989:261). They are important truths.

1

Textual "Truths" and Other Conversations

Upon entering one of the over two hundred strip clubs in Ontario, you would notice a number of scantily attired women sitting and listening with apparently rapt attention while men regale them with stories. Most likely on the stage a dancer would be doing contortions and periodically removing an item of clothing while (male) patrons look on with surprising indifference. Wander into the champagne room, and you would see more women dancing for, or talking with, (clothed) men who are sitting only inches away from their naked bodies. The male voice of a disc jockey or manager might rise over the music, arguing with a stripper and threatening her with dismissal if she does not appear on-stage. The markers appear unmistakable — the power, oppression and exploitation are so self-evident that to undertake an analysis hardly seems necessary.

Nonetheless, things are not as straightforward as they seem. The strip club is, in fact, a complex cultural, social and economic space. What we see and how we interpret it is also highly subjective and context-bound. If we ask a patron, it is entertainment; for the anti-pornography feminist, it is violence; for the criminologist, it is deviance; and for the moral majority, it is sinful and corrupting. If we asked the women "deep" in conversation or dancing on the stage, they would tell us they are at work.

This multiplicity of subjective perceptions begs the question: whose experience is privileged as speaking the "truth"? Given that the creation of knowledge speaks to relations of power (Foucault, 1980), the legitimacy of some perspectives and the disappearance of others is neither random nor irrelevant, but profoundly political. As an introduction to the book we will trace some of the "textually mediated discourses"3 (Smith, 1987:110) — feminist, insider, criminological and popular — that have been propagated about the industry and its workers in the recent past, and reflect on what is being said, what is not being said and who is empowered to speak.

FEMINIST TEXTS

The traditional anti-pornography position is associated with conservative opposition to non-marital sex, nudity, homosexuality, recreational sex and "perversity" as well as their depictions. Ideologically, the feminist anti-pornography position that emerged in the late 1970s was very different. At that time, new theories of gender hierarchy, a recognition of violence against women and an increased consciousness of women's objectification gave rise to a discourse on pornography that politicized male sexuality as violence or dominance.4 In this political and intellectual context, a new form of pornography, sexist and violent as distinct from sexy, apparently emerged (Lacombe, 1988:41). The 1977 release of *Snuff*, a pornographic movie that claimed to show a woman's actual murder, contributed to a perception of escalating pornographic atrocities and gave the issue prominence. In response, women across Canada organized into anti-pornography lobbies such as the Toronto Women Against Violence Against Women (established in 1977). This movement relied on assumptions of a universal female understanding and/or anecdotal material to legitimate their argument that pornography reflects violence, causes violence and ultimately *is* violence against women.5 In spite of very different ideological positions and political agendas on issues of women's equality, homosexuality and the primacy of the family, these feminists shared with right-wing lobbies the profound belief that

pornography was harmful enough to justify, and even necessitate, regulatory strategies. Arguments of civil libertarians aside, in practice, as we will see in the coming chapters, state intervention further marginalizes, stigmatizes and criminalizes industry workers.[6]

Throughout the early and mid-1980s, the principal feminist challenge to the anti-pornography position,[7] while politically valuable, continued to be somewhat constrained by its oppositional nature. Envisioning pornography as symptom/symbol rather than cause, these feminist authors championed more proactive measures to further equality and strenuously rejected the repressive methods of the anti-pornography position. Nonetheless, the two positions rarely moved beyond the pornographic "product" to integrate a consideration of workers' experiences. At best, when this critical literature paid attention to the dimension of labour, it normalized the skin and sex trades as work like any other.[8] Such an approach, though valuable, does not necessarily bring us any closer to an understanding of everyday workplace experiences, and also risks obscuring the specificity of participation in stigmatized labour markets.

By and large, feminist discussions of pornography tend to focus on product or text. Bodies are everywhere, but actual people — as social and personal agents — strikingly rare. The result is a reading that negates subjectivity (Lacombe, 1994:62). This is most disturbing when anti-pornography campaigners accuse feminists who oppose their control strategies of failing to listen "with serious and honorable attention to women who have been exploited in pornography" (Dworkin and MacKinnon, 1988:93). Ironically, it is in the anti-pornography literature that the much-maligned actions of the pornographer are mirrored: the skin-trade[9] worker is objectified as a representation of all women's degradation and shame.[10]

Moreover, in spite of vowing "not to override or dismiss any woman's voice"[11] (Price, 1989:59) the pornography model of anti-pornography analysis is a caricature — stripped of her soul/humanity/subjectivity through the feminist lens, if not the pornographer's camera, the skin-trade worker truly is "not someone we might know" (Griffin, 1981:36). Apparently "we do not even enter those places where it [pornography] is sold" (Griffin, 1981:3) and "self-respecting women do not want to

[even] see pornographic magazines" (Bat-Ada quoted in Lederer, 1980a:116). Presumably they do not frequent strip clubs either.

It follows that women who support the skin trades and maintain their right to participate in the consumption or production of pornography can be condemned as complicit in the subordination of all womankind, agents of patriarchy whose lack of political consciousness allows them erroneously to assume themselves to be self-determined actors. Or they are victims.[12] Victims are, by definition, not autonomous actors.

Evidently they are not credible witnesses either, since under this framework, the workers' own understanding is ignored, or worse, reconstructed and appropriated as proof of their subjugation.[13] These assumptions continue to resonate in some recent feminist analysis. An exploratory study of migrant sex workers (McDonald et al., 2000), for example, much to the chagrin of the workers themselves, categorized stripping as sex-trade work (2000:55). The study discounted the women's own accounts of their experiences and ignored their assertions that they were not trafficked, and instead confidently maintained that "at least half of the women interviewed were trafficked into Canada" (2000:68).

Ultimately it seems to me that a separation between the feminist subject and the sexualized object, between knower and known, structures discourses and practices that are not only oppressive but also more alienating, offensive and damaging than the experience of the skin trades themselves. This sense of "othering" is evident even in texts that consciously seek to overcome binary understandings. The 1987 collection *Good Girls/Bad Girls*, edited by Laurie Bell, is self-reflective and humorously identifies its authors' own stereotypical assumptions (Bell, 1987:12). It is nonetheless subtitled "Sex-trade Workers and Feminists Face to Face" — as if the two groups are mutually exclusive.

INSIDER TEXTS

The problems detailed above notwithstanding, a feminist approach should not be rejected; rather, the parameters need to be expanded by forcibly integrating what "other" women say. Over the last decade, the underlying assumptions of the pornography debate have been

destabilized by new work that demands, and begins to carry out, the integration of real people's experiences and accounts.

Sex radicals[14] first challenged the dichotomous and limiting parameters of the pornography debate by reinserting sexuality. Among those at the margins, the constraining and alienating discourse around sexuality aroused anger and spurred action. After the suppression and denial of the sexual that had characterized feminism in the 1970s and 1980s, this work asserted that the sexual, including the pornographic, *was* significant. Furthermore, sex radicals claimed agency over sexuality. A diverse collection of sex-positive work[15] sought, with varying degrees of success, to transcend the feminist, liberal and libertine sexual and discursive boundaries through experiential accounts as well as careful analytic considerations. This literature, which holds considerable promise for a more adequate theory of sexuality, sex work and the skin trades, warrants consideration, although it remains confined by the very marginality and pluralism that gives it strength. It certainly offers unrepentant workers entry into the discourse through reflective work that informs, and is informed by, theory.

In addition, in the late 1980s and throughout the 1990s a number of Canadian (Ample, 1988; Atkinson, 1995; Dragu and Harrison, 1988; Tracey, 1997) and American (Mattson, 1995; Snowdon, 1994) autobiographical or semi-autobiographical accounts by former industry workers were published. At times workers explicitly challenged the patronizing position of some feminist academics:

> You're not giving legitimacy to our story of how we're being hurt and who is hurting us. You — with your unwillingness to contact us — you're hurting us.... You sit on your little pedestal ... you don't like my definition of who's doing it, and so you don't want to hear my story (Bell, 1987:182).[16]

While the quality of these accounts is uneven — few are as insightful as Lindalee Tracey's complex consideration *Growing Up Naked* (1997), they collectively constitute a critical mass of public proclamations by strippers. Whatever the individual works' weaknesses, the very existence of this body of work holds the promise of new ways of seeing —

articulate voices that (I hope) cannot be easily dismissed and rendered silent. While I applaud these women's contributions, these texts are limited by the particular moment in which the authors experienced the trades. These writers all worked in the 1970s and early 1980s, before table-dances and champagne rooms transformed the labour from entertainment to a service industry.[17] This shift, as we will see, had profound implications for how the labour is organized and experienced. More importantly, for the most part, the writers of this group of auto-biographical works consistently believe that they participated in a "golden age" of stripping and are consequently not sympathetic to the practices that emerged in the trades during the 1980s. Ample, the most outspoken critic, describes the table-dancers with whom she refused to work as "part hookers part dopers," although she allows that "there are probably some really nice table-dancers" (1988:160). Lindalee Tracey stops well short of such condemnation but identifies the shift toward table-dancing as undermining the dynamics of the strip club so that:

> It hardly makes sense to have strippers at all. Sometimes fifteen go-gos are wiggling on their separate boxes during my show — it looks like a Roman orgy out there, men's eyes firmly planted on a thigh, a belly, a breast only a nose away from them (Tracey, 1997:183).

In short, not only are these accounts about very different labour processes, but they ironically legitimate stereotypes that undermine "normalization."[18] For my part, I shared some of these preconceptions and, at a minimum, assumed the shift to table-dancing had resulted in increased exploitation and stigmatization of workers. Instead, I discovered that class, culture and labour process interact in convoluted ways, resulting in a more complex environment and more complicated subjectivities than I would have ever suspected.

POPULAR TEXTS

Over the last ten years stripping has become somewhat trendy, at least in terms of popular culture. Not only have a number of Hollywood

films (most notably *Striptease*, featuring Demi Moore as a single mother who begins to work as an exotic dancer to support her daughter) been produced, but clubs and strippers have been integrated into mainstream films as diverse as *Independence Day* and *Forrest Gump*. At the very least, these presentations challenge taken-for-granted assumptions of deviance by normalizing the industry and the women who labour inside the clubs. While a number of stereotypes continue to be perpetrated by portrayals of strippers in mainstream film (lack of education, standards of beauty, high earnings), for the most part, dancers are portrayed as "decent" women who are motivated by economic consideration. Unfortunately, not only is the fictional stripper's financial need rarely situated in terms of gender and class stratifications, but it is inevitably explained in relation to her individual maternal obligations. At one level, of course, this is not a fabrication. Many exotic dancers are sole-support parents. However, the extent to which this theme reverberates through mainstream cinema inadvertently perpetuates the notion that stripping is disreputable, and at the same time it reaffirms gender scripts by allowing that a woman's participation in the skin trade is understandable, even commendable, when (and implicitly *only* when) it is carried out as a strategy to fulfil her "highest calling" — motherhood. Strippers without the legitimating discourse of altruism are almost by default rendered suspect.

When we turn to fashion magazines targeted at young women, we also notice articles about stripping appearing with some regularity. Here, mother/strippers are, not surprisingly given the target audience, absent. Instead, respectability is signified by aspirations outside of stripping — university attendance being the most common indicator. To their credit, these articles acknowledge stereotypes about stripping and self-consciously challenge prevailing assumptions with titles proclaiming that "Nice Girls Undress for Success" (Langton, 1996). Young women are advised that "the audience is more likely to be wearing a Brooks Brothers suit than a dirty trench coat" (Langton, 1996:98); that exotic dancers' annual income exceeds $50,000; and that stripping is an effective strategy to combat low self-esteem (Peistrup Hambrecht, 1999). Though a compelling antidote to the pathetic victims of the anti-pornography literature, this presentation

is nonetheless also problematic. This romanticized vision of stripping is incomplete: not only does it obscure the exploitation and oppression of the industry, but it glosses over the reality of table-dancing and fails to acknowledge the emotional labour involved. In short, that stripping is not *fun* but hard *work* is conspicuous in its absence.

CRIMINOLOGICAL TEXTS

In the late 1960s and throughout the 1970s[19] a number of studies in the symbolic interactionist tradition were undertaken that explicitly rejected a focus on the characteristics of "deviants" or state definitions and instead argued that since for the participants, crime constituted work, analyzing crime as labour held considerable promise. Criminologists were urged to "overcome their fascination with the 'illegal' part long enough to focus on the 'occupation' part" (Polsky 1969:91). Numerous ethnographic studies sought to transcend moral and social bias in order to apply sociological, rather than traditional criminological, frameworks to illegal or marginal (no distinction appears to have been made) occupations. Considerable work was carried out on women as prostitutes (Bryan, 1965; Lanar, 1974), fortune tellers (Tatoe, 1974) and strippers (Boles and Garbin, 1974; McCaghy and Skipper, 1974; Miller, 1978).

Although this work constituted a considerable break within criminology, it nevertheless displays the limitations of its time and place. First, the theorists were unable to transcend common (non)sense assumptions regarding deviance. If the skin and sex trades were deviant, so was getting an abortion (Ball, 1974) or being a lesbian (McCaghy and Skipper, 1974). Since the deviant designations were never challenged, only temporarily set aside in favour of a different point of entry, the literature replicated and legitimated prevailing definitions. Second, these studies show an inadequate theorization of sexuality and gender. McCaghy and Skipper (1974) went so far as to link stripping and same-sex partnerships in a deviance-begets-deviance scenario. Thus, in the best male-stream tradition, there was something of an obsession with, but little insight into, women's sexuality.

Third, the distance between the criminologists' and their informants' social spheres was never actually traversed. Criminologist-scholars failed to fulfil the basic Meadian[20] task of taking the position of the other. Consequently the language continued to be "othering," with reference to "subcultures" rather than work culture, and the labour itself dismissed as low-moderate skill (Miller, 1978:166). Fourth, the interesting possibilities that these studies opened up were never realized — because the theorists were blind to their own social location and also because of their inability to analyze the "deviant" jobs as *jobs*. While a concept of occupation was employed, it was not extended to the point of erasing the line between "legitimate" and "illegitimate" occupations, and more importantly — if we want to better understand what workers do and how they actually experience their workplaces and relations — between legitimate and illegitimate workers.

Finally, beyond a few general remarks regarding disadvantage (the mark of liberal texts), capitalist and patriarchal social structures were inadequately theorized in these writings. Thus, the analysis replicated the astructural bias for which symbolic interactionism in general has been thoroughly criticized (Gouldner, 1973). This failure is particularly notable when we appreciate that at the same time the "New Criminology" of Taylor, Walton and Young was highlighting the need "for a sociology that combines structure, process and culture in a continual dialectic" (1973:171).

Unfortunately, recent literature in this symbolic interactionist tradition (Forsyth and Deshotels, 1997, 1998; Sijuwade, 1996) largely reproduces the problems of the earlier work. The weaknesses of the existing criminological applications do not, however, negate the conceptual framework or the value of the approach's underlying assumptions, but rather provide a point of departure. First, understanding the subjectivity of strippers in relation to the labour they perform means joining the interactionist tradition to sociological analysis of labour and resistance. Second, we must locate skin-trade work and workers within dynamic social, economic and structural contexts in order to overcome symbolic interactionism's astructural bias. Finally, emphasis needs to be placed on gender relations and hierarchies.

OTHER CONVERSATIONS

The theoretical and political agendas of this project emerge out of the strengths and weaknesses of these feminist, insider, popular and criminological knowledges. By assuming a different point of entry, placing workers at the centre and forging a methodological and theoretical space to make sense of these missing subjects and their subjectivity, the limitations of the literature can be transcended. The analytic approach, which considers structure and experience as well as the interplay between the two, endeavours to demystify the industry, to add a new dimension to the understanding of labour by forcing consideration of the (usually ignored) margins and expand symbolic interactionism through an integration of structure. At the same time, extending the theoretical tools of criminology opens up new ways of seeing the deviantized. Finally, this project takes seriously the feminist commitment to redressing the long tradition of women being "kept off the record" (Spender, 1982:14) by taking women's lives and experiences as a central point of departure, legitimating women's understanding and generating politically useful knowledge (Smith, 1987).

Focusing on the labour of strippers allows us to see them as agents and to explore their subjectivity without obscuring the fact that they are engaged in economically marginal, culturally stigmatized "immoral" work that blurs the boundaries between private and public, presentation and identity, work and leisure. Dancers inhabit a space that is on the margins of the economy, of morality and sometimes, of legality. It is work that cannot easily be categorized. While it is labour, it also resonates with multiple social and cultural meanings which operate independent of the labour market. This complex space, where discourses intersect, is a space that needs to be explored.

Strippers tell us they are at work; this book is about that work. Chapter 1 sets the stage by situating young working-class women in the context of economic trends, gender discourses and cultural expressions. Chapter 2 sets a different sort of stage by (linguistically) painting a picture of the strip club — the physical and interactive space in which strippers labour. Chapters 3 and 4 are about labour processes and consider the regulation and organization of strippers' labour and

their skills and tasks respectively. The focus shifts somewhat in chapters 5 and 6; in chapter 5 we look at the ways strippers resist and contest relations of power, while in chapter 6 the ways that stigma is experienced and negotiated — personally, socially and at work — are considered. Chapter 7 concludes the book by using the contradictions that have emerged throughout the study to rethink the meaning of work in the margins.

CHAPTER

2

Class Matters: Women, Work and Morality

The exotic-entertainment industry is, in many ways, "on the margins" and does not fit easily into existing labour theory. On the one hand, it is socially separate from mainstream Canadian society and remains, as we will see in the coming chapters, the subject of moral condemnation and regulation. On the other hand, the industry and its workers are ideologically and physically embedded in Canadian society and the market economy. In this chapter we momentarily suspend questions of difference and, in the tradition of political economy, focus on the latter. We need to consider where skin-trade industry workers, as working-class women, are situated in relation to broader market and labour trends as well as in terms of cultural expression. More specifically, we are exploring some of the ways gender and class intersect to condition the possibilities for young working-class women in Canada today.

Throughout the 1980s and 1990s, Canada experienced periods of recession and a general stagnation of fiscal growth following the postwar upward swing in economic activity (Phillips, 1997:73). During this time Canada was "wracked by high unemployment, rising inequality, falling real wages and a collapsing welfare state" (Phillips, 1997:64). There was a general impoverishment of the population and many Canadians experienced a steady erosion of their standard of living (Luxton and Corman,

2001:4). Not only was the economic climate dismal, but the emergence of a global economy, a new technological revolution and free-trade agreements had real implications for the types of work available, how labour was organized and possible forms of resistance (Phillips, 1997). As corporations undertook restructuring, manufacturing jobs were increasingly displaced into Third-World countries, where labour was cheap and regulation minimal. At the same time, however, the service sector grew as capitalism expanded into areas such as child and elderly care that had previously operated outside of the capitalist labour market (Maroney and Luxton, 1997:93). The growth of the service sector did not, as optimists had predicted, lead in absolute terms to better, more interesting knowledge-based jobs (Rinehart, 1996:74). Instead, what we saw throughout the 1980s and 1990s was an increase in those areas of consumer services that are defined as semi-skilled[21] (itself a value-laden term which obscures the multitude of competencies that workers must bring to the labour market) and prone to non-standardized labour practices such as part-time and casual labour (Rinehart, 1996:78). Increasingly, these jobs are being performed by the one in six Canadian workers who is classified as self-employed (Hughes, 1999:1).[22]

In addition, the effect of the "assault on unions and collective bargaining" (Phillips, 1997:66) that began in the 1980s was exacerbated in the 1990s. In Ontario, the neo-conservative policies of the Mike Harris government not only attempted to deflate the power of unions but systematically eliminated those aspects of the social-welfare state that aided the most vulnerable Canadians: nonprofit housing, subsidized child care and transfer payments. As a result, greater and greater segments of the population were forced below the poverty line (Rinehart, 1996:58) and the socioeconomic classes became increasingly stratified (Luxton and Corman, 2001:18).

The implications of these trends were not uniform. In spite of a widespread desire to see Canada as a classless society, and to celebrate the post-feminist age, such optimism is misplaced. When we reflect on the distribution of economic, social and cultural resources and the nature of the labour market, the stratifications that continue to characterize Canadian society at the dawn of the twenty-first century are brought into sharp focus, and we can appreciate the ways

that the transformation of the labour market in the 1980s and 1990s were classed and gendered.

As an advanced Western capitalist society (Clement, 1988, 1997; Nakhaie, 1999), Canada's economic system is structured in particular ways. The means of production are privately owned by capitalists (the bourgeois), who purchase the labour power of those who do not own or otherwise have access to the means of production and are therefore obliged to sell their labour power (the proletariat). By selling their capacity to work, workers are *alienated* from their labour. Capitalism is structured on the basis of profit — profit that is realized by *exploiting* workers in the wage exchange and by creating ever greater patterns of consumption through *commodification* (Rinehart, 1996, 25).

As we will see, these Marxist (1954 [1859], 1976 [1864]) concepts of exploitation, alienation and commodification are still relevant for understanding the nature and experience of the labour market today. At the same time, since the classes have experienced shifts in composition and size and continue to be reconfigured in a post-industrial age, we are forced to modify our analysis to take into account the modern organization of labour and the nature of the contemporary labour force. Quite simply, classes cannot be envisioned as unified wholes. Rather, Canadian society, like all advanced democratic societies, is characterized by diverse labour relations. The concept of contradictory class location (Wright, 1989a, 1989b) provides a useful tool for thinking about intra-class stratifications at a structural level by drawing our attention to the importance of skills/credentials (the expert dimension) that workers bring to the labour site, as well as their ability to organize the labour process (the management/coordination dimension).

To appreciate the complexity of class we must, however, move beyond structure and one's relation to the means of production, and factor in the multiple intersecting social processes, practices and discourses that further condition class. What emerges is a more complex and nuanced approach to class that acknowledges structure, but attends to intra-class stratifications[23] and dynamic inter-class social processes, and additionally makes a space for subjects and subjectivity.

First we have to factor gender into the equation. Socialist feminists have demonstrated the need for an integrated approach to gender and

class (Maroney and Luxton, 1997). Gender cannot be added on to class, or conceptualized as constituting an additional level of oppression; rather, class and gender are mutually dependent so that "gender has entered into the very construction of class and class into the construction of gender" (Cavendish, 1982:67). The most recent economic downturn has had special implications for women as certain labour-market advances realized during the earlier period of relative economic growth were lost (Luxton and Corman, 2001:15). This has been aggravated by neo-conservative government policies that undermine or, as in Ontario, attempt to abolish employment equity.

We know that Canadian women increasingly participate in the paid, formal labour force and do so for longer periods of time (Statistics Canada, 2000). This trend is hardly surprising in light of an economic climate where it takes sixty-five to eighty hours of paid work a week to support a family of two adults and two children (Maroney and Luxton, 1997:94). Participation rates of 55% (Statistics Canada, 2000:99) notwithstanding, women as a group continue to be disadvantaged earning just 64% of the male wage in 1997 (Statistics Canada, 2000:41). At the same time, increasing numbers of women are sole-support parents. For these women, the picture is particularly bleak: fully 56% of families headed by lone female parents are living below the poverty line (Statistics Canada, 2000:139).

That 70% of Canadian women continue to be employed in traditionally female occupations of health care, teaching, clerical work, sales and service (Statistics Canada, 2000:107) suggests that despite the rhetoric of equality, the collective access of women to traditional male bastions of occupational power continues to be limited through complex ideological and practical dynamics. At the same time we must remember that in spite of the real gains over the past three decades, women, whether employed outside the home or not, continue to assume primary responsibility for housework and child care (Statistics Canada, 2000:97). The resulting "double day" (Luxton, 1990) clearly has an impact on women's relation to, and experience of, the paid labour force, limits their employment options and conditions strategies of resistance.

WORKING-CLASS WOMEN AND LABOUR

While we can discuss in general terms women's relation to the labour force, or the disadvantaged position of the working class, there is a wide range of experience — the extent of which challenges essentialist assumptions and reinforces the importance of specificity. Class and gender interact with the current economic situation to structure the location and experience of working-class women in the paid labour force in particular ways.

In everyday terms, working-class women (and men) have jobs, not careers; jobs that are traditionally associated with neither high educational attainment nor status. In addition, while not all working-class jobs are manual, physically challenging jobs are usually filled by members of the working-class. Consequently, the labour sold frequently involves a socially unacknowledged (though recognized by the wage-labourers themselves) youth imperative and uncompensated costs in terms of health and well-being (Dunk, 1991; Houtman and Kompier, 1995:221). While this is, in part, a function of the manual/body imperative of much of this labour (Shostak, 1980), it is also directly linked to capitalist profit orientation and the failure of the state to effectively monitor corporate behaviour.[24] The result is that not only are employees frequently not protected, but they may also actually be endangered by their labour-market participation.

Working-class women, like 86% of all women in the paid work force, are employed in the expanding service sector of the labour market (Statistics Canada, 2000:106). When we look carefully, we can appreciate that to discuss the service sector as a unified whole obscures internal diversity and the ways class and gender relations are reflected in specific labour location. The service sector is comprised of social and producer services — the former the sphere of middle-class women, the latter dominated by men — and consumer services, or what have been referred to as the "servant industries" (Boyd et al., 1991:428). Working-class women are clustered in the latter.

The consumer (or direct personal) services are labour-intensive and are characterized by low pay, low capital-labour ratio, limited job security and poor working conditions. They are also likely to be

non-standard labour arrangements. In principle protected through labour legislation, in practice marginal, non-unionized workers in this sector have limited recourse to legal protection and are susceptible to a range of exploitative practices. They can, of course, "protest with their feet" — but this strategy is hardly attractive in the economic climate sketched above.

The implications of being situated in the worst paid, least protected and most vulnerable sectors of the labour market are compounded by socio-structural factors. The double day has special meaning for sole-support parents and for individuals who do not have the economic resources to benefit from the commodification of the labour that is traditionally performed by women in the home.[25] The dismantling of the welfare state means that poor women's burdens have increased: unable to purchase these services, they are required not only to assume extra labour but to organize their paid work in a manner that allows them to meet their ever-increasing obligations. The shift toward contract work and self-employment (or, more accurately, self-account work)[26] can be understood not as an indicator of upward mobility but as a strategy embraced by workers who must meet increasing family and financial obligations as the state decreases levels of support.

At the same time, we have to remember that class and gender not only intersect to structure the conditions of possibility, but also shape an individual's relation to labour so that the meaning of employment cannot simply be determined through an evaluation of the labour process and the work site — it is always mediated by subjectivity. Working-class women's subjective experience of the labour force is not as straightforward as is sometimes assumed. Some analysis is marked by classism that dichotomizes women's relation to the paid labour force as either middle-class emancipation or working-class obligation (Ferree, 1984). This binary not only trivializes middle-class women and their own contributions but (since this argument is not advanced in relation to men) results in the gender-specific and over-simplified conclusion that working-class women would prefer not to work (Ferree, 1984:64).

In fact it is much more complex. Wage and exchange labour[27] have historically constituted an important component of working-class

women's lives, and women workers express pride in their personal and generational relation to labour (Frankel, 1984; Sacks, 1984). As problematic, dangerous and exploitative as labour can be, most working-class women continue to work, or want to work. Besides the economic resources so valued in consumerist society, a job, whether or not it meets middle-class standards of what is "interesting" or "fulfilling," may provide other non-economic rewards. These include social contacts, support and friendships (Connelly and MacDonald, 1989:66); a recognition of one's work contribution that is not afforded full-time home-makers (Reiter, 1991:106); and a sense of self-worth and self-esteem (Penney, 1983:21). Ironically, it has been noted that working-class women sometimes have higher levels of job satisfaction than their middle-class, career-oriented counterparts, precisely because they assume that labour will be unpleasant, and do not anticipate achieving emancipation or personal gratification through the experience of capitalist exploitation (Ferree, 1984, 1990; Willis, 1977).

Working-class women's desire to participate in paid labour does not, of course, discount class differences in the rewards realized, or in the motivation. For example, there is evidence that not only do a working-class woman's family relations and identity shape her work environment (Livingstone and Luxton, 1989:246), but that labour itself is instrumentally motivated by family need rather than personal fulfillment (Porter, 1991:8). The long tradition of women in the informal sector[28] began as a function of the exclusion of women from the formal labour sector, but also suggests that working-class women adapt to the reality of multiple domestic responsibilities and do what is necessary to meet their own and their families' needs.

RACE AND ETHNIC STRATIFICATION

The interplay of class and gender is of course further complicated by racial and ethnic stratifications which have "always been one of the bedrock institutions of Canadian society, embedded in the very fabric of our thinking, our personality" (Shadd, 1991:1). In practical terms, Canada's history of colonization, discriminatory immigration policies,

systemic racism, stereotypical media portrayals and racist discourses (Henry et al., 2000) has resulted in a distribution of economic, social and discursive resources that places visible minority Canadians generally, and women in particular, at a disadvantage. The implications of this are diverse and are manifest in, for example, disproportionate rates of economic marginality, criminalization, health concerns, under- and unemployment. At the same time racial and ethnic stratification operates in the interests of capitalists, who manipulate biases to further fragment workers and undermine solidarity (Luxton and Corman, 2001:250).

Unfortunately, my research sheds little light on the question of how race/ethnic stratifications within broader Canadian society condition the exotic-entertainment industry. None of the strip-club managers in the community where my research was conducted ever, to the best of my knowledge, discouraged any woman from working in their clubs on the basis of race or ethnicity. Furthermore, during field work and interviews, the issue of race/ethnicity did not emerge beyond a denial of racism by the two women of colour interviewed and a number of disparaging comments regarding the ethnic background of particular club owners. Of course it is certainly possible that as a white woman I did not *see* or *hear* problems or deconstruct the subtext of the interactions I observed. In light of these circumstances, the most principled approach was to integrate the minimal literature that addresses the questions of race and ethnicity in the exotic-entertainment industry throughout the text, but to leave a systematic analysis of this important question to future researchers.

CLASS, GENDER AND EXOTIC ENTERTAINMENT

In summary, although it might be ideologically and politically expedient to do so, neither ignoring the existence of the working-class in Canada nor celebrating gender equality is justified; we must consider the complex ways class and gender interact to condition not only working-class women's labour-market options but also their experience of that labour.

To fail to do so renders the material and experiential reality of a large population of Canadian women invisible.

Attending to these factors opens up two sets of questions *vis-à-vis* stripping. First, when we consider the nature of the labour market and the opportunities available to working-class women we can ask: What impact has economic restructuring had on the industry? What is the relationship between the industry, economic downturn and the demise of the welfare state? How does the possibility of employment as a stripper intersect with the changing ideology of labour and the existence of good and/or "respectable" employment opportunities for working-class women? And how do changing market conditions affect how this marginal labour is organized?

The second set of questions emerges when we factor in subjectivity. Here we ask: What social, economic and personal rewards are realized, or expected, by workers in the industry and at what costs? Does the inherently competitive labour process allow skin-trade workers to offer each other social, emotional and physical support? Do they, like other working-class women, develop and confirm (alternate) knowledges regarding labour location? How are camaraderie and relations of support (or lack thereof) determined by labour structure and marginal status? How are social relations and behaviour organized to facilitate a successful work environment?

CLASS MATTERS: CULTURE

In order to address the questions posed above, we have to expand the parameters of the discussion. In multiple other ways "class matters" (Phillips, 1987:16). Not only do structural relations have a real impact on economic and social (dis)advantage, they also shape our understanding of the world, how we situate ourselves and the cultural forms and practices we employ to express that understanding. So while economic relations do not determine culture, the meaning of cultural expressions can only be understood within the context of economic structure (class) and the range of options available (Dunk, 1991:22).

We see cultural expressions of class in such diverse things as

linguistic codes and the use of expletives; clothes, fashions and pres-
entation-of-self; entertainment and leisure pursuits; humour and art.
The markers of working-class culture surround us, yet in spite of
Canadians' willingness to celebrate multiculturalism, working-class
expressions are not only negated they are often not even acknowl-
edged as culture. When we suspend judgement, it becomes evident
that working-class culture is not second best, as the dominant ideol-
ogy would have us believe, but is incredibly textured.[29] On the one
hand it embodies resistance to capitalist appropriation through the
construction of alternative versions of the self and the social that are
outside the relations of ruling.[30] On the other hand it subverts —
through the creation of new meaning, the inversion of existing hier-
archical arrangements and the creation of alternate discourses (Dunk,
1991:159). The failure to embrace Marxism or develop a systematic
analysis of class does not mean that subordination is not resisted. Put
another way, whether consciously or not, class and class conflict are
expressed in culture.

We must, of course, be careful. While working-class culture is
clearly evident even in Canada where, unlike our British counterparts,
we do not celebrate either class location or its cultural expressions, it
is not straightforward either. Cultural manifestations of class loca-
tion are complicated by a range of intra-class differences as well as by
the way class functions in relation to, and combined with, other social,
economic, political, cultural and ideological dynamics (Clement,
1988:22). We can acknowledge class culture, but cannot assume a
unified, single working-class culture; instead, we have to make room
for specificity by inserting gender and morality.

The distinction between the "reputable working-class" and the
"rough working-class," though limited, at least allows us to begin to
appreciate diversity within the working-class, and simultaneously to
recognize the importance of morality without undermining the exis-
tence of a community grounded in distinctive relations to production.
When we factor gender into the equation, we can see how this strat-
ification intersects with morality shaping not only expectations but
the meanings imposed. While disreputable behaviour by men (for
example, loafing and drinking) is more readily associated with a lack

of commitment to legitimate labour, women's respectability is contingent not only on a positive relation to (legitimate) labour but to sexuality as well. In this framework, strippers' labour and their labour site are both located at the rough end of the respectability spectrum (Marks, 1996). Not only that, but strip clubs themselves are, at least at one level, an expression of working-class culture.

While class location and class-cultural expression shape expectations, they are also central to the subjective experience of the labour site and condition possible understandings of sexuality and femininity. For example, sexual interaction may not necessarily be understood as sexual harassment (Westwood, 1984), and ethnographic accounts offer a very different image of such practices as sexually explicit shop-floor banter (Barber, 1992:81). Furthermore, positioned to recognize the costs of capitalism and patriarchy (Ferree, 1990), working-class women may question the advantages afforded by labour-site "respectability." This would have a very distinct impact on the extent to which sexuality is openly employed, or (as in traditional middle-class practices) obscured, denied or manifest as maternalism. If the relationship to sexuality is classed and working-class women are, like the young women in Angela McRobbie's 1991 study *Feminism and Youth Culture*, prepared to claim sexualized expression as their own cultural terrain (1991:51), then a willingness to engage in erotic labour speaks not to a lack of "virtue" as the moral majority would postulate, but is conditioned by class and reflects an approach to sexuality that is culturally supported.

The challenge to middle-class morality, the inter-class variance in leisure sites and pursuits, the ways strip clubs reflect working-class (male) culture and, perhaps most importantly, the explicit sexuality that is associated not only with disreputable working-class culture but also with the claims to sexual autonomy made by women of that social strata (McRobbie, 1991; Rotenberg, 1974) suggest the strip club is the site of a complex interplay of class, culture and morality. This may in part explain why strippers' labour continues to go unacknowledged as *labour* within dominant (middle-class) discourses, and also why their work site is the target of moral censure. The arbitrary distinction between high and low culture tells us a great deal about relations to truth, and who is entitled to name, define and ultimately

dismiss or applaud (Allen, 1991:40). It is hardly a coincidence that the cultural representations that have historically provided pleasure, entertainment and, of course, employment to working-class individuals continue to be the unquestioned subject of moral regulation.[31]

This being said, we must exercise caution. Recognizing the importance of culture and commonality does not mean we can make sweeping generalizations. It is imperative to always factor in individuality. This brings us to the question of how identity functions in relation to class when we factor in the apparent ambivalence of Canadians towards working-class identity and the complexity of class location on the margins. A unified working-class identity is not necessarily embraced by Canadians who share the same sorts of relations to the means of production. The dominant ideology of classlessness and the myth of meritocracy have thoroughly mystified the sources of oppression, so that class may be suppressed rather than celebrated, and class culture (and its expressions) may then operate as another "hidden injury of class" (Sennett and Cobb, 1973). For the most part, in Canada class is largely a passive identity, an identity that structures our social world but is generally not at the forefront of our understanding (Bradley, 1996:25). So while class is important, our identity is something that is much more complex. It is fractured (Bradley, 1996), the outcome of the interplay between social, personal and economic locations, existing discourses and how we relationally position ourselves (Mead, 1934).

THINKING ABOUT CLASS MATTERS

The economic downturn of the 1980s and 1990s and the dismantling of the welfare state have had serious ramifications for working-class women in Canada. For this segment of the population, the shift in the labour market coupled with declining real income resulted in a move from the informal-employment sector or manufacturing jobs to low-level service-sector employment that is characterized by poor pay, poor working conditions, non-standard labour arrangements and minimal or no protection from unions or the state. Furthermore, these women

workers must struggle and adapt to meet ever-increasing domestic and social obligations at the same time as their resources and state support are dwindling.

When we think about strippers as working-class women and consider what that means in terms of labour-market location, opportunities and obligations, it is immediately apparent that strippers are choosing their occupational location in an economic climate characterized by unappealing choices. Stripping may not always be a "nice" job, but neither are the alternatives. For some working-class women, stripping may be a viable strategy to realize the economic and social benefits afforded by participation in the paid labour force while also offering sufficient flexibility to accommodate their many other commitments.

At the same time we must be wary of economic determinism. The labour market may condition possibilities and limit options, but it does not by itself determine choices. That is one of the reasons it is so important to factor in class culture and the complex ways class operates in relation to the meaning of morality and gender stratifications. None of this is intended to imply uniformity or negate the complexity of how identity operates in relation to labour location. The university student who on occasion works as a dancer may well be responding to the shrinking labour market and the contemporary idealization and exploitation of youth. However, unlike her working-class counterpart, she likely understands the work as temporary and envisions a future filled with reputable opportunities.

3 Making Sexualized Labour Work

The strip club, in its incarnations as both leisure and labour site, is a cultural and commercial anomaly located somewhere between a bar and a brothel, part of an industry that is both like and unlike other businesses. Predicated on the ethnographic truism that we can only begin to understand the experience and actions of social actors in relation to the context in which they occur, the following attempts to set the stage for the subsequent analysis by drawing a picture of the physical and interactive space of the strip club.

THE INDUSTRY

Straight and Sexy Stratifications

Insiders understand the industry as clearly stratified according to "dirty/straight" and appearance criteria. The former refers to the amount of dirty dancing — illicit touching or sexual contact — that is tolerated in a club. The "dirtiest" bars have brothels attached, where sex-trade workers, not strippers (although they sometimes overlap), work. The second set of distinctions refers to the appearance standards imposed by club management for the dancers. The most exclusive clubs accept only the most conventionally attractive strippers. Although managers are increasingly embracing a more complex consideration of

beauty that values diversity, the standard continues to be the blond, tall, well-endowed beauty with tan lines[32] and without visible tattoos. This idealized image of young white womanhood obviously has particular implications for women of colour.[33] These lines of stratification are not parallel, and they reflect both demarcations imposed by management (appearance criteria) and the dancers' relation to the labour (the dirty/straight continuum). In general, however, the straighter the club, the more selective it can be, the "nicer," cleaner and more luxurious the interior and (generally speaking) the more reasonable the expectations of the clientele are likely to be.

In practice, a circular, self-perpetuating dynamic is established. The more popular a bar, the more strippers want to work there — the more "girls" there are, the more clients are attracted. The result is that some clubs can legitimately advertise thirty strippers and regularly turn away freelance dancers who do not meet their appearance or behaviour standards, while the less successful bars have difficulty obtaining workers and their claims are considerably exaggerated. Of course, the more popular a bar, the more management is in a position to impose rules, and the more likely dancers are to comply. At the same time, some bars become known as particularly bad places to work because they impose excessive expectations (by industry standards) and inflict harsh sanctions for non-compliance. Regardless of how popular the bar is, or how enticing the pay, most dancers refuse to work these "sleazy" bars. As a result, these clubs rely largely on the most marginal of dancers: women whose appearance, tattoos or past behaviour limit their employment opportunities. Shamelessly exploiting the women's marginality, such establishments "treat the girls like shit" (Jake, disc jockey).[34]

Employment Opportunities: House Girls, Freelancers and Features

In Ontario, some clubs continue to hire dancers "on-schedule," paying them between thirty-five and forty dollars per shift. For the most part, however, dancers exchange labour and bar fees for access to customers: "You have to work for four hours and pay the DJ fee. Ten bucks to be there, so you pay them to work there. And you go on stage, y'know, one to five times a night, depending on how busy the bar is, how many

girls they have" (Jamie). In short, dancers not only receive *no* direct financial compensation from the establishment for their work, but their fees pay the wages of the disc jockey, who also often receives no remuneration from the club.

This innovative approach to realizing free "employees" by positioning them as self-account workers will be developed further in the next chapter. For now, the fine status gradations between "house girls" and "freelancers" needs to be considered. House girls are usually freelance strippers (although they may be on-schedule) who, in a mutually advantageous arrangement, develop an association with a particular club and work there on a regular basis. This allows dancers continuity and the opportunity to build up a client base, as well as to participate in a familiar work environment, to know the specific limits, expectations and rhythms of work and to develop social relationships with the other dancers and support staff. Since bars depend on house girls, there is some reciprocity. The house girls are treated with considerably more consideration than other dancers and allowed some leeway with regard to club rules. In contrast, freelance dancers rotate among clubs. They do this for a number of reasons: to stave off boredom, for example, and to maximize their earnings. The outcome is complex. Freelancers are more vulnerable, but since they are not associated with any particular club, they are better positioned to remove themselves from the stressful and competitive internal dynamics that develop within one club or another.

The labour experience of "features," the elite strata of the industry, is strikingly different from that of most strippers. In the early 1980s, in conjunction with the growing film and magazine pornography industry south of the border, American porn actresses began to appear in Ontario clubs (Schlosser, 1997). These stars work the North American circuit, earning up to $15,000 a week (Tracey, 1997:107). They assume a highly professional approach, often bringing their own lights, sound equipment and entourage. Like the burlesque stars of the past, they employ gimmicks ranging from lions to fire to showers and often maintain an interactive rap with the audience throughout the four thirty-minute shows they perform daily. There is also a second level of features, Canadian strippers earning between $1000

and $2000 a week. At one time, these women were the recipients of legitimate titles such as Miss Nude Canada. By the mid-1980s, however, there were so many contests, many fixed, that titles started to mean very little; dancers started to fabricate titles in what Annie Ample refers to as the "Great Canadian Skin Scam" (1988:86). Though the earning potential is substantial, this is not a simple matter of upward mobility. Recognizing the high outlay, continual travel and lack of camaraderie involved in feature dancing, few strippers aspire to this career in the industry.

Agents: Mediating Between Work and Workers

The final players to consider are the agents, who sometimes mediate between entertainer and employer. In Ontario, these "strange beasts with voracious appetites" (Billington, 1973:21) have been displaced over the last fifteen years as dancers have either developed standing arrangements as house girls or assumed responsibility for identifying and contacting clubs themselves. For the most part, agents continue to arrange the engagements for features but only book table-dancers when they go "on the road." While ostensibly providing a service for the worker who pays him or her, alliances are enigmatic and inevitably determined by economic relations and the search for profit. That is to say, since the club is the more valuable commodity for the agent, it is rare for agents to side with dancers in a dispute. Observation suggests that their primary task is to ensure that strippers comply with the expectations of the club. For the worker, this relationship resounds with the flavour of obligation, not to mention power. Although perceived as inevitable in some areas of the industry, the essentially exploitative nature of the relationship is not lost on the workers (Tracey, 1997). Alex was particularly outspoken: "They're whore masters! Ya no shit!"

THE STRIP CLUB

Historically, burlesque theatres and nightclubs have run the spectrum of plush to Spartan. With the proliferation of clubs in the early 1980s,

a McStrip model emerged that rendered clubs increasingly similar. It is this homogeneity that allows the following presentation of a *typical* club and its *typical* distribution of labour.

The appearance of the exterior of the club is largely determined by its geographical location. That is, clubs located in the downtown core tend to restrict their outside promotion to a neon sign bearing a club name that leaves little question as to the nature of the entertainment, and (bylaws permitting) perhaps the nude silhouette that appears to be the unofficial emblem of the industry. Clubs located in rural or industrial areas are more explicit in their self-promotion, and billboards frequently grace their parking lots. These signs are as likely to announce pool tournaments, upcoming events, pizza and big-screen televisions as to promote an inflated number of exotic dancers.

Upon entering a strip club, one is immediately struck by the exceedingly subdued lighting. At the entrance, just past the coat check,[35] is inevitably a glassed-in notice board, which promotes future events and contains pictures of current and upcoming features. To one side there are pool tables and assorted electronic games. In addition to the perpetually running pornographic videos, the bar itself is decorated with an eclectic collection of risqué images, beer advertisements and sports memorabilia. Off to the side, so as not to interfere with anyone's view of the stage, is the bar where drinks are dispensed. It is essentially a service bar with a few stools scattered in front. This neutral zone affords patrons a place of acculturation and allows customers who are unwilling to acknowledge themselves as "the sort of guy who goes to a strip club" a non-threatening point of entry. The pool tables, at times, fulfil a similar function.

In most bars you will find a kitchen that is either operated by the establishment or leased to an independent restaurateur. The extent to which clubs cater to the gastronomical desires of their patrons varies considerably. Most clubs offer an assortment of pub fare; in some, a more varied menu is available. Periodically clubs provide free lunchtime buffets on Thursdays and Fridays to entice patrons into the establishment during a traditionally slow period of the day.

The disc jockey's primary work site is a room or booth measuring perhaps five feet by ten feet, positioned above the floor with a large

window and equipped with microphone, table and chair. Most of the space is taken up with assorted sound, lighting and special-effects equipment. The booth is further cluttered with personal belongings and compact discs. The bar and the stage are under the continual surveillance of the disc jockey. In some clubs disc jockeys are also positioned to observe the champagne rooms, either directly or via a series of monitors. Hidden from view but close to the DJ booth is a dressing room, a communal space shared by all the table-dancers. Equipped with mirrors, shelves and hooks, these rooms are uniformly poorly ventilated and overcrowded and smell of a mixture of mari-juana and tobacco smoke,[36] sweat, perfume and body odour. The illu-sion of sexuality stops at the door.

Off to one side are the "champagne rooms," the site of ten-dollar private dances as well as variously priced dirty dances. Since cham-pagne is rarely served in Ontario strip clubs, we can hypothesize that the term is intended to convey a totally extraneous sense of luxury and exclusivity.[37] These cubicles, measuring perhaps three feet by five feet each, are equipped with two (most often vinyl) chairs facing each other, an ashtray and a ledge to hold drinks. While the cubi-cles are usually hidden from the general view of the club, they are open to be monitored by anyone passing down the aisle of this area.

Inevitably, pride of place is reserved for the stage. Backed by mirrors and surrounded by perpetually flashing mini-lights, it is outfitted with assorted lighting and effects equipment. In the middle of the stage there is always a pole, which is employed for sexual poses as well as more acrobatic innovations during the strip show itself. Surrounding the stage is "perv row" — chairs along the perimeter of the stage, in front of a somewhat lower ledge that accommodates drinks and ashtrays, afford patrons a close-up view of the stage show.

The stage is the centre of activity. Depending on the club and the number of dancers who are on the floor at a given time, shows run continually or with one break song between dancers. Each dancer is expected to change into a costume and dance for two fast songs, during which she strips to her g-string. She then disappears briefly and returns wearing a sheer covering to do her final slow song. The

quality of the stage show is highly variable, and depends largely on the extent to which an individual dancer is prepared to "do a stage."

Manufacturing the Atmosphere

The club is above all a male space, culturally reproducing the masculine atmosphere of the tavern that earlier generations of men enjoyed as a result of laws that banned women. As in any bar, customers congregate in a strip club to drink. They also eat, talk, play pool or video games and purchase illicit substances. At the same time, a strip club is not a bar like any other. The most noticeable difference is that women are scattered throughout, uniformly dressed in abbreviated, sexualized attire that at times borders on the bizarre. Carrying purses to prevent theft and towels to prevent diseases, they wander through the club, chatting, posing and giving off the visual and verbal cues of availability. These women, present throughout the public space of the bar, are inevitably confined by their roles. From the perspective of the client, the female employees in the strip club are there to serve by catering to his physical or sexual desires. In either case, any pretense of equality between men and women is suspended. Within the framework of male-stream dualism, where the dichotomous positions available to women are those of either whores or Madonnas, women in the club are whores. This is important; their whore status allows male patrons to act as if no women are present at all. Moreover, none of the concessions afforded non-whores in this supposedly emancipated age are necessary. The situation is disconcertingly reminiscent of earlier eras of gender relations; women in the club can be openly rendered objects of the male gaze.

Paradoxically, the very proliferation of female bodies ensures the continuation of the club as a male space. Not only do anti-pornography feminists condemn women's consumption of male-stream erotica, but within the whore-Madonna dichotomy, "respectable" women do not frequent strip clubs. By definition, then, women who enter for leisure are, at a minimum, suspect. More frequently the assumption is made by male clients that these women are not only *like* whores, but *are* whores. "Other" women are both subtly and actively discouraged, and are generally encouraged to leave through physical and verbal cues from customers and sometimes management (though for the most part not

by the dancers). The exclusionary processes are sometimes not so subtle and unaccompanied women may be asked to leave the establishment. Not surprisingly, female customers are rare. Women who do enter a club are generally careful to provide verbal and non-verbal cues that they are unavailable, and to legitimate themselves through their association with a male patron or an employee.

In addition to the proliferation of represented and real naked female bodies, the maleness of the environment is further strengthened through that other stereotypical marker of masculine culture: sports. When not tuned to pornographic videos, the big-screen television inevitably transmits images of athletic prowess. Conversation, rituals and pools further reinforce the importance of sports to the bar culture. Seen by club managers as a strategy for encouraging patronage, the presence of sports in the club can become an undesired and disconcerting source of competition for the dancers: "They [management] put the hockey game on the screen.... They [customers] forget about us. Totally! That's bad" (Tina).

A cursory examination of the club reveals three types of clients, with very different relations to the establishment and its employees — the boys, the regulars and the loners.[38] Without analyzing the motivations of customers, it is evident that management, support staff and dancers are not only cognizant of these distinctions but organize their behaviour accordingly. The "boys" collect in groups, talk and joke amongst themselves, watch the stage sporadically and generally enact the rituals of male bar culture (Dunk, 1991). These men rarely accept invitations to the champagne rooms, although they periodically converge on "perv row." Consistent with the general rhythms of bar patronage, the end of the week is popular. This clientele dominates on Thursday and Friday nights, making these shifts less profitable for the dancers than might be expected given how busy the bar is likely to be. "Regulars" are likely to frequent the bar at any time, singly or in groups. Treating the club like a neighbourhood pub, they form friendly associations with the staff and house girls. They look at the stage with studied indifference and rarely contribute to the dancers' income, although they may treat the women to alcoholic beverages or pizza. In contrast, "loners," who are often regular clients of individual strippers, come on their own and often with the

intention of enjoying private dances. While these individuals provide the bulk of the dancers' earnings, they are also the clients who are invariably contemplated with pity or disdain by staff.

THE OTHER WORKERS

The strip club, like any other social setting, is a complex web of social relations and interactions that constitute and are constituted by, the particular environment. The strip club is also a labour site, not just for dancers, but for managers, bartenders, waitresses, doormen and disc jockeys. Not only do these other workers have tasks and responsibilities that can facilitate or undermine dancers' efforts to make money, but they provide the interactive context of the dancers' labour.

Support staff and dancers all operate under the supervision of a manager. Most clubs are fairly flat organizations where one manager, usually an employee but occasionally the owner assumes overall responsibility for ensuring the smooth running of the establishment. These traditionally male[39] but occasionally female individuals are responsible for a variety of tasks including negotiating with agents for features; establishing rules; arranging special events; hiring and firing support staff; and of course recruiting strippers. Managing a large semi-autonomous group of workers undeniably poses a variety of challenges and success is contingent upon developing the necessary competencies. While, as we will see, managers generally share a particular understanding of the labour and employees, they also adopt disparate strategies for realizing control. Some assume a highly authoritarian approach, others are abusive, some are distant and aloof, others strive to establish a labour community. While the relations of power in the club are complex, officially these individuals retain final authority. They are responsible for the effective operation of the club, are legally and fiscally accountable and are empowered to organize the club by establishing rules and identifying expectations.

Support Staff

Considering the employees of the strip club as two disparate groups — dancers and support staff — replicates a distinction that is based

not only on labour process, but also on how the relationship is experienced by participants. In spite of the interdependence and the semi-autonomous status of most of the workers, the lines of solidarity are clearly drawn in terms of relations to the establishment. Increasingly, the doormen are the only staff members who are actually paid by the bar. The loyalty of staff is therefore not bought by wages; it is the organizational structure and task distribution that ensure a commitment to the business.

If we examine the experience of support staff, the first thing that becomes apparent is that this labour site shares many of the characteristics of other working-class labour environments (Ferree, 1990; Paules, 1991). The joking relationship (Spradley and Mann, 1975) is manifest in a particular sexualized manner in spite of, rather than because of, the environment in which it occurs.[40] Furthermore, in direct contrast to the findings of Spradley and Mann, there is a great deal of camaraderie; and solidarity is considerably more than "a thin veneer" (1975:76). This rapport is strengthened by the oppositional position that the support staff occupies *vis-à-vis* dancers. This will become clearer as we consider the specifics of various jobs and the perceived need to manage and control dancers.

The bartender, either a man or a woman, is in the first instance responsible for bar tasks. That is, she is expected to stock the bar — making sure that the beer cooler and liquor cabinet are full, all mixes and garnishes prepared — fill drink orders, serve customers and provide beverages for the waitresses. She is also responsible for the cash and must reimburse the house for any shortages. This task encompasses giving change, supplying and collecting the waitresses' floats, running the Interac machine and paying for supplies that are delivered. She often also assumes quasi-managerial responsibility for the smooth running of the establishment, particularly in the absence of a manager. While performing these tasks, she is of course also expected to engage in cheerful banter with customers.

The environment shapes her labour in several ways. Not only are the clients predominantly male, the interactions hyper-sexualized and the gratuities exceptionally generous,[41] but the existence of a population of independent workers with no clear commitment to the establishment

increases her physical and emotional labour. In both her own and the bar's interest, she is motivated to maintain good working relations and a positive atmosphere. Quite simply, when there aren't any dancers working in the club, or very few, not only does the bartender's income decrease, but she must face annoyed customers who are paying, in their overpriced drinks, for non-existent entertainment. At the same time, the bartender is expected to collect the house fees from dancers, negotiate conflicts, identify dirty dancers and in general retain control over an environment that can be highly unstable.

The bartender must develop strategies that allow her to maximize her control over the workplace. These would include cultivating good interpersonal relations with other staff, creating situations of social (or labour) indebtedness and assuming an authoritative presentation-of-self. Like workers in other service-sector labour sites, dancers and support staff operate, each in their own interests, in an informal "economy of favours."[42] What transpires is essentially an effective, if unacknowledged, process of reciprocity, where the bartender offers such things as free drinks, notification of generous patrons and pseudo-friendship, and occasionally, cover for dancers by withholding information about rule infractions from management; and dancers repay these favours in kind by conceding to the bartender's requests to go on-stage or to acknowledge a customer. This informal economy of favours operates outside managerial control, and while it is generally consistent with managers' interests since it ensures that shifts run smoothly, it can also function at management's expense. In short, because bartenders are in an ambivalent relationship with dancers — characterized by both reliance and conflicting interests — relations between these workers tend to be managed instrumentally.

Unlike the bartender, the inevitably female server will rarely assume managerial responsibilities, although she does unofficially monitor the floor and sometimes the champagne rooms. Her time is filled getting orders, making change, clearing and wiping tables and arranging seating. Working the floor also means she is denied the physical barrier from customers enjoyed by the bartender. Accordingly, she must be careful to ensure that she retains the customers' goodwill, in order to realize the gratuities that constitute her income, while also protecting

her physical space. She must do this because some customers take phys-
ical and verbal licence with the female staff in strip clubs that they
would never presume in other service encounters. It is not all bad; many
patrons are highly respectful. Furthermore, servers can and will "call" a
customer on his inappropriate behaviour and are usually backed by the
bartender, manager and/or doorman.

Then there are the doormen (or bouncers), who are conspicuously
visible not only at the club's entrance but throughout the public space
of the club. In non-stripping bars these individuals are employed to
control the clientele and ensure that, in an establishment predicated
on the consumption of alcohol, the situation remains stable. To be
successful they must possess physical agility but also, and perhaps
more importantly, effectively employ verbal dexterity, exercise good
interpersonal skills and construct a presentation-of-self that is impos-
ing without being confrontational (Laxdale, 1999). In a strip club, the
management of violence is layered over the management of morality.
Accordingly, the job description of strip-club doormen includes the
monitoring of champagne rooms. While this reflects their responsi-
bility to protect the dancers,[43] it also speaks to their obligation to
ensure that dancers do not contravene established guidelines with
their customers. At the same time, the relationship of control is
undermined by the doormen's reliance on gratuities from dancers to
supplement their income. Their job is further complicated by the
tension that exists between protecting dancers, on the one hand, and
accommodating management's resistance to losing "good" clients
(from the bars', not the dancers', standpoint), on the other.

The final occupational group to consider is the disc jockeys. The
work of these individuals is much more directly shaped by the labour
location than that of other support staff. In other drinking establish-
ments, these predominantly male employees are responsible for creat-
ing the atmosphere of the bar, employing a sophisticated use of music
to keep customers on the dance floor, to ensure that they enjoy them-
selves and to encourage them to frequent the establishment again. In
a strip club the music is (at best) secondary. For the most part, it is
repetitive mix of seventies disco, eighties dance and selected rock
tunes. Instead, the disc jockey ensures atmosphere through his "rap"

as he endlessly promotes dancers, specials and coming events, urges patrons to "enjoy a private dance with the lovely Betty" and announces dancers as they go on, or come off, the stage.

The disc jockey also assumes a managerial role in relation to the dancers. Ultimately it is his responsibility to ensure that dancers are available and prepared to go on stage and that they don't cross the lines of "decent performance." He is also expected to advise the manager of any untoward behaviour on the part of the dancers. As one research participant put it, "I'm a babysitter ... it's degrading as a DJ" (Brad, disc jockey). These managerial responsibilities must be understood in relation to his dependence on dancers for his income, which in most clubs is directly proportional to the number of dancers who pay the required bar fee. In this specific labour dyad, the disc jockey finds himself in the unenviable position of controlling the labour of others, but with little real authority or power. The few sanctions he can apply, such as removing a dancer from the floor, are often contrary to his own interests and, in any case, are likely to be overturned by managers highly motivated to placate and retain their entertainers.

Put this way, it is apparent that a disc jockey's organizational assets of authority are, in practice, undermined by both his direct reliance on those he manages for his income and the hierarchical authority structure. Disc jockeys, as a rule, have few illusions:

> In a way the DJ is supervisor over the dancers, but it's hard to get girls up [on-stage].... See, my problem is enforcing it — I can take them off [the floor] but I'm always worried about them running up to management. Right now I'm going to start to enforce it more and take advantage of the position I'm in 'cause I'm the only disc jockey (Jake, disc jockey).

Conflicting Labour Interests

Strip-club support staff and dancers are similarly located autonomous workers. In spite of this, the structure of the labour itself, combined with outside regulation and financial self-interest, effectively positions these workers oppositionally. The interests of the different groups

necessarily conflict when staff are required to manage dancers and monitor or control their labour strategies. The possibility of cohesion or coordinated action is structurally undermined and a complex set of social relations is set up that is always confined by this pervasive conflict. It is hardly surprising, then, that as we will see, staff are unlikely to applaud the resistance efforts of the dancers, but instead perceive these as opposed to their own immediate interests.

THE RHYTHMS OF WORK

Before the bar opens, staff start arriving. For the bartender, mornings start with cleaning away any remnants of the previous night, setting up the bar, counting and stocking beer into the coolers, putting the liquor into the cabinet, preparing condiments and organizing her cash. This process will be repeated at shift change. Next, the disc jockey and dancers start arriving. The latter, in sweat pants and without make-up or hair-pieces in place, appear to be the antithesis of the stereotypical stripper. As they proceed to the change room to effect their metamorphosis, the lights go down, the music starts and the doors open at eleven o'clock in the morning.

The day and evening are spent with workers going about their assigned tasks. The bartender serves, cleans, fills orders, stocks, washes dishes and referees disputes. The waitress runs back and forth filling drink and food orders, emptying ashtrays and cleaning away masses of dirty glasses and empty beer bottles. The disc jockey confers with the dancers about music and establishes the order of appearance, a process that frequently involves extensive negotiations with the house girls. He then spends the remainder of his time playing compact discs; promoting food and bar specials, upcoming events or the champagne rooms on the microphone; and cajoling, begging or threatening the dancers onto the stage. The doorman intersperses periods of standing at the door with his rounds of the champagne rooms and pool tables, chatting with patrons or staff, looking at the stage and occasionally playing a game of pool. The employees appear to be, and in fact are, oblivious to the nudity around them. For most, it is more of an annoyance than titillation.[44]

The women emerge from the change room with "war paint and costumes" (Ann) in place to work the floor. Their strategies of approaching patrons, chatting with them and soliciting dances depend on both the personality of the dancer and the regulations imposed by the particular club. The result is that at any time one might see dancers chatting among themselves, playing pool, sitting alone at a table or engaged in conversation with customers. In spite of the advertised availability of five-dollar table-dances, these are rare. Most dancers simply refuse to remove their clothes in the middle of the bar. At any rate, most patrons are easily persuaded to enjoy the privacy afforded by the champagne rooms, where the stripper either dances on a stool or sits in close proximity to the customer and moves — a dance in name only.

The club follows somewhat erratic daily and weekly rhythms, with intervals of intense activity interspersed with periods of relative calm. The arrival of a stag party can suddenly and dramatically transform the atmosphere in the club. Similarly, special promotional events sponsored by beer distributors, competitions like wet T-shirt contests or periodic "Miss Nude Something-or-Other" competitions offer a welcome diversion from routine. On a normal day the workday is broken up by "stages." That is, since the prerequisite of a strip club is the presence of a woman at some point of undress on-stage, dancers periodically emerge from the dressing room for a stage show. Throughout the day, new dancers arrive (most often brought by one of the many driving services that operate expressly for dancers) to complete their minimum four-hour shifts; they leave when they are either discouraged or have earned sufficient money. Thus the number of dancers in the club is in continual flux, although some clubs attempt to regulate shifts. Midway through the day, around seven o'clock, there is a general shift switch when support staff and a number of the dancers leave and new workers arrive. Periodically, uniformed police officers — perhaps they think they are participating in community policing — enter the club, patrol the champagne rooms, briefly wander around the floor and then, their presence acknowledged by all, make their way out the front door.

At one-forty-five in the morning the disc jockey announces "last call for alcohol." Lights are turned up and the music ceases. The

waitresses run around wiping tables, stacking chairs and emptying ashtrays — although a cleaning service arrives in the early hours of the morning to do a more thorough job. The bartender reverses the tasks of her day-shift counterpart and closes her cash, locks up the liquor and cleans the bar. The doorman checks the nooks and crannies of the club to ensure that no patrons remain. By two-fifteen in the morning the dancers, disc jockey and waitresses have all left and the doorman and bartender are often desperately encouraging some (usually) intoxicated stragglers to depart. When they do, the cash is put in the safe, the doors are locked and the alarm set and the doorman escorts the bartender to her car. Barring a routine police check the last staff member has left the parking lot by three o'clock.

The Interactive Day: Conflict, Friendship and Chaos

A labour site is not just about performing tasks, it is also about relationships and interaction. How people perform their tasks and how they experience the job is necessarily shaped by this interpersonal context which, while providing meaning and pleasure, can also be distracting and undermine the ability of workers to do their jobs well. This duality is clearly evident when we look at strip clubs.

All employees have access to a backstage area to which they can retreat when the environment or clients become insufferable. In the case of dancers, the change room frequently has more occupants than the floor. There the dancers share information about clubs, staff and other dancers. At the same time, support staff and dancers spend considerable amounts of time congregating around the bar, engaging in conversation and inevitably, "bitching." The result is a camaraderie of sorts but also a continual undercurrent of stories and gossip:

> They all are full of shit, it's not news unless it's something, you know — really interesting. If it's bizarre they'll keep it that way, but like you could go in there and say, "Oh ya, I bought a new car." You buy a little Cavalier or something, next week it comes back to you: you bought a Camaro and you slept with the owner of the lot for it (Ann).

There is also considerable alcohol consumption. In fact, drinking by dancers is actively encouraged by management in some bars. When there are no generous patrons to pay for the beverages, dancers end up as "captive consumers" of the inflated prices charged for the entertainment which they themselves provide.

To summarize, the strip club is an intense, dynamic and often chaotic place. It is impossible to understand the conditions of the labour without appreciating the unique atmosphere that prevails there. It is a space where "there is always bullshit, just *bullshit*" (Jake, disc jockey). The exact source of this, I would argue, is the complex convergence of a number of dynamics. The gossip and stories, the social atmosphere, the instability engendered by shifting expectations, the class culture, the self-dramatization and the very real crises occurring in individual women's lives mean that not only are there real stressors, but minor at-work issues tend to be exaggerated. The feeling of general instability is exacerbated when customers act unpredictably. Although incidents are usually effectively contained by staff, the general experience is unsettling — a dynamic that is further exasperated by dancers' periodic intoxication and, of course, the competition and lack of personal space inherent to their labour in strip clubs.

4 Regulating the Labour of Strippers

S trip clubs' unique position of being commercial enter-
prises embedded in the market economy while simul-
taneously being the product and focus of dynamic social
processes, including moral and legal regulation, has rami-
fications for the labour experience of industry workers.
For strippers it means that although their occupation is
legal, they are nonetheless entangled in a complex web of
discursive and regulatory practices that are unknown to
more "reputable" occupational groups.45 At the same
time, they are also subject to regulation at work as clubs
seek to manage their labour and extract maximum value
from their labour power. These intertwined processes,
which together constitute the regulatory framework that
dancers must negotiate, are the subject of this chapter.

MORAL PRESUMPTIONS AND LEGAL PARAMETERS

Strip clubs, like all commercial endeavours, are subject to
a variety of regulations — including meeting fire and
building codes and insurance and health standards. What
marks strip clubs as unique is the extent to which regulat-
ing strip clubs is about regulating morality. In the complex
jurisdictional distribution that marks the Canadian polit-
ical landscape, morality is a federal matter. Since the 1950s,

when burlesque came to Canada, strippers have periodically and somewhat randomly been charged with appearing in an "immoral theatre performance" contrary to section 169 of the Canadian Criminal Code, and with public nudity "without lawful excuse" (CCC 174). Though the Supreme Court of Canada ruled in 1973 that women's bodies are not inherently obscene,[46] the courts continue to police nudity by stipulating that strippers can remove their g-strings provided they wear some item of clothing and do not, through their actions, "offend against public decency or order" (CCC 170.2).[47]

The federal court's authority, at least in principle, extends beyond the stage and into the relatively private champagne rooms. The result has been confusing. On the one hand the Supreme Court of Canada ruling in *R. v. Mara*, practically speaking, made lap-dancing illegal as of March 1997.[48] Citing the 1992 *R. v. Butler* decision that behaviour that degrades or objectifies women is socially harmful and, therefore, beyond community standards of tolerance, Chief Justice Sopinka determined that lap-dancing represented the *undue* exploitation of sex that is deemed illegal under the Criminal Code.[49] In December 1999, however, the Supreme Court complicated the issue when it upheld a Quebec Court of Appeal ruling in *R. v. Pelletier* that touching between patrons and exotic dancers in private cubicles does not contravene community standards of tolerance (SCC, 1999).

Federal jurisdiction notwithstanding, over the last twenty years the authority of the judiciary has been challenged and the federal courts have been displaced as the guardians of morality as community groups, municipal politicians and to a lesser degree provincial officials have sought to employ their authority over space, labour and health to contain and regulate the exotic entertainment industry and its workers.[50]

Community Agitation

Strip clubs emerged as a "social problem"[51] in the early 1980s. In part this was engendered by changes within the industry. It was during this time that clubs with carefully designed stages, good lighting and sound equipment and an environment explicitly and consciously focused on erotic entertainment proliferated. These clubs increased competition, resulting in progressively "raunchier" entertainment; more well-

endowed stars; duos; and special events such as wrestling (in mud or Jell-O) or wet T-shirt contests. The clubs also became more visible; they aggressively advertised their special attractions and the newly implemented table-dances. Perhaps most importantly, they migrated out of working-class areas.[52]

It was in this context, parallel to the concern that surrounded street prostitution, that strip clubs began to be discussed as a social problem in a number of communities across Ontario (including Toronto, Ottawa and Hamilton). Using moral-contamination arguments, activists suggested, somewhat hysterically, that strip clubs were "breeding grounds for rapists and murderers" (Adami, 1982)[53] and made reference to sexual danger for "other" women, although most stopped short of the Alberta group that directly linked sexual assault to the observation of strip shows (Edmonton, 1988). During this period, in large measure as a result of media portrayals that rarely contradicted those of the interest groups, the clubs also became *discursively* associated with organized crime, illicit substances and all forms of vice, further legitimating the fear expressed by community member that an increased presence of strip clubs would result in higher levels of crime (Miller, 1985).[54]

The discourse on clubs that emerged at this point and continued throughout the 1980s and 1990s interfaced on the one hand with the public fear of moral disorder that was sweeping Canada. The brutal 1977 homicide of twelve-year-old Emanuel Jacques in Toronto's red-light strip came to be thought of as an indicator and eventually a symbol of the (moral) breakdown of urban Canadian society generally and the danger inherent in commercial sex in particular. This broadened support for state intervention (Cooke, 1987; Lacombe, 1994).[55] On the other hand, the discourse also intersected with a more general moral panic surrounding crime. While a public "fear of crime" is not based on any statistically real increase in violent or property crime (DuWors, 1999), it is real in its consequences to the extent that people, particularly women, restrict their public behaviour to avoid danger (Statistics Canada, 2000).[56]

Municipal Regulation

In response to the perception of strip clubs as an urban problem, city councillors across Ontario adopted a position that clearly identified

them as defenders of the moral *right*. Their attempts to implement explicitly moral regulatory strategies and to govern what was happening in the clubs or, more specifically, what was on, or not on, the dancers' bodies were stymied by the Supreme Court of Canada in February 1985.[57] However, shortly thereafter, in October 1986, the Supreme Court implicitly upheld municipalities' authority to regulate strip clubs on the basis of city planning principles.[58] Communities moved quickly to enact severe zoning restrictions banning clubs from residential areas, restricting the clubs to commercial (and sometimes industrial) zones and stipulating no-strip club parameters around churches and schools. In effect, municipalities found a way to circumvent their jurisdictional limitations and still directly address the moral concerns expressed by community groups. Their position was strengthened in 1990, when the Ontario Municipal Act was amended by the provincial government and municipalities were authorized to limit (to one), but not ban, strip clubs. Smaller communities quickly imposed a one-club limit instead of the prohibition which they would have preferred (Tolson, 1990). Ironically, these bylaws, while intended to regulate the industry, often work in the interests of individual clubs and to the detriment of dancers. Not only do such regulations limit competition for customers, they may also restrict employment opportunities. The subsequent shortage of work means dancers in some communities are competing in a "buyer's market," with all the disadvantages that can entail.

Throughout the 1980s and into the early 1990s, a number of municipalities throughout Ontario began to further regulate the industry through licensing, which among other things facilitates more effective surveillance of clubs and workers by police (Corporation, 1991:8). Under these provisions, the strip clubs and the newly designated "exotic entertainment parlour attendants" are required to purchase annual licences, under threat of closure in the case of the former and fines and even imprisonment in the case of the latter.[59] The nature of the licensing is revealing and speaks to the moral subtext of these strategies, and the extent to which unproven discourses with regard to drugs and vice can become embedded in regulatory practices. For example, in Toronto strippers are categorized along with massage-parlour attendants, while in Ottawa attaining a licence is contingent

on dancers' first demonstrating that they have not been convicted of indecent acts, procuring, prostitution or any offence under the Narcotics Control Act.[60]

While some municipalities have suggested that licensing professionalizes the industry, in practice no benefits are derived for workers (Cooke, 1987). Instead, licensing can have a number of negative consequences beyond the obvious economic costs — affirmation of marginality, taxes, increased external control and the potential for a lasting stigmatic designation. When the licensing of exotic dancers is enforced (it isn't always), it also excludes some women from the industry. At the same time, the licensing of clubs further restricts employment opportunities: live entertainment ceases to be economically viable for smaller clubs in light of the hefty annual fees.[61]

Labour Standards

During the 1990s, a series of zero-tolerance health initiatives, engendered by the fear of the potentially fatal transferable diseases AIDS and Hepatitis C, became part of the Canadian regulatory landscape (Kinsman, 1996). Given the (unproven) association in the public consciousness of the two principal high-risk behaviours — drugs and sex — with strip clubs, it is not surprising that this emerged as a further regulatory strategy. In 1995, the Ontario Labour Minister ruled that lap-dancing could expose workers to fatal diseases, and therefore constituted a potential health hazard for workers according to the Occupational Health and Safety Act (Ontario, Ministry of Labour, 1995). While this did not make lap-dancing illegal in Ontario, workers were in principle afforded recourse from compulsory lap-dancing inasmuch as owners could be charged under the provincial statute if dancers registered a complaint. Not surprisingly, few strippers, working as they do in marginal labour environments and in practice risking dismissal for challenging labour practices, took advantage of this privilege (Wallace, 1995).

While the labour laws did little to help strippers, they did provide municipalities with a new regulatory tactic. In 1995, a number of municipalities, including Toronto, implemented bylaws outlawing lap-dancing, citing the newly established health risks associated with the

practice. The Ontario Divisional Court rejected the clubs' claim of Charter infringement and, in October 1995, upheld the municipal jurisdiction. By 1996, municipalities across the province had tabled similar bylaws and lap-dancing had officially ended (for the time being) in Ontario. Once again the municipalities had found a strategy to preempt the Supreme Court of Canada and federal law by eliminating the problem of lap-dancing in a way that carefully circumvented the question of morality. This means that while the federal courts have not ruled conclusively against lap-dancing on the basis of morality, in Ontario touching between patrons and customers is prohibited through a series of municipal bylaws enacted on the basis of health. The research for this book was completed prior to the Pelletier ruling (SCC, 1999). It would appear that since that time, municipal bylaws notwithstanding, lap-dancing is once again a common practice in some Ontario clubs.

Media

For the most part, throughout this period the media reflected and reinforced community and political discourses about clubs and strippers. By the late 1980s, an association between dancers and drugs appears to have been firmly established and the connection provided a subtext for many newspaper articles on the trades. The problematic nature of the industry was further confirmed in the media by rather questionable reports, such as a story that chronicled the slide into drugs by Cherrye, a stripper who was described as follows: "It may be hard to believe, but she's basically a nice girl. The product of a typical two parent suburban hearth" (Campbell, 1989:50). Further verification of this was "reformed" insider Annie Ample's exposé indicating that cocaine and its derivative, crack, had infiltrated the clubs to such an extent that "the girls ... were rapidly becoming coke whores" (1988:84). For the most part, the use of illicit substances by dancers was seen as an indication of the general disrepute of clubs. It was the lap-dancing debate that had the most telling implications.

During the mid- and late 1990s virtually all reports and commentaries on lap-dancing drew attention to the prostitution question. Ultimately the two labour processes became conflated in the dominant discourse, and the value-laden moral condemnation of sex-trade

workers was extended to strippers. In addition, by once again focusing public attention on the women working in the clubs as opposed to the concerns of the community, the lap-dancing debate resurrected questions and judgements about industry workers. Certainly the series of articles and letters that appeared in the *Ottawa Citizen* in response to the December 1999 Supreme Court ruling in *R. v. Pelletier* (SCC, 1999) not only reaffirmed the link to prostitution (Jaimet, 2000; Kay, 2000; Morse, 2000) but went much further, reiterating the contradictory but prevalent image of women in the skin and sex trades as simultaneously degenerate and victimized. We were advised that strippers are "to be pitied" but at the same time are not victims, since the individual dancer is "free to impose on herself the same standards of behaviour that other young women (even financially desperate women) impose upon themselves" (*Ottawa Citizen*, 2000).

Policing

While policies are rhetorically and ideologically important, it is their enforcement that renders them relevant for industry workers. The role of the police and bylaw officers as gate keepers is important to bear in mind.[62] By the mid- to late 1990s police practices in pressing charges reflected the belief that strip-club activity is equal to prostitution; increasingly employed was the bawdy house provision (section 210) of the Canadian Criminal Code. This had an impact on the labour site. In the past, managers were sometimes charged with, although rarely convicted of, the hybrid offence of "allowing an indecent theatrical performance" (Canadian Criminal Code section 167(1)). Today bartenders, doormen and managers are periodically charged with the indictable offence of "keeping a common bawdy house" (Canadian Criminal Code section 210(1)). Put another way, not only has the potential stigma and penalty of state sanction increased, but moral regulation has been extended to those who share the strippers' labour site.

To summarize, strippers are positioned within a complex web of regulatory policies and practices. At the broadest level, there is a general discourse of disrepute that links strip clubs to drugs, crime and immorality. This position emerged through the efforts of community groups in the early 1980s and has since become embedded in the "truths"

spoken by the media, municipal politicians and provincial administra-
tors. These discourses have in turn become the basis for an array of
municipal initiatives that through licensing and zoning effectively regu-
late the location and staffing of clubs. Most recently, municipalities in
Ontario have employed health-related arguments to disallow touching
between customers and attendants. Strippers' behaviour is also regulated
by federal laws that prohibit indecent stage performances, public nudity
and being an inmate of a bawdy house. These regulations are enforced
through careful monitoring by police and bylaw officers who patrol strip
clubs and periodically charge industry workers.

The moral regulation of strip clubs is multifaceted. In part this is a
function of jurisdictional divisions that result in municipal, provincial
and federal regulations being imposed in complex and sometimes
contradictory ways. In part it is because the clubs operate in grey,
undefined areas of the law, so that at times the industry becomes a site
where questions of morality are played out publicly. Federal jurisdic-
tion notwithstanding, issues of morality appear to be sufficiently
provocative that governments at both the provincial and municipal
levels have developed strategies to restrict and control the industry.
Not infrequently these controls, while intended to regulate the indus-
try, in practice also further restrict the options of women workers. In
the next section we consider how this broader context is manifested
specifically at the labour site as it intersects and conflicts with manage-
ment's interest in extracting dancers' labour power and minimizing
operating costs while avoiding state interference.

LABOUR-SITE REGULATION

Most clubs are owned by individual businessmen who take a greater or
lesser interest in the day-to-day management of the club. While clubs
are usually independently owned, there is considerable interaction
within the industry as dancers, bartenders, waitresses, doormen and
disc jockeys rotate through the clubs. Owners and managers commu-
nicate not only socially but also professionally in associations that fight
threats to their collective economic well-being.[63] These interactions

create a community of sorts as well as consistency in the internal organization of clubs. The former comes with all the benefits and drawbacks entailed in the notion of community, including a continual sharing of information throughout the industry about the unethical behaviour of particular dancers. Rachel explained:

> I remember before it was really bad. Like when I first started dancing it was a big competition and the stealing and they'd rip off your costumes.... Nobody could be trusted and no dancer could've, would've been trusted back then. But now it's just like, you always see each other anyway, you always run into each other whether it's a year from now or a month from now. So it's like everybody, you can pretty well trust each other now, 'cause everybody knows pretty well everybody. If I don't know somebody, Lori probably knows her from somewhere else. So I figure if I know three girls who dance, I figure through those three girls I probably know the whole circuit.

The second implication of workers' and managers' close association with each other is that labour is managed in remarkably similar ways among clubs, and innovations (read strategies of exploitation) that are successful in one club are quickly adopted throughout the industry. The trajectory of strip clubs since 1973, when amendments to the provincial Liquor Control Act expanded the definition of "theatre" (Ontario, 1973) and made it possible to combine alcohol and nudity in a legal commercial endeavour in Ontario is revealing, and speaks to industry-wide approaches to the management of labour as well as to the extent to which these strategies are shaped by state regulatory strategies while they intersect with broader market and labour trends. In the mid- and late 1970s, strippers were entertainers who in exchange for wages[64] were expected to perform five sets of four songs each (three fast, one slow floor show) during a six-hour shift. In the early 1980s, in light of what were inaccurately referred to as the extra "tips" workers could earn by soliciting customers to purchase five-dollar table-dances, wages for dancers were cut to thirty or forty dollars a day, shifts were lengthened from six to eight hours and bar fees were implemented.

In other words, in the context of economic decline and dwindling

options for working-class women, the strip-club industry was able to deprofessionalize workers' trade by redefining the entertainers as service providers (who earn tips) while simultaneously reducing wages and increasing the labour expected from them. At the same time, clubs were able to hire more dancers, promote table-dancing as a fresh attraction and implement a new industry standard of continuous shows. In the early 1990s, the economy continued to spiral downward, threatening even the bad jobs in the service industry and as the regulatory strategies imposed by municipalities to govern the exotic-entertainment industry effectively limited the employment options of strippers, clubs went from exploiting workers to the full appropriation of their labour. While the impact of the reduction in numbers of clubs was mediated by clubs' increased demand for labour, many dancers nevertheless found their regular pay eliminated as they were offered the option of working for tips or not at all.[65] In short, strippers have experienced a labour trajectory that mirrors that of many of their working-class sisters — consumer-service-sector employment, intensified labour expectations and non-standard labour practices. At the same time, unlike more reputable labour sites, the industry itself is subject to particular restraints that are imposed by the state precisely because it operates on the margins of morality. In practice, this regulation not only operates contrary to the interests of strippers, but actually positions clubs to exploit the vulnerability of their workers to an even greater extent.

Managing Strippers' Labour

Strippers working in Ontario clubs today are either on-schedule or freelancers. In the case of the former, the club has purchased the labour power of the worker; for the latter group, no such economic exchange has taken place. Under the freelancing system, individual dancers enter into verbal agreements with the club to pay the established bar fee of between ten and twenty dollars, follow house rules, remain in the bar for a minimum of four hours and perform between one and five three-song sets on-stage. Clubs in some parts of the province have also implemented policies that oblige dancers to pay the bar a portion of their earnings from private dancing.[66] At times a bar might make a dancer's

access to the labour site contingent on participating in special events, wet T-shirt contests or beauty pageants:

> There's a Miss Nude — happening now. That's where all the girls are. It's really stupid. Mostly dancers need a title to become a feature.... I was working this club and the only way I could keep working was to enter. So I did (Sarah).

Like other workers under subcontracting arrangements (e.g., electricians), exotic dancers are responsible for furnishing tools, in this case music, costumes and transportation. In exchange for the dancer's labour, fees and compliance with the expectations of the club, the bar provides the labour site — the physical space (bar, chairs, champagne rooms) and other coordinated and necessary labour by disc jockeys, bartenders, servers and doormen. This setting is, of course, crucial. Without it, a dancer cannot solicit dances to make her money.

Dancers who are on-schedule generally earn between thirty-five and forty-five dollars for an eight-hour shift.[67] In spite of a rate of pay that at five dollars an hour is well below provincially mandated minimums, these workers' labour and general deportment remains under the control of management.

> You have to follow the bar rules, which are usually posted in the change room. No fighting with customers. No touching customers, or letting customers touch you. No drinking in certain areas of the change room. No smoking drugs. Some places have a thing, no cut-off jeans. You can't wear cut-off jeans.[68] You can't walk barefoot. Things like that (Jamie).

Control is realized through economic sanctions that take the form of fines that are deducted from dancers' earnings. Workers can be fined for a variety of infractions:

> If you lose the keys you're fined. Like you have to pay the key fee, if you're late you're docked off your pay — anything from five to fifty dollars. It can be quite substantial. I can give you an example. There

was this special, you could get two-for-one. Two dances for the price of one between two and four in the afternoon. And if you didn't do it, one girl didn't do it for two afternoons and she got docked a hundred bucks, fifty bucks a day for not doing the two-for-one. That place had *forty-one rules*. I never saw that before. And one of the rules was don't associate, don't become friendly with the staff. Like the doorman wants to take you out for coffee at one o'clock — you can't go. You can't go to Harvey's and have coffee. You can't say, "Hello, how are you." That is some kind of stigma (Kelly).

Dancers are not always just fined part of their income, but sometimes fired so that all their income is lost.

You can get fired for anything. Being too fat, for having a big ass, because the owner doesn't like you, for looking too young. I've been fired for looking too young.... Clubs just fire you! They are really sleazy. You're on-schedule and on your second day, you have no recourse, you've worked for free (Sarah).

While the imposition of fines is characteristic of the industry, what dancers are fined for is largely dependent on the particular club. The use of illicit substances, violence or dirty dancing can result in fines in some bars, outright dismissal in others. This is somewhat ironic given that the legal parameters of behaviour are, in principle, dictated by the state:

It's supposed to be no contact. I still see some girls rubbing but it's nowhere near as bad as it was [prior to *R. v. Mara* ruling]. There's no nipples thrust in the mouth, what have you. Whereas before there was, you know, a lot of munching going on (Debbie).[69]

It would appear that definitions of "dirty" are quite flexible; particularly with the uncertainty engendered by the Supreme Court ruling in Pelletier, it can mean touching in one club, oral sex in another. In practice, the ever-present potential for municipal bylaw or federal criminal charges notwithstanding, rules continue to be somewhat fluid and subject to change without notice. All of this increases the

instability of the environment and leaves workers unsure of expectations and parameters:

> There are rules? You're supposed to have rules [mocking]? Before it was chaos. Now it's organized chaos. Now the laws have been sorta set [but] they try to change them, monthly. So we don't know what to follow. We just go by whatever's posted in the change room. Whatever they tell us to do that week (Debbie).

Since the main purpose of placing dancers on-schedule and paying them five dollars an hour is to ensure a steady supply of employees, those who fail to complete their contractual commitments are summarily denied all their earnings:

> So like say you worked three or four days and Friday you had to work day shift, which is at, you have to be there at 11:30, and you didn't show up or something, stuff like that. Even when you call in sick or something last minute. It's like you're off schedule and you lose all the days that you've already done (Diane).

Some women are particularly vulnerable. A woman who is tattooed or overweight has fewer options:

> The only thing that was holding me back is my tattoos and my lack of tan lines.... There's only two clubs I can dance in.... Well I need tan lines, that's what I've been told by, like, every club owner except one or two. I need tan lines and I need to cover up my tattoos. So I wear stockings, but the ones on my legs are hard to cover (Jamie).

These women are liable to be subject to an excessive degree of managerial control and exploitation, as the following story by Jake, a strip-club disc jockey for over four years, amply illustrates:

> Steve, okay he does book girls, forty dollars a shift. You have to work eight hours. He would find any excuse to take money off the girls. For instance a girl comes in five minutes late and that's fifteen bucks

off your pay. Donna was working there and she wasn't going to get her cheque because an uncle of hers died and she went to the funeral. So she missed one day in that week that she was booked. She wasn't going to get her cheque unless she pulled a double on the Saturday. And she wasn't going to get paid for that Saturday or the day she missed. She did what he said 'cause she needed the money. She had to. She has four kids and she's a little on the chubby side and not many bars would probably have her. And she does have a tendency to get intoxicated on the job. That tends to be a big thing in this business, people, you know, they have children or you know, they're doing this 'cause they need the money.

In general, while the practices are recognized as sometimes unreasonable, the withholding of pay and the imposition of fines are largely taken for granted by industry workers. Perhaps on the margins, labour relations are shaped by the expectation that they are exploitative. Certainly dancers are able to appreciate the adversarial nature of labour relations and deconstruct the relationship to management; a dancer might dismiss the on-schedule pay as "only two hundred bucks, it's nice 'cause it just gives you that little extra at the end of the week" (Diane). Nor do dancers expect protection from the state, since they are well aware that in practice, if not in policy, clubs operate outside of the security afforded by labour laws.

Most dancers do not even enjoy the minimum and fragile benefits of the schedule process. Going on-schedule is increasingly an option only in rural communities that book dancers for week-long engagements and in urban clubs with an unreliable clientele:

Before you didn't find a bar with more than five or ten dancers. That's the most. Now there are so many freelancers, bars don't need to book girls. They can rely on their freelancers. But a club like The Pit, they can't rely even on the freelancers because there's not enough people that go there, there's not enough customers, there's not enough girls. Well one thing, one takes the other to draw in — the one ain't helping the other (Sally).

While it results in lower labour costs, freelancing also means that managers are faced with a highly unstable labour force and decreasing levels of control over workers. In an effort to re-establish their authority, managers may employ a number of contrasting approaches. Some may attempt informal paternalistic strategies such as bestowing status and privileges on house girls, while others may aggressively recruit new freelance dancers.[70] While the former is unlikely to have the desired effect of establishing employee loyalty, both tactics effectively destabilize the environment and, not incidentally, undermine worker solidarity.

For the most part, control is realized by the club's power to deny a worker access to customers. A dancer who is defined as troublesome, who complains "too much," who doesn't follow the house rules or who leaves with a customer may be suspended from the club for a finite period or even indefinitely. With regulation and freelancing there has also been a general "tightening" of the industry and greater sharing of information between clubs whose managers understand their collective need for a disciplined labour force. As a result, dancers risk being blacklisted for their behaviour; this can have dire consequences inasmuch as a marked dancer will be unable to pursue her trade anywhere in the city.

REVISITING REGULATION

While there are a variety of state laws, policies and practices that are intended to regulate the behaviour of strippers, it is clear that on a day-to-day basis management retains considerable authority over dancers' labour. Managers set the rules, fees, hours and expectations; they can impose fines or withhold access to customers. This is, however, complicated by the dependence of managers on dancers, and by the organization of the labour itself. An individual dancer, though operating within a complex web of regulation, nonetheless retains considerable autonomy: she determines the hours, location and nature of her work, decides with whom she will interact and establishes for herself the level of her labour output. Furthermore, because private dancing constitutes

all or most of her income, she is not, or is only marginally, economically dependent on an individual capitalist.

Without negating the reality of control, it is important to acknowledge this autonomy. Too often the "truth" about working-class people is written by researchers constrained within a particular set of assumptions that are highly classed, so that "apparent contentment with conditions the observer defines as exploitative is a sure sign that one suffers from false consciousness" (Paules, 1991:186). Traditional analysis assumes that working-class labour is characterized by limited organizational assets (Wright, 1989a), so that autonomy has been associated with a quality of work that is by definition middle-class. Perhaps what we need to do is suspend intuition and instead listen to what workers *say*. Certainly autonomy appears to be valued by dancers themselves.

> There's no job like this job y'know [laughter]. You work whenever you want when you want, no job can give you that y'know. If some weeks you don't want to work, you are sick, or this or that, or mentally. You can't do that somewhere else. But in a club you can (Tina).

For some women, it is precisely the lack of managerial control that is an appealing aspect of the job: "I'm there for the money and that's it, that's all and I go in, I make what I have to make and then I leave" (Debbie).

REVISITING THE ORGANIZATION OF THE LABOUR

The organization of strippers' labour is complex and defies easy classification. At the same time, to perceive the arrangement as an anomaly risks reaffirming its marginality by locating it outside of established labour practices. In fact, organizationally, stripping is comparable with the non-stigmatized service occupation of realty. Like strippers, real-estate agents are in such a paradoxical relation to their "employers" that the term is hardly appropriate. Realtors are actively recruited by

brokers; they are hired and they can be fired. But since they receive no direct financial remuneration for their labour from their employers, the relationship is nuanced. In exchange for legal protection and access to the necessary legitimizing context (including the use of the firm's name, licence, insurance) and means of production (phone services, office space and technical support), the realtor commits her/himself to a particular brokerage firm (including providing "free" labour staffing the office). Similarly, dancers receive access to the necessary legitimizing setting and technical support for their labour, but are not financially compensated by the owner of the labour site. Like realtors, they cannot simply practice their trade in any location and have to exchange labour and fees for access.

Of course, realty and stripping are not completely analogous occupations. Clearly there are differences, including educational requirements and legitimating provincial standards. The regulation and self-monitoring (via professional associations) of real-estate agents stand in sharp contrast to the multi-level, intrusive, morally motivated control of strippers by both administrative and coercive arms of the state.

CHAPTER

5

Working the Club

Though it is frequently ignored in labour theory, sexuality does not operate outside of the labour market. Rather "sexuality is a structuring process of gender" (Adkins, 1992:208) and gender and sexuality are central "to *all* workplace power relations" (Pringle, 1988:84). Certainly women's interactive labour, the consumer-service sector where working-class women are clustered, explicitly or implicitly demands a feminine and attractive presentation-of-self. One of the skills women are traditionally required to bring to the labour market is the ability to present a pleasing "made-up" appearance so that "part of job for women consists of looking good" (Adkins, 1992:216). However, more than just a *good* appearance is required. There is a process of sexualization involved in women's working attire (Adkins, 1992:218); in fact, much of the publicly visible labour that women undertake has a sexual subtext. Sexualized presentation marks the labour process of much of working-class women's paid work in the main, and is also correlated to the application of moral stigma (e.g., the costume of cocktail waitresses). At times this sexualization may be made respectable by the terms though which it is described. For example, secretarial graduates are assessed in terms of their "femininity, defined in terms of appearance, fashion awareness, clothes and taste" (Pringle, 1988:132). Put this way, the erotic component of

strippers' work situates them on a continuum of visible sexuality which frequently characterizes working-class women's labour force engagement. So while Susan Cole is right when she maintains that pornography is not mere representation but the documentation of real sexual events (1989:27), this sexuality does not locate the skin trades outside of the realm of labour, as Cole appears to assume. Rather, it provides an intriguing analytic point of entry.

Acknowledging the intersection between sexuality and labour does not negate the need to attend to subjectivity. The meanings ascribed to workplace sexuality that in turn shape how sexuality is integrated into everyday practices (Aronowitz, 1992:62) are always mediated by a range of other factors, including class culture. Perhaps working-class women are more prepared to assume authority over their sexuality and claim the erotic terrain as their own than their middle-class counterparts. Perhaps it speaks to resistance. At the same time, we must be wary of slipping into a liberalized celebration of the working-class hero by romanticizing their engagement with the instruments of capitalist and patriarchal oppression. Sexuality is never simply of our own making; the sexual, like the beautiful and the feminine, are culturally constructed. We are at some level constrained within the discourses of what is sexual, what is erotic, what is acceptable. Erotic presentations within already scripted discourses of sexuality are certainly not inherently emancipatory. In fact, the body in erotic labour, like the body in manual labour, must be disciplined.[71]

When we think about strippers' labour as a job, we can ask: What does the work entail? What skills, competencies and strategies do dancers employ to manage the labour site and the expectations of management and patrons? When we think about dancers' work in relation to erotic labour, leaving room for gender and social constraints and remembering subjectivity, new questions open up: What is the meaning of the erotic for workers and how does it shape their labour process? If a woman's site of discipline is the body, to what extent can she transcend her-self through the body and reproduce sexuality without internalizing an alienating and oppressive regime of physical representation?

PUTTING ON A SHOW

A woman working in a strip club as a stripper has, first and foremost, to act like a *stripper*; whether she is on the stage or not, she is always *performing*. This involves both the ceremony common to employees of "playing [her] condition to realize it" (Goffman, 1959:76) and the fact that the dancer is allowed some creativity but is, like actors generally, required to assume a role that is neither her own nor of her making (Henry and Sims, 1970).

To entertain, she has to "do a stage." This public erotic labour involves the ability to perform for, but also interact with, the audience whose very presence legitimates the work. The dancer engages with the indicators of sexuality and these links to the erotic appear to define her job as a *stripper*. However, even this most explicitly erotic labour operates at the level of the visible body. It is not about sex, but about nudity and the visual presentation of the erotic: "You manipulate your body in a certain way and you throw a sexual aspect to it" (Debbie). Put another way, dancers engage in surface acting where "the body not the soul is the main tool of the trade. The actor's body evokes passion in the *audience*, but the actor is only *acting* as if he has the feeling" (Hochschild, 1983:37). The eroticized setting, available props and their own expectations may ensure that the audience defines the entertainers as sexual, but the experience of workers is markedly different:

> At the Blue Lagoon it's a lot easier because there [are] TVs. So I can't see anyone from the stage so I watch TV. I'll listen to music and I'll watch TV and I'll just dance. I've been doing it, you know when you do it so often you're looking straight at people's eyes but you're kinda looking over yonder, looking at the TV there. You're doing your little crawl and you're like giggling inside 'cause there's some show on. I mean I've lost it completely because I was doing a show and I was trying to talk to someone and *The Simpsons* came on TV and I started pissing myself laughing. I couldn't do it anymore. I walked off the stage (Debbie).

In contrast to the idea prevalent in anti-pornography literature that women's erotic bodies are simply objectified (Cole, 1989; Dworkin, 1979), strippers have agency even as they are being constituted as an object of the male gaze. They establish the interaction with the audience and they determine the pace, the actions and the movement of the show. The audience's reading of her sexualized form does not erase her authorship. We see this clearly when a dancer enacts a fine parody as she plays with her own and her audience's sexuality — although she is usually quite careful, given the economic-power dynamic, not to let the audience in on the joke.

By definition, the stripper's act requires a degree of comfort with nudity and the willingness to expose herself physically (as distinct from exposing oneself intellectually, as do some other performers). In order to do her job, a self-assured and confident presentation-of-self is essential. An entertainer of any type who appears truly vulnerable, as opposed to assuming the role of a vulnerable female, is liable to experience a considerable number of disturbing encounters. Many strippers develop a strong stage presence and a number are competent dancers, proficient not only in the standard stripper "moves" but able to incorporate and execute (in very high heels) their own eclectic mix of ballet, jazz, acrobatics, aerobics and posing. On-stage a dancer must continue smiling, or at least assume the appropriate sexually vacant expression — "I think about doing laundry or watch the TV" (Debbie) — in the face of apathy and sometimes taunts. These kinds of verbal comments touch not only on her performance but, in light of the gendered appearance imperative, on her value as a woman. In short, she needs to develop the capacity to distance herself from the negative evaluation of the audience.

Although the difficulty of the dancer's work is overshadowed by the performance component and by her nudity, it is physically demanding manual labour, and like much other physical labour, it can be dangerous. On the one hand there is the threat of infectious disease. While many dancers take protective measures,[72] the dressing rooms, washrooms, stage, pole and chairs are not necessarily well maintained or hygienic. There is also the obvious potential harm of dancing in stiletto heels, and many other less immediately apparent dangers — "You wreck

your knees when you do floor shows" (Kelly). Some dancers take steps to avoid harm by attempting to control the actions of other dancers:

> I've physically hurt myself. They're careless on-stage. They got, you know, oils and waters — shit like that. And they don't care about other people. So I do certain things on my stage, so the girl who's before me always gets told, "Use a blanket." They don't (Debbie).

The work is also exhausting and technically difficult: "Pole work is a lot of hanging upside down, it's a lot of balance, muscle technique. It's hard to look sexy when you're upside down and all the blood's rushing to your head!" (Diane) Clearly, the "moves" can only be erotic if they appear effortless and natural, a feat that necessitates practice, skill and considerable muscle development. Constructing sexuality is hard work; however, the more effective the illusion, the more sexual the portrayal, the more the work is invisible to the audience. We are once again brought face to face with the problematic dichotomization of sexuality and labour: dancers are highly cognizant of the fact that being sexy is not natural or easy, but rather *work*.

This work also requires capital investment as well as countless hours in unacknowledged labour related to appearance, clothes, make-up and sometimes tanning salons or plastic surgeries — as well as such intangible capabilities as comfort with nudity and a sexualized presentation-of-self. Gender stereotypes including the whore complex mean that these competencies go largely unrecognized, dismissed as either normative female comportment in the case of the former or indicative of immorality in the case of the latter.

What does this public erotic labour mean for workers? Certainly "putting on a show" is *sometimes* exhilarating and ego-enhancing:

> You can feel kind of down or beat, having problems with a boyfriend or whatever, and, you go to work, and it kinda takes your mind off everything. And you have people looking at you and you have nice guys being nice to you. And they want you. And you think, Who cares about that guy.... Look, I have all these guys begging for more (Diane).

For the most part, the rewards hardly compensate for "exposing myself for free" (Jamie). Furthermore, most experienced dancers have become disillusioned: "[I was doing] the splits and working the poles and everything and then sometimes they wouldn't even clap" (Rachel).

Of course dancers recognize that the stage show "doesn't make any difference. Before we used to make it a really good dance and [we would have] everything timed, and the more it's going, the less we're giving, because money-wise it's the same. So why try hard?" (Tina). More importantly, the stage uses up the worker's time, and hence her ability to make money. During the time required to prepare and perform a show, no private dances can be solicited or performed. Furthermore, the stage is considered to potentially undermine earnings by offering nudity for "free." Accordingly, dancers frequently employ strategies to foil this exposure — for example, by demanding low lighting and mastering the illusion of nudity while really "they see nothing, I show them my breasts — that's it" (Tina). In short, while the stage physically dominates the club and is discursively central to the concept of stripping, it is peripheral for the women who work that stage.

Nudity and sexual presentations and interactions are normalized within the cultural environment of a strip club. It is perhaps not surprising then that the erotic nature of the labour is essentially a non-issue for the participants. "I found I liked being a sex object, because the context is appropriate. I resented being treated as a sex object on the street or at the office. But as an exotic dancer that is my job" (Sundahl, 1987:176). Moreover, unlike at other labour sites, in the club sexuality is explicit and monetarily compensated. "It [sexual harassment] was all over, in what I do, *no* that's the place" (Tina). In addition, out in the open, sexuality can be managed:

> Wouldn't you say in a restaurant, the owners, the cooks they're gonna grab you for free at their convenience? But in a bar, first of all they *don't* grab you, they're gonna be thrown out and whatever happens they're always forking out the bucks for it (Kelly).

Soliciting: "Wanna Dance?"

As the stage has receded as the primary site of labour in a strip club, the "floor" has become central. Considerable energy is invested in selling (and of course providing) private erotic entertainment. Deriving little or no direct income from the club and carrying liability for bar and transportation costs, these workers are well aware that "if I don't work the club, I don't make money" (Josey). Approaches are constrained by specific house rules and shaped by club (and regional) practices:

> Working in Toronto is very different. There the girls hustle, going around in a circle asking, "Want a dance?" If I did that here I'd probably get punched out. Basically the dancers here are lazy (Sarah).

For the most part, though, individual inclination and willingness to engage in particular labour practices determine whether a dancer adopts a passive, social or hustling approach to solicitation. Some dancers flatly refuse to approach customers: "I'll never ask a guy for a dance, 'cause I feel it's begging" (Rachel). In fact, there is a marked level of disdain for dancers who hustle: "Some girls go around and ask, 'Hi baby, how you doing' and start shaking their things in front of him. No! I don't like that at all. I just wait for them. If they want me bad enough, they'll come and get me, they'll signal me or tell the waitress" (Rachel).73 The irony of this approach to work is not lost on some dancers:

> We would be sitting there thinking we're little prima donnas [laughing], going, "You want me to dance you can get off your ass and come ask." Or sitting and talking to each other and it's almost like, we act like sometimes we'll get in a conversation, the girls and we're huddling and we're "blah blah blah," having a drink of wine and the guys almost feel like they're interrupting or something to come ask us to dance. I mean it's hard. It's bad enough the guy has to get up to come over to ask us if he can give us some of his money for a job we're supposed to be doing — but then we look at him like, "*What!*" (Diane).

More frequently dancers "work the floor," socializing and engaging promising-looking customers in conversation.74 Time spent at a customer's table is, of course, purposeful. Many customers are looking for company and are willing to compensate a dancer for her time whether she is providing a social or an erotic service. Although customers are undoubtedly cognizant of the commodified nature of their relations with dancers, they can be highly obtuse. This necessitates that the dancer simultaneously "play the game" and ensure that the customer appreciates that this is a financial and not social interaction. To carry out these two tasks with their contradictory demands is in itself a stressful endeavour. Failing to do so means that a dancer will "lose time talking for nothing" (Tina). It can be a frustrating activity:

> Ya I *hate* that. You never know when you go to pick up a guy to sit down, you never know if he likes you to start with. Maybe he doesn't like me but he's too polite to say, "Bye, don't sit down." You know what I mean? So it's not easy (Tina).

The most aggressive hustlers greet all customers. At a minimum they "give them the eye, just like you would in a bar" (Debbie). Usually the approach is more blunt: "I play on them you know like 'Has anyone ever told you you're really cute na-na-na?' 'I'd really like to dance for you'" (Debbie). There is little point in being coy, since "everybody knows what they are there for" (Debbie). This approach is both the most labour-intensive and ego-defeating and the most profitable.75 It would appear that a willingness to hustle and the possession of good interpersonal skills, rather than appearance, are the best indicators of income potential:

> There was a girl that worked at Fred's. Like all of us would be sitting around and good-looking girls and this girl, she was tall, skinny, she had no boobs and no bum at all, nothing, and short fuzzy blond hair. And she'd come out and wouldn't sit down the whole night. She'd walk around and even if there was only four or five people in the bar, she would stop and say "hi" to each person

and try to talk to them. And sometimes she got a dance. She'd always make money (Diane).

Unfortunately, aggressive hustling can also earn a dancer the disdain and animosity of her colleagues:

I mean, how girls can walk to a table: "You wanna dance?" "No, okay," walk to another table, "Wanna dance?" "No, okay." They just keep going and going and that makes it harder for the rest of the girls that are trying to make money, with these ones hounding them, you know (Sally).

In some clubs, when business is slow dancers will resort to selling tickets. This is a lottery where dancers sell six tickets for a champagne-room dance at two dollars each. The disc jockey announces the winner, who is entitled to "enjoy a private champagne room dance with the lovely Pamela." The dancer keeps her usual fee of ten dollars and the disc jockey receives a two-dollar "cut" for his assistance. This practice, which not all dancers engage in, is labour-intensive but sometimes effective; it provides the worker with the opportunity to interact with customers without soliciting outright and — particularly on Friday nights when "the boys" monopolize the club — generate some income.

Regardless of a dancer's approach to making money and in spite of the fact that most dancers have good distancing skills because you "can't take it personal" (Ann),[76] the failure to make money can be perceived as rejection:

If you're working and you've put a costume on, you can feel good about yourself, and you go out and sit for a few hours and you're not getting any dances. Then you go back in the change room and you put another costume on. And the longer you don't make money, the more times you change [laughter]. And the more make-up, you keep fussing with yourself…. So then you're not smiling anymore. And then you look bitchy so you're not, so even more you're not going to make money. And it's just like a snowball effect.

It just gets worse and worse. And you get feeling like you're fat, you start feeling like you are ugly (Rachel).

The Private Show

In the late 1980s and early 1990s private dances moved from the floor (table-dances) to the champagne rooms, a shift welcomed by many dancers. One dancer described the problem of dancing naked in the middle of the bar:

> Didn't appeal at all! I hated it, hated it! I wouldn't dance on the box. No. I danced on the floor, because their face was at my flippin' crotch level, you know. I hated it. *I hated it.* But then when champagne rooms came in — when it was both of them and someone asked me to dance for them on the floor, "Ten bucks same as the champagne room," ya. Anybody, even now, they ask me for a dance on the floor, ten bucks. You might as well take it in the champagne room (Sally).

In some ways the work remained essentially unchanged: private dances continue to be about the removal of clothing and sensuous movement. It is essentially about "how much sex can you give the guy on that little two feet by two feet square" (Marie). This is not necessarily easy:

> When I first started I had no idea how to go about it, but I finally discovered. It took me about a year to go from four hundred a week to over a thousand. I couldn't pin-point it, I couldn't pin-point it. It's the way you walk, the way you look at them, the way you move on the box (Marie).

When clubs permit lap-dancing, some dancers engage in a different sort of erotic labour. As the name implies "You sit down on the guy ... with your panties on ... and he's allowed to touch you all over" (Tina). It "involves a lot of body rubbing ... kind of a seductive rub — from head to toe, sitting on their lap making sexual gestures" (Debbie).

Not only did the added privacy make some dancers feel more

secure, since with table-dancing "there are too many people and I'm naked in the middle of the room" (Jamie), but it also changed the social and economic dynamics in the club, rendering the dancer both more vulnerable to aggression and pressure by customers and in a better position to increase her earnings by dirty dancing.

In order to make her money, the dancer has to first sell her service. To do this, she employs a range of strategies, including bartering:

> I'll charge them, like for the first song, because they're a little hesitant, I'll charge them half price. Make them think they're getting a really great deal. "But I'll only do it for you na-na-na." Well, I'll tell them that. They give me a ten and they don't see their change. So, "Ya ya, I'll bring it to you." Just give me the money (Debbie).

She then seeks to maximize the spending of each of her customers using a variety of special skills. "Once they come and get me, they're screwed. They're stuck with me and I'm gonna keep them and siphon out every last dime I can get" (Rachel). In the champagne room, she carefully choreographs the interaction to her advantage and polices the boundaries she has established for herself:

> If it's gonna benefit my wallet, pardon me, I'll do it. Except I will draw the line. I will not step over the line. To me, I guess to me prostitution is actual penetration or ... holding his, ah, genitals with your hand, your mouth or, ah, there [your crotch]. That's the line! 'Cause I mean, I've had several people touch my chest. To me my chest is nothing. [But] you touch me *there* [my crotch], and we'll have words. That's the line. That's the only thing private to me (Debbie).

The dancer needs to encourage the customer, retain his attention and goodwill and yet remain firmly in control of the situation:

> It's not what you do, it's how you do it. That's where the experience comes in, you know. These girls think you have to touch all over every customer. It doesn't have to be that way at all (Sally).

Because they are vulnerable in relation to both customers and — should the situation cross the obscure but very important line between dirty and straight — the bar, dancers employ a variety of tactics to protect themselves. Strategies are shaped by their intentions. If a dancer anticipates engaging in dirty dancing, she may take care in selecting the particular setting:

> It's [the champagne rooms] like a cattle stall. When you go in they're all open booths and it's a row of them. And you have to walk by them to get to whatever one you choose. The further down you go the nastier the dancers are, 'cause the less people walk by (Debbie).

She might also bribe the doorman:

> If I'm gonna get really close to a customer because he's a good paying customer, he's got lots of money, I'll pay them to close an eye. [When?] You have to do it either before the dance or after the dance and you have to explain to him [pause]. He usually knows, but now, he'll only close his eyes to an extent. He'll only let you go so far (Debbie).

More frequently, she will employ "straight" strategies to maximize her income:

> I don't stop [dancing] until they tell me to stop and then I tell them how much. I don't do one dance and then sit.... I used to do that, one dance and that's it. Then you don't get another dance. So I just keep dancing (Sally).

For dancers, making money also renders them vulnerable to physical or sexual aggression. As a result, they are attentive to clues and refuse customers they perceive to be potentially dangerous. For Sally this means favouring older patrons:

> I find the older guys, they're there for communication. Really to communicate. They look at you, but they don't look at you with sex

the way young guys do. Ya, like old guys *do*, but not that same way. You know what I mean? They're more with the look of admiring rather than the look of attacking sort of thing, pulling your clothes off, you know. It's different. Young guys are too rude ... they got egos, they're the ones who are more likely to just reach out and touch someone.... [But] not all the old ones are good.

Sally's wry note that "not all the old ones are good" suggests that this tactic is not without limitations. In practice, dancers routinely rely on each other for protection — "In the champagne room we're all watching each other's back" (Debbie) — and most of the more experienced dancers have also perfected strategies that maximize their control of the interaction. One research participant described her atypically candid approach:

I stand [and] I make them open their legs like this. If they give me a problem, my knees are right here. Ya, I'm serious! Every guy has to sit with their legs open. I want full range. Some of them say, "Why?" — "'Cause if you get out of line I'll kick you right there." Fucking right, you hurt me I'll hurt you right back. These are the rules, you don't like them, you get the fuck out, don't ask me to dance. A lot of them [dancers] sit with their legs wide open — he's going to get his hands to your crotch before you get your feet to the floor 'cause he's got a hold of your legs (Sally).

Without undermining the potential for sexual and physical aggression that dancers must contend with on a daily basis, we can nonetheless appreciate that unlike most female employees who are victimized by inappropriate sexual attention, strippers are positioned to effectively reverse the subtext and exploit their customer's vulnerability and/or investment in a non-deviant social identity:

A couple of weeks [ago] a guy bit me on the ass and I said to him, "I'm in here giving you pleasure and you fuckin' come in here and disrespect me like that. I'm doing you nice things and you bite my ass. Is that a normal thing in your life? You bend over and bite people on the ass?" I fuckin' belittled him something awful. How dare he?

Drove him in the head with my elbow — he hit the wall. "What you do that for?" "What did I do that for?" Bite me again and I'll show you why I did it. I made him pay me fifty bucks! It was the first dance, I had my knees on his balls, I said, "That's fifty fuckin' dollars, ra ra ra." I said, "You pay it or I'm gonna break your balls," I wasn't gettin' off him either — *best defence* (Sally).

During field work a similar incident unfolded. A customer exposed himself to a young but "wise" (Goffman, 1963) dancer. Not perceiving the situation to be threatening, she elected to manage the incident herself. As she explained to staff in comic detail after he had left, she had righteously advised him that his behaviour was inappropriate and criminal, but that she would be prepared to "forget it" if he compensated her for her trauma. He complied.

As the above incidents illustrate, strippers learn to assume control over situations and to assertively enforce their expectations. This competence, which is traditionally denied young women who continue to be socialized into "niceness," also facilitates an individual's assumption of agency in social interactions. As Debbie noted:

Ya, it's [stripping] given me self confidence. It's taught me a lot.... Because things happen and if I feel uncomfortable with it — I stop it. Whereas before I would have done it 'cause that's what I was expected to do. So I'm more confident.... It's what I say that goes. I am the boss. It's up to me. Before, I was very naive, I was a very very naive girl, very gullible. Now I'm cold-hearted, a lot stronger emotionally, physically and mentally.

EMOTIONAL LABOUR, OR FRIENDSHIP AT TEN DOLLARS A SONG

Arlie Hochschild, in her groundbreaking study on airline stewardesses, argues that the boundaries of labour have expanded and new expectations are being imposed on workers. Capitalism has colonized some emotions, so that within an increasing number of service industries, the "emotional

style of offering the service is part of the service itself" (Hochschild, 1983:5). Rather than simply selling her mental and physical labour, the modern service worker must now engage in emotional labour. This requires the worker, in exchange for a wage, to "induce or suppress feeling in order to sustain the outward countenance that produces the proper state of mind in others" (1983:7) and engage in "deep acting" by re-creating personal experiences in a commercial setting. Such a worker must manage her feelings not just for private social relations (which we all do), but as a commodity to benefit the corporation that pays her wage. The process, which requires her to transform her smile into a *sincere* smile, cannot avoid creating a sense of alienation from feelings (Hochschild, 1983:21). That is, as new areas of social and interpersonal life are transformed into services to be bought, the alienation inherent to the labour process in modern capitalist societies is extended into a new arena. Even coping strategies intended to mitigate the appropriation have costs:

> ... dividing up our sense of self, in order to save the "real" self from unwelcome intrusions, we necessarily relinquish a healthy sense of wholeness. We come to accept as normal the tension we feel between our "real" selves and our "on-stage" selves.... (Hochschild, 1983:183).

The concept of emotional labour has resonance in the work of strip-club dancers. Since dancers are self-account service workers, all or most of a particular worker's income is directly paid by customers in a fee-for-service arrangement. Explicitly, the primary service is private dances or erotic entertainment. Equally prevalent, but largely unacknowledged, however, is another private interactional emotional service that necessitates a unique set of skills.

Many customers, particularly the "loners," are only marginally interested in nude entertainment whether it is on the public stage or in a private champagne room. Instead, these men "want someone to talk to" (Rachel). Perhaps they are socially isolated:

> They work, they have a normal life and maybe they don't know really where to go to meet some people, or girls or something, or too shy or something. So, they go there. And they spend a couple

of hundred bucks and they sit there and talk to a girl that's nice to them and makes them feel good for a few hours. And that's it, y'know. And sometimes ... you get ones that just go to see you all the time and get a little more attached and stuff like that (Diane).

Another research participant was much less empathetic:

I have one gentleman who the girls refer to ... as my sugar daddy, but I call him a friend in front of him. In his face I call him my sweetie. He's about fifty-four. He's married, he's got grandkids ... he's fairly well off and all he wants is a friend. And he's willing to — he's willing to pay anything for my friendship. So, *he's paying me to be his friend* [emphasis mine] (Debbie).

These customers are the source of endless discussion by support staff, who regard them with a mix of pity and contempt: "When you have to pay ten dollars a song to talk to somebody, that's a lot of loneliness" (Brad, disc jockey); "Ah, customers, well, mostly I feel sorry for them" (Janet, waitress); "They're losers" (Kevin, doorman). While a market for social relations would appear to say a great deal about the alienation of social actors and commodification in modern society, the question remains: If an interactional service is being purchased, what does this mean for the labour experience of the service providers?

To be successful, the dancer has to master "playing the game." The "game" can be employed as a strategy to procure dances, but it can also be compensated labour in its own right. It is a parody of social relations: "It's playing a game, of course it is. It depends on the guy, the drippier you are, the more money you'll make. The more you laugh at his jokes, the more money you'll make" (Sally). In essence, the dancer presents a "cynical performance" (Goffman, 1959:18), instrumentally and consciously playing to the expectations of an audience of one:

I mean obviously they're going to be nice. They're being paid to be there so it's not like, it's not a good idea to be a bitch or something. Guys aren't gonna spend money on you. And that's what you're there for (Diane).77

The game analogy is particularly appropriate when we recognize that the audience is playing along in a fine parody of social interaction where the script is known — but never publicly acknowledged — by all participants. The client helps to maintain the fiction by "engaging in protective measures" (Goffman, 1959:212). Clients cooperate by never challenging the dancers' presentation-of-self and by focusing conversation on what defines her within the club — her appearance: "His conversation was like, 'Have you always had your hair that length?' 'Did you ever have it shorter or longer?'" (Judy) In the end, though, the dancer's livelihood depends upon her ability to maintain the fiction and "treat them like they're people. You don't just treat them like they're a ten-dollar bill" (Rachel).

For the dancer, the charade becomes routine as she re-enacts the game over and over again with her customers. In each interaction, she is required to create the fiction of a novel interaction with a "special" person. This constructed reality is fragile and susceptible to disruption at any time. With her regular clients, who might collude in the play but nonetheless expect narrative continuity, this is sometimes problematic:

> It's hard to keep your story straight. You tell different stories. I mean, you're one thing for one customer, you're one thing for another customer. And they come in and they start talking and you forget what you told them and you're — [questioning expression] refill (Ann).

While the interaction between clients and dancers can be conceptualized as a game, it is, for the women, *work*. With the introduction of private table- and champagne-room dancing, workers have to sell not only their entertainment service but also a "social" service. To do so, they employ a range of highly specialized interpersonal skills, their presentation-of-self and sales approach simultaneously. Maintaining the balance can be difficult:

> Some girls, they sit and talk to them three hours and expect to be paid three hundred dollars. And some guys are thinking in their head,

"Well, she only danced, ah, ten songs, I only owe her a hundred and it's her own fault if she sat there for two extra hours to talk to me," y'know. He's only gonna pay the hundred that he owes and that's it. And she's freaking out 'cause she figures she should be getting two hundred more. I figure, well, if you don't tell a person at first that you're charging a hundred an hour, then it's your own darn fault (Rachel).

Dancers also engage in extensive emotional labour as they interact with clients and construct social relations. Most of the money that dancers make is from their "regulars." Getting and maintaining a regular clientele involves special relationship and boundary-maintenance skills:

They [regulars] come to see you [pause]. Some of them get a little weird and you just gotta know when to back off, I guess. It's different with table-dancing than just being on-stage. Because now when you table-dance you sit with them, you're sitting with them for a few hours and you're talking one-on-one with the person a couple of hours every week. Plus you're going to start getting to know each other.... I mean, he's obviously physically attracted to you or he wouldn't have asked you to dance in the first place, and then if he comes back to see you, then he likes your personality too (Diane).

Of course, in spite of a time commitment that mirrors friendship, it remains an instrumental relationship. As Diane later noted, "They know nothing, nothing about you." Policing the boundaries can, at times, become a matter of survival:

When I was working at the Copacabana there was this guy.... He'd come and see me and I'd knew him from before and stuff like that. And he kinda got a little ex-excessive, y'know.... First he was really nice. And then and then he started being like, ah, weird.... So then I stopped talking to him. And then when I stopped talking to him he ended up being like, "Oh, why are you treating me like this?" Then one day he was outside my house so I had him barred from the bar and he got really upset with that (Diane).

Not only are strippers continually playing the role of a stripper, they are also adopting other personas. In effect they play a number of roles within a particular spectrum of possibilities, consecutively and sometimes concurrently:

> I used to give every guy a different age depending on what they wanted. I also gave different stories, but that's complicated to keep track of. Sometimes I acted really young and walked around the club in a skirt being cutesy. You don't even have to look that young, just act young. It's really weird. Different guys want different things (Sarah).

Most dancers use intuition to "read" the patron in order to determine the particular presentation-of-self they should conjure up. Others are more forthright. Debbie noted that "the first thing I ask my customers is 'what do you like?' 'What do you look for in a woman?' And I go with it.... They are there for the fantasy."

Thus, to be successful and to make money, dancers engage not only in the surface acting of cynical performance but also in "deep acting" (Hochschild, 1983). Deep acting goes beyond the *pretense* of emotion, requiring an individual to dredge up *actual* emotions to respond in an "appropriate" manner and to construct a self that is able to be (virtually simultaneously) assertive and coy but always pleasing and interested. It necessitates the management of all aspects of appearance; "My facial expressions, my body language, my vocabulary, I'm a [giggle], I'm a cold-hearted bitch." And, of course, "You make it look like it's fun.... If I'm not having a good time, then they're not going to want a table-dance" (Debbie).[78] Jamie, who used to work in the sex trades and was, at the time of the interview, frustrated with her job, was much more cynical:

> I'd rather be hooking. It's the same men you get in the champagne room. When [I] was lap-dancing it was easier, you didn't have to smile at them, pretend you're enjoying your dance in front of them. Now ... if they get ten dances, they blew a hundred bucks and they didn't get any [sex]. And you have to be pleasant, make them feel great. If you're hooking, you get a customer and you get it over with — like usually as fast as they can get it up. And you don't have to see them again.

Like other direct-service workers (such as airline stewardesses and waitresses), a stripper has to be able to manage her emotions and anger in the face of ignorant and trying customers. In light of the fact that the male clients define strippers as "other," as ersatz or real whores and since a whore (within the hierarchical gender dichotomy of the dominant discourse) has few rights and even less private space, she is likely subject to high levels of verbal and physical harassment. But there is more to it than this. The stripper participates in a financial interaction that masquerades as a social relationship, with a social relationship's sense of reciprocity: "I should probably have my Ph.D. in psychology by now for all the problems I've listened to and all the advice I've given" (Rachel). Social relationships are normally defined by mutual concern. In the strip club, however, the appearance of concern becomes a commodity that is purchased: "I feel guilty when they tell me things. Because personally I don't give a shit. But I have to pretend I do" (Jamie). Notably, unlike the professionals to whom Rachel compares herself, a dancer lacks the professional language and training that might guide her through the interaction; instead, she has to improvise by continually reinventing herself and adapting her performance.

While talking to customers may appear to be a rather innocuous activity, many dancers express exasperation about it: "You have to go sit down with the guy and blah blah blah blah blah blah blah blah. I hate that" (Tina). In fact, talking to customers, which is described as "hard on the head" (Diane), is dancers' greatest source of complaint. On reflection, this is not surprising. Strippers are alienated not just from their bodies or from their surface sexual self-presentation in a way that was normal in the burlesque theatres of the past. They are alienated from something more — their social selves:

> Temporarily you're someone you're not, just for this guy, just so you can get his money. If he wants to believe something, then you just play right along with it. "Ya I'm from wherever," and make yourself up to be something you're not (Sally).

The result is a disassociated sense of self; so that "I pretend I'm somebody else and I get all glamorous and I go into work. I'm a completely

different person in the club, a completely different person" (Debbie). Workers are very explicit about the need to distance and separate their different selves: "I have a very distinct difference between my job and my life and I find if I mix the two of them that I can't keep it straight" (Ann). This assumption of separate identity is in part facilitated by the use of stage names so that "on-stage I'm Kim so it's not me either" (Alex). Still, the implications of this self-transformation can be very stressful. This breaking of boundaries suggests that it is not the naked body but the exposure of the self that is so difficult. We see the complex ways personal and social identities can be fractured when a job requires identity management of this magnitude:

> I have a hard time — you know — coming back, coming back to earth. I have a hard time remaining myself. When I get cornered, my defences always go up, whether it's needed or not. It's made me, it's made me a much harder person ... but I'm learning how to deal with it.... Who I play in the club [chuckling] is a completely differ-ent person from when I first started. When you learn how to play the game, I find myself playing the game with boyfriends, umm, not, umm, not consciously you know (Debbie).

Perhaps Jamie's comment is most revealing when she links her emotional labour with interpersonal relations: "I'm used to playing roles. I had a lot of bad relationships."

Erotic Labour? Emotional Labour?

The strip club is a business that self-consciously relies on women's bodies. While other service industries may use women's bodies to make a product or service more appealing (Adkins, 1992), here, the service and the body are conflated. This play on sexuality permeates the indus-try, so that while sexuality is a subtext in many jobs and an underlying dynamic of most (Hearn and Parkin, 1995), strippers' labour is explic-itly erotic. The question now becomes: How does this shape the labour? Perhaps the most telling finding was how few comments were made by interviewees about sexuality; it appeared to be largely incidental. It would seem that financial success is contingent not on an outstanding

appearance, but on finely tuned interpersonal skills and the presentation of friendly sexuality. Accordingly, the dress and body language of dancers reflect an eroticism that is as much social and emotional as it is visual and physical. Rather then engage fully with sexuality, they adopt a script and even on-stage play the roles in a half-hearted manner: "Y'know, I do little moves and stuff" (Diane).

Before the deprofessionalization of the industry, appearance was very important, because a stripper's success was contingent on her providing public erotic entertainment. In the late 1970s and early 1980s, "shop talk" centred on moves, costumes, the quality of the stage and audience response. There was considerable pride in doing a good show, and a sense of affirmation was realized when the audience responded enthusiastically. Today, though a dancer might be congratulated on her "set" by her co-workers, such conversations are largely absent. However, a sexualized self-image — so that "you feel good about yourself" (Sarah) — remains important. Put another way, self-sexualization, perceiving oneself to be sexually appealing and worthy of male adoration, is imperative for effectively engaging in the emotional work where a dancer can make money.

Of course, an over-inflated sense of self-worth can have negative repercussions both at the job site and in a dancer's broader social and interpersonal relations. Women who take the script too seriously and mistake fantasy for reality are liable to be "called" on their attitude:

> I don't have my mouth shut though. Like I tell them — "You're no better then I am or the next girl, so don't walk around with your nose in the air and your ass stuck out like I have a cucumber up there. Like a Barbie doll. Chill out. You're no better than anybody else" (Sally).

For the most part, dancers are skilled at maintaining an ironic distance from their patrons' proclamations. At the same time, the sexual atmosphere and visible plays on the physical appear to have a positive impact on the workers' self-image. The acceptance of and open appreciation shown about women's bodies in the club seems to translate into a positive body image. I was continually struck by how dancers, unlike

any other population of women I know, are content with and actually *like* their bodies. This acceptance and comfort frequently extend to the other naked bodies with which there is continual interaction. This can open up new spaces for sexual expression:

> I'm experimenting right now. So it's [stripping] opened my mind to different things. I mean, I would never ever ever in a million years would I ever think about touching another woman, when I was growing up. Now there are certain women I would love to go to bed with. I would. You know it's opened my mind to new ... it's expanded my way of thinking (Debbie).

In short, when we explore erotic labour from the perspective of its participants, nuances emerge that speak to the importance of moving beyond dichotomies. We can appreciate that sexuality is imposed, but it is also owned and manipulated as a source of power and pleasure (Pringle, 1988:102); we can furthermore recognize the ways that sexuality and its erotic manifestations can be destabilized and emerge as *contested* terrain. This being said, it is clear that strippers are involved in not only erotic labour but emotional labour as well. As capitalism expands and the service industry swells to include a supply of emotional and interpersonal services (for men) in a commercial imitation of authentic social relationships,[79] the product is not just the service, but the servers themselves. For workers, engaging in this level of emotional labour in an erotic environment has significant ramifications.

NOT AN EASY JOB

As we have seen, strippers are part of the burgeoning service industry, and like other direct-service workers, they do a job that requires erotic and emotional labour. Yet, theirs is not simply a job like any other. So while dancers share many of the processes and practices of working-class women in the work force generally, such commonalties do not negate the need to attend to the specific hidden costs of participation in this marginal labour sphere.

Stripping can be a physically dangerous occupation. As already noted, there is the ever-present threat that customers will act aggressively. In spite of the strategies that all the research participants had developed to protect themselves, over half had stories of violence, often sexual, perpetrated against them:

> I've had to have the bouncer physically remove a customer from me ... several times. Same with other girls. I've seen girls get cornered in the booths and the doorman is, he's not quick enough That sudden thing is what stays with you for the rest of your life (Debbie).

Like their working-class counterparts in the manufacturing industry, these workers receive little protection from their employers, who appear all too ready to blame the victim. Furthermore, there is a realistic fear that customers will contravene the established parameters (and criminal) law by attacking a dancer outside the club. "In danger? Quite a few times [pause]. Oh ya, sure. I'm working in this little place and there's three young guys.... [When I left] the three young punks they follow me" (Marie).[80] Sometimes the consequences are horrific: "My girlfriend was raped.... Ya, some guy I guess followed her home a couple of times. Y'know, knew where she lived and everything (Diane).

Physical acts of aggression are not just committed by customers. As we will see in the coming chapters, the relations between dancers, which are shaped by an individualistic and competitive labour structure, are frequently antagonistic. Fights are certainly not the norm, but they do occur, and can be frightening in their intensity:

> There was a new girl dancing in a club and there was a house girl and she was infamous for her ... temper. And this new girl approached this girl's customer and the customer touched her. She didn't know any better. I mean, she told the customer "no," but the girl saw her customer touching her. And her and her friend jumped this poor girl in the back room and beat the crap out of her — to the point of hospitalization (Debbie).

Debbie later suggested that some of this hostility may also be a result of the labour situation that leaves dancers frustrated and angry: "They're taking the violence that they get from a customer out on another dancer. They're taking their frustrations out on her."

In short, dancers labour in a highly volatile environment, where the potential for verbal or physical aggression is continually present. This possibility of aggression seems to exacerbate an already stressful environment. When asked what she did not like about the job, Tina volunteered:

> To have to cope with those fights in the dressing room — things like that [pause], maybe the jealousy between the girls.... All those fights. I don't have to cope with this at three in the morning, these fights, you know. Kids' fights. We had one the other night and... that girl was shouting all the time. I said, "You're like kids," so she said, "No, I'm a mom." I said, "I'm a grandma so shut up... shut up. Grandma says to shut up."

The danger of physical assault is compounded by the physical- and mental-health considerations of labouring in stressful environments (Shostak, 1980). A dancer might work eight hours and make no money, even losing bar and driver fees; or she might earn $300 during a four-hour period. This instability of income not only increases workplace tensions and conflicts, but increases the stress these workers experience in their day-to-day lives:

> It's still kinda nice sometimes to have that steady income like a normal job.... Like instead of dancing, just have a normal nine-to-five job. That way you can really do your budget. 'Cause I find, when you don't know what you're gonna make, or one day it's a hundred bucks, you go and you spend it 'cause you figure tomorrow I'll make it back, y'know, it's fine. But tomorrow you go and the next day you only make fifty.... It's never the same. You can never really budget yourself and you spend it as it comes in (Rachel).

For dancers, "role overload," identified as a key contributor to workplace stress (Levi et al., 1986:55), is normal. Dancers must continually negotiate two discrete and sometimes conflicting jobs during their workday. The quasi-contractual obligation of the stripper is to perform strip-tease shows and hang out "looking like a hooker" (Debbie) — tasks for which she receives not a paycheque but the opportunity to "make her money": that is, the chance to utilize the profitable skills of soliciting and playing the game. Her job requires that she fulfil a number of roles at the same time, and that she continually manage the emotional and sexual demands of patrons. She must try to maximize her income while engaging in boundary maintenance and protecting her emotional and physical space. In addition, dancers are subject to the stress shared by other labourers engaged in emotional work (Adelmann, 1995:372) as well as the particular stressors shared by entertainers — performance anxiety and a fear of even minor physical injuries that could effectively curtail their careers (Sternbach, 1995): "I can't work with black eyes, I can't work with big scars across my face" (Jessie).

What does this mean for workers? Recent research suggests that stress is not simply the result of objective conditions; rather, "it is the interactive nature of the relationship between demands and the perception of the demands that is important" (Tattersall and Farmer, 1995:140). This highlights the importance of subjectivity. If autonomy and control over labour processes mediate against stress (Houtman and Kompier, 1995:210), perhaps the autonomy positively identified by workers in the industry is an important buffer. Seen this way, the definitions of self-as-entrepreneur that we will explore in the next chapter can potentially be understood as part of dancers' stress management strategy. This may be particularly important when we appreciate that some dancers are denied the supportive labour and home environments which are known to mediate against stress (Levi et al., 1986:55).

How individual workers cope with the stressors of their labour-force participation is diverse, and is necessarily shaped by the resources at their disposal and by their personalities. It would appear that humour may serve both as a tactic to mediate stress and to affirm boundaries. The ironic distance that is evident throughout the dancers' narratives — in their stories, in their language and in their analogies — speaks to a

sophisticated use of humour. By drawing attention to the absurd, not infrequently at their own expense, dancers signal not only their insightfulness and ability to assume distance, but their resistance to the capitalist appropriation of the self. Put another way, this working-class cultural-expressive form positions a dancer to illuminate power relations and insulate herself from their implications. She may be obliged to engage in erotic and emotional labour, but this need not touch her-self.

Of course, not all coping strategies are as benign as humour. Some are potentially problematic and may exacerbate the very dynamics that contribute to stress in the first place. Alcohol and illicit drugs provide readily available means for self-medication:[81] "The days that I can't do it and I need the money, ya, I'll probably smoke a joint — and then I'll go to work" (Debbie). We must appreciate that emotional labourers are particularly susceptible to the abuse of substances (Hochschild, 1983); furthermore, since the dancer's work site is also a leisure site for men, she is surrounded by the markers of social activity. For some women, alcohol and drugs become more than periodic aides. It is important that we acknowledge this potential cost of the occupation but remember that contrary to the dominant discourse, the immoderate use of drugs and alcohol is far from normative. During field work, I witnessed two cases where individuals started to "party" excessively at work. It is a disturbing process to watch and one that aroused a great deal of concern on the part of both dancers and support staff, who frequently attempted to intervene in what was clearly defined as a destructive pattern. Discussing one such situation, Sally remarked:

> Fuckin' right I told her. I said, "Look at yourself, you came in here wanting to get money for your baby and now your whole life is the bar. That's what you talk about. That's all you think about. You roll out of bed — you come to work." It's sad, you know.

RETHINKING SKILLS

Skills are generally assumed to be a legitimate barometer of a worker's contribution and thus of the economic and social rewards to which

their holder is entitled (Gaskell, 1986:361). Labour stratification is assumed to be a function of degree of skill, so that the distinctions between skilled, semi-skilled and unskilled labour are largely unquestioned outside critical labour studies. In fact, skills are not neutral measures, but are embedded in ideological constructs that reflect gender and class bias, and in turn legitimate wage and status hierarchies (Cockburn, 1986).

The stripper's job, like that of non-unionized working-class women in general, involves hard work and offers limited job security and virtually no possibility of advancement. The job itself is physically exhausting, emotionally challenging and definitely stressful. Success is contingent on the development of complex skills and competencies. The very existence of these skills belies the customary focus on deviance (rather than work process) that is found in much of the literature on strip-club labour. Given that these skills are largely learned "on the job" through informal apprenticeships, the work can be classified as semi-skilled labour. However, the term is misleading, as it suggests that anyone can successfully undertake the tasks. In fact, during field work I observed many women who, enticed by the reported high earnings and relative autonomy associated with stripping, attempted the job but found themselves unable to master the necessary tasks successfully. That these skills are largely dismissed or rendered invisible is not unique to the skin trades, but characterizes many working-class women's jobs (Gaskell, 1986). It does, however, affirm once again the relative and subjective nature of the definition of "skills."

In the late 1970s and early 1980s, we could have argued that strippers received financial compensation consistent with the scarcity of their skills and other attributes brought by them to the marketplace — including the willingness and capacity to suspend traditional propriety, and the ability to transcend social norms regarding the appropriate location for nudity. In addition, they were presumably being compensated for the stigma their work incurred.[82]

With the industry shift towards service, the worker is now required to employ considerably more skill, face more danger and experience more stress than her counterpart twenty-five years ago. However, the

work has been rhetorically deprofessionalized[83] and the labour redefined as not just semi-skilled, but essentially unskilled, so that the worker is someone "who can instantly be replaced by another if she or he doesn't smile enough" (Reiter, 1991:129). It would appear that a scarcity of jobs and the virtual absence of good jobs available to young working-class women through the 1980s and 1990s increased the labour pool and facilitated a construction of the dancer's labour as unskilled. When the skills necessary to stripping are scarce and when there is a shortage of labour, skills are recognized. Be that as it may, when the labour and job markets shift, the same (or even more complex) skills are rendered invisible. What we see as skill is always contextually defined and subject to reconceptualization when the labour becomes no less difficult, but labourers more available (Gaskell, 1986:373).

6

Everyday Politics

The marginal and disadvantaged position of strippers sketched in the preceding chapters does not mean that strippers themselves are simply victims who are acted upon by sexist and classist labour and social processes. Like working-class women throughout history, they employ a variety of strategies to counteract exploitative appropriation in the labour force. That these strategies are constrained by their social, labour and gender location, contingent on available discourses and cultural capital and complicated by the far-reaching ideological instruments of advanced capitalism (Scott, 1985:320) does not mean their resistance is any less real. It does, however, confirm that structure conditions the possibilities of action, and highlights the need to examine everyday politics.

Resistance, like oppression, is multifaceted, a war of "bread and roses" (Shapiro-Perl, 1984:194) fought on many fronts as subordinated people seek to challenge the status quo. We need to attend to the subtle and not-so-subtle discursive and material strategies that working-class women employ to *contest* the apparent relations of authority (Rose, 1999: 279), to assert their interests and to isolate themselves from the demands of both the labour site and socially constructed gender. It is perhaps testament to the complexity of resistance and to the limited resources and need for innovative strategies on

the margins that resistance to broader discourses and practices is realized in interpersonal relations. It is at the level of individual and social interaction that we must look to *see* the complex negotiations around power in strip clubs.[84]

CHALLENGING MANAGERIAL AUTHORITY

The most recognized form of labour resistance in Western countries — the formation of self-defence organizations like unions — has been, with some notable exceptions (including San Francisco's Lusty Lady Theatre workers, who joined local 490 of the Service Employees International Union (Funari, 2000)), rarely embraced by dancers.[85] This speaks not to a lack of consciousness but perhaps affirms that traditional forms of labour action do not always lend themselves to all labour conditions. Not only have established performance-artist unions historically not welcomed "disreputable" labour (Corio and DiMona, 1968), but the organization of the labour itself is increasingly inconsistent with unionization. The stratification of workers that has characterized the industry from its inception (Corio and DiMona, 1968) is exacerbated by market competition among freelancers and the individualism of the workers in today's clubs. In addition, investing time and energy in organizing may not seem worthwhile for participants in an occupation that is understood to be temporary — limited by the youth imperative and by the potential for "burnout." Organizing may also require awkward identity management and a distasteful engagement with stigmatic assumptions in the public arena. Finally, given the limited legal recourse and protection afforded strippers, a dancer who attempts to organize her co-workers may find herself blacklisted and unable to practice her trade. Instead of unions, workers employ a range of tactics, some collective, others individual, that allow them to realize a measure of control at the labour site.

Collective Strategies of Resistance

Where the organization of dancers' labour works against unionization, it does facilitate the realization of a work culture that expresses

shared meanings, values and beliefs. Specifically, the rhythms of the workday dictate that periods of activity are interspersed with intervals of leisure, allowing workers time to interact socially, talk, gossip and exchange stories as dancers hang out in the dressing room, around the bar and sometimes, in the absence of customers, at tables.[86]

In a dynamic process, individuals interactively forge an understanding that makes sense of their experience of, and relation to, the labour site. This shared meaning is constructed informally, but as it develops it becomes the basis upon which rules, expectations and relations are either accepted or resisted. These beliefs are made public, and, when challenged, become an ideological and personal resource that legitimates collective action and shapes the strategies employed.

Loosely structured but highly political affiliations among exotic dancers periodically emerge in response to particular labour concerns. For example, in 1995 Toronto-area dancers organized the Association for Burlesque Performers, through which they collectively fought mandatory lap-dancing (Chindley, 1995). At other times collective passive resistance can be effective: when licensing was first introduced in Ottawa, dancers simply refused to comply. Although a few workers did, under threat of sanction from bylaw officers, procure licences (Scullion, 1992:58), the bylaw quickly fell into disuse.[87]

Far more common forms of organized collective resistance are ad hoc, immediate reactions to situations that come to be defined as threatening. These strategies are largely contingent on alliances that emerge as complex and fluid coalitions in response to particular labour struggles. A worker who can effectively manage social relations, earn acceptance and maintain positive work relations with her colleagues positions herself not only to survive in this volatile labour environment but to become an active participant in the creation of collective meanings.

These largely unarticulated "common knowledges" become apparent when they are threatened. For example when a "hustler" enters a club where her aggressive approach to soliciting customers for private dances is not common, it challenges existing labour practices and can potentially undermine the earnings of dancers who are not prepared

to approach customers in this manner. Similarly, if a dirty dancer starts to freelance in a club, the established practices are disrupted and the income of the house girls and other freelancers can be jeopardized:

> These bad girls! ... Customers won't get you to dance, they won't get you to dance. They'll get you for one dance and you're not like the other ones, so fuck you. [It] doesn't matter how cute you are — y'know. Fuck man. I know I look better than some of these girls. Why are they making two hundred and I'm only making fifty? Not right! (Sally).

Such situations are usually effectively dealt with through rumour and gossip as word of the offending behaviour (most often real, sometimes fabricated) is conveyed to management either directly or, more frequently, using support staff as intermediaries. The latter approach allows dancers to impart knowledge, invoke sanctions and reinstate previous expectations without being a "rat" or necessitating confrontation.[88]

> If there's a girl that's usually doing more than the other girls and, y'know, if the doorman doesn't see them doing it, usually one of the other girls will complain about it. Because [pause] I guess it's taking money away from the other girls if someone is willing to do more than the others (Diane).

The intent is:

> To damage the other girl's reputation. To get you kicked out. Oh ya. Now it's a lot easier you just say so-and-so has been doing such-and-such in the champagne room and if they catch you, you're thrown out. But they usually watch you like a hawk, which means you can't do certain things. Ya, there's always bending of the rules to get the money out of the customer. And you can't do it if you're being watched like a hawk (Debbie).

If allegations of immorality based on accusations of theft or dirty dancing[89] fail to ensure the removal of the disruptive presence, dancers

can draw on their lack of commitment to a particular club and "protest with their feet." They simply stay away from a workplace until the situation is rectified and the offending dancer barred. The disruptive impact of a mass walkout or a collective failure to show up for work in an environment defined by the strippers' presence renders this a particularly effective strategy.

Managerial attempts to assert control over the work situation by changing the rules may also be met with strong and quickly organized resistance. During this researcher's field work, a new manager imposed unprecedented expectations on the dancers (that they circulate continually and solicit drinks) and attempted to gain compliance through fines and threats. In an illuminating instance of the construction of collectivity, established conflicts, animosities and loyalties were temporarily set aside as the focus shifted to the new communal threat. There was a considerable amount of "bitching" as the latest evidence of the manager's "tyranny" was repeated and considered. In effect, this complaining allowed particular definitions of the situation to be affirmed. In this atmosphere of general unrest, discontent and temporary alliances, the manager threatened to withhold pay from a dancer for a minor infraction. She quickly instigated a walkout, in which all the dancers and a number of the customers left *en masse* to go to a nearby club. The few remaining customers disappeared soon after and the support staff were left in the empty club playing pool and watching videos. It was a highly effective labour action. The club lost not only earnings but credibility with patrons; the support of the already empathetic non-dancing staff, who of course also lost their earnings, was solidified; and the manager was removed from his position. More importantly, the collective power of the dancers was confirmed. This story, along with other, similar incidents at other clubs, became often retold, affirming tales.

Individual Strategies of Resistance

While collective action can be a powerful tool, it is not the most pervasive form of resistance in the clubs. More commonly, workers resist in their own individual interests, seeking to undermine oppressive labour practices and processes while maximizing their income and autonomy. Dancers regularly "call" management on their ability to dictate the

rhythm or content of work, refusing, for example, to maintain a continual presence on the floor. It is, however, the stage, where unpaid labour is required, that becomes the key site of resistance. Dancers challenge the scheduling of shows and offer any number of excuses for why they cannot perform. Sometimes they are trying to protect income:

> I had the stage to do and the doorman came to me. And I said, "No stage — I'm gone, b-bye." If I was to go on-stage at that time I was losing, like, three hundred. And we don't have any pay (Tina).

At other times, the reasoning is less clear. Excuses such as: "I've just eaten," "I'm about to order food," "I'm tired" and "I've just come out of the champagne room" appear to have more to do with retaining control over the labour process; what emerges is a battle between disc jockeys and dancers. Sometimes rules and expectations established by the dancers override formal house rules. At one point during field work, several of the house girls simply decided that they would not dance if there were fewer than five patrons in the club. They subsequently resolved that only patrons paying attention to the stage "counted." Since customers are unlikely to sit and stare at an empty stage and will at those times amuse themselves with other barroom activities, this proved to be a highly effective way to circumvent managerial expectations of free labour. When dancers refuse to comply with the club's expectations, management is rendered largely impotent, and the complex power relations that underlie the clubs are exposed. In principle, a manager can fire or fine dancers; in practice, unless his is one of the more popular clubs or the dancer has few options, a manager will opt to judiciously employ sanctions.

In the club, a physically attractive appearance, a large client list and loyal customers are organizational resources (Wright, 1989a) that increase a dancer's capacity to resist. As in any occupation, workers can capitalize on their organizational and material assets to manipulate their labour experience. To illustrate: Janet, an exceptionally attractive dancer, was approached by a manager while she was socializing with friends. The manager politely and amicably requested she "work the floor." She responded in Southern belle fashion, complete with drawl

and invisible fan: "If I have to leave here, where will I go?" Since her employment had not been threatened, her response deliberately raised the stakes by reminding him of his relative powerlessness in the face of her alternatives. He implicitly acknowledged her victory when he laughed, retreated and had a drink delivered to her table.

Whether they quietly threaten, dramatically pack their bags or simply fail to show up for work, dancers identify themselves as valuable and position themselves to dictate aspects of their own labour process. Awareness that the club relies on their organizational assets renders management vulnerable and facilitates self-empowerment: "The way I look at it, they need me, I don't need them, my customers will follow me to the next bar I want to dance at" (Sally).

In addition to moments of confrontation like those above, resistance can and does take more subtle forms. These everyday informal strategies are not second-best; rather, they can be appropriate given that "open insubordination in almost any context will provoke a more rapid and ferocious response than an insubordination that may be as pervasive but never ventures to contest the formal definitions of hierarchy" (Scott, 1985:33).

Furthermore, while disempowered individuals may be obliged to negotiate an imposed script, there is agency to the extent that the script can be exploited and employed to the worker's maximum advantage (Scott, 1990:133). Framed in this way, the "sucking up" that many dancers unabashedly utilize to further their own agendas is a resistance strategy. This might include sexual innuendo, playing sick and whining — in effect adopting a weak female persona that, perhaps because it is consistent with social role expectations, is extremely effective in gaining some control and autonomy. Asked if she felt autonomous in her job, Debbie's nuanced answer speaks to both the subjective importance of agency and her awareness of it:

> It all depends on how the day is going. When it's a really dead day and I'm forced to be there, I don't feel like my own boss. No! When I'm in there, like I go in for say 4:30 and it's good money — I'm my own boss. I'm working. But when I'm sitting around [idle], I'm forced to be there. I can't leave unless I whine.

Nonetheless, this kind of manipulation can undermine collective solidarity. One individual's advantage may be realized at the cost of group support, as acts of favouritism are inevitably noted and commented upon: "They have their little prima donnas, their little favourites. Like the teacher's pet, y'know, they have manager's pets.... So that I hate. That part of it — I hate it" (Rachel).

Organizing Subjectivity: Self-as-Entrepreneur

The above-detailed strategies of resistance to managerial authority rest upon dancers' carefully maintained subjectivities as entrepreneurs. This individualistic, entrepreneurial self-definition by working-class workers is not unique to the field of stripping, as research on domestic workers (Dill, 1988) and diner waitresses (Paules, 1991) has shown. There are of course legitimate reasons for strippers, domestic workers and waitresses to define themselves as entrepreneurs. What is of interest is how this understanding of self is maintained discursively and interactionally in an environment where, the lack of pay notwithstanding, dancers are not only managed as employees but also subject to oppressive regulatory strategies.

Linguistic strategies are employed to support and legitimate definitions of self-as-entrepreneur. Dancers understand themselves to be self-employed, and their narratives draw attention to their autonomy: "I like the fact that you work when you want to, take vacations when you want to, you're your own boss"(Diane). So while dancers use the linguistic designation "work," they do not frame the process in terms of a job, or certainly not a *normal* job: "Dancing is something you can always return to. You don't have to apply to anybody for a job. 'Can I work here?' 'Sure,' 'Okay.' You're on your way" (Judy).

Essentially, stripping is work that operates outside of standard labour practices. Additionally, most dancers have a radical understanding of labour relations and recognize that the paternalistic presentation-of-self that managers sometimes attempt to project is instrumentally motivated. They assume that management views them with a pornographic eye. At a minimum they understand that from the viewpoint of management, their bodies are part of the means of production, objects that facilitate profit: "We're meat — *we're meat*

[pause]. That's all we are, that's it, that's all. We can come and we can go, they don't care, as long as there's somebody on stage" (Debbie). All of this leads to healthy skepticism — "I don't trust management" (Jamie) — and the recognition that "they could fire me but they need girls" (Tina). Since a dancer is her own boss, an entrepreneur rather than an employee, the establishment is not perceived as having rights to impose its expectations and she will expect compensation and consideration for any "favour" she does. If none are forthcoming, the manager will be reminded of his "debt."[90]

The entrepreneurial subjectivity is not only discursively but also interactively realized. During field work, I was initially frustrated by the lack of camaraderie between dancers and support staff. After all, we shared similar histories and the same labour site, had to cope with the same annoying customers and, most importantly, no one was being paid by the establishment. Eventually I recognized that the distance I witnessed derived from our particular physical and labour locations within the club; this distance was also an important component in the dancers' strategies of resistance.

Though support staff and dancers periodically congregate around the bar, there is no common backstage area. Dancers have a change room, but other than the disc jockey booth, all other space is front stage. Bar staff tend to congregate beyond the bar, in an area that is prohibited to dancers. Without a space to interact privately, to construct a unifying world-view and forge solidarity, the extent to which exploitation and working conditions are shared among different groups of workers is rarely recognized. Each group of service providers makes sense of the environment in a manner that affirms the otherness of their co-workers. This division is reinforced by the control support staff is expected to exercise over dancers. This may be why one interviewee maintained that "In some bars, waitresses or managers, the female managers, just don't like dancers. If you don't like dancers, why do you work in a strip club? ... They give you a hard time" (Judy).

This lack of common space is exacerbated by the workers' contradictory organizational positions. Support staff operate in their own interests, interests that frequently coincide with those of management and conflict with those of the dancers. A bartender's desire for a smoothly running

shift with lots of satisfied (and therefore tipping) patrons can be directly undermined by dancers' resistance strategies of not going on-stage, disappearing for extended periods or leaving early. For me, the result was ironic. As a feminist researcher, I applauded the women's innovative tactics, but as a participant, I found myself frustrated and annoyed and quite incapable of celebrating their resistance.

As a result of these dynamics, both support staff and dancers avail themselves of the informal "economy of favours" to ensure compliance. Since this operates outside of formal labour relations and expectations, it implicitly affirms dancers' self-definition as autonomous entrepreneurs by positioning them to accommodate or withhold their labour power. Dancers, for their part, also carefully negotiate interpersonal relations and labour practices to maximize their income, but always in ways that are consistent with self-determination. These include the offering of generous tips and the development of amicable relationships with bar staff.

The extent to which dancers relationally position themselves *vis-à-vis* support staff re-emerges frequently. Strippers are certainly cognizant of labour exploitation: "Slinging hamburgers at McDonald's for minimum wage" was mentioned by most interviewees and many have personal experience with the abuse characteristic of low-status jobs. "One job I did, I was a nanny but I did a lot of housework and I didn't get holidays that I was supposed to have. I never got paid what I was supposed to" (Jamie). Dancers also appreciate that the club is potentially an exploitative labour site and express indignation at the situation of support staff:

> I don't understand why anybody, why doesn't somebody call, ah, Better Business Bureau or whatever the hell you call. Those people who would help you out in situations like that. He has no right to charge you twenty-five dollars a night to work. No! I mean I would have [complained] if I was working there as a waitress and he's hitting me with *that*. Like who the hell do you think you are? (Rachel).

Consistently, labour-force exploitation (in a Marxist sense) is identified by dancers as extraneous to their experience. Carefully distinguishing

between support staff, who are exploited and themselves, independent workers who are not exploited, further verifies their subjectivity.

Finally, the particular subjectivity of the entrepreneur informs and is reflected in interactions between dancers. Relationships between dancers are complex and fragile, and at times appear contradictory. In fact, they are fundamentally structured to realize the twin goals of maximizing income and retaining autonomy. As we have just seen, dancers will work collectively when they perceive threats to their autonomy or income.

This is also evident when dancers work cooperatively. For example, dancers will come to each other's aid. Sometimes they alert the manager or doorman to danger:

> I will watch another dancer's back when I'm dancing. When I'm in the champagne room, we're all watching each other's back. When we're leaving, if we notice that the girl is in distress and is afraid to say anything because he's holding her hand, or he's holding part of her ... that he could hurt her with like a wrist or a pinky or whatever. You look at looks on their faces and when you go out it's, we say, "We think there's trouble." 'Cause they can't hear everything that goes on in there (Debbie).

When that protection proves inadequate, some take action themselves:

> Well, I've been grabbed. Like, I think it was the first year I was dancing and this old man.... I went to kneel, crouch down, and he just kinda put out his hand and grabbed me right between the legs. It was this young guy [who had] asked me. He said "It's my father's birthday," or something, "so can you go over and dance?" So I go over to dance right at the stage with the stool. Right at the stage. Like, not like it was hidden somewhere. And he did that! I just like — I was — it was — I hadn't been dancing that long and I just like freaked. And I walked in the back and I was freaking out. And then the doorman came in and I told him and he said, "Well, what do you want me to do about it?" And I said, "Well, obviously kick the guy out, fuck." Y'know. Like Carmen's with me and she's like "Kick him out." So he goes back and he comes back and he says, "Well,

I told him he has to leave after he finishes his beer." So Carmen got all upset, so Carmen walked out and whacked him over the head with one of the stools [laughter]. Ya (Diane).

Assistance can also take the form of advice about the opportunities and/or dangers that particular workplaces present:

> We exchanged ideas on travelling. "That place is good or that place is bad," or "If you go there, watch out for the boss's son, he's a real womanizer," or "There's this good customer, if you just smile at him two or three times during the show, he's going to give you a fifty-dollar tip" (Marie).

While a dancer will, as in the case of Carmen, selflessly come to the aid of a friend, these interactions also speak to the collective need for a safe work environment and a wish to retain the prerogative to dictate parameters. In essence, dancers maintain their ability to operate as entrepreneurs by periodically acting together and offering mutual support.

The limits of these fragile alliances are revealed when individual interests conflict and when one dancer's business is threatened by another's. In an approach that is fully consistent with the entrepreneurial ideology, an offended dancer may employ the strategies of rumour and gossip, or resort to the more antagonistic strategies of verbal or physical confrontation in a radical defence of her property — be it a song, a routine (her means of production) or a customer (her market):

> It can get very nasty. It can be. 'Cause [there are] a lot of confrontations in the change room [and] a lot of confrontations on the floor. I had one problem with one girl I work with in particular. She approaches my customers, and everybody knows ... when you're a newcomer in a club there's always respect for the house girls. When you approach my customer, which you know is mine, after you see me with them — fine. If you go before I've had a chance to get to my customers, then yes, I'll get in your face (Debbie).

The market-driven environment that requires dancers to compete for

a limited number of clients undermines the possibility of systematic unity and true cohesion. Put another way, class solidarity, with its sense of shared interests, is quickly replaced by the competitive ethos of capitalism when there are threats to the individual's conditions of production or market.

Class Matters: I'm a Worker/I'm an Entrepreneur

What we see over and over is that strategies of resistance can be affirming in one way, but detrimental in others. The use of rumour and gossip to resist managerial authority over labour practices and staffing affords dancers a measure of control over the workplace, but also carries costs. By defining some strippers as immoral, sex-trade workers or thieves, dancers are appealing to, and hence legitimating, the discourses of sexual immorality and dishonesty that are used to legitimate labour-site regulation in the first place. In addition, although the various strategies of resistance do operate at the level of the club as a whole, a more systematic approach would be more effective (Shapiro-Perl, 1984:207). None of this speaks to a lack of agency; rather it highlights the extent to which, with limited discursive, material and ideological resources, dancers use the tools at hand to contest the relations of authority and further their interests.

There is something else happening as well. When we step back and examine the various strategies of resistance employed by dancers against the authority of management, a number of striking contradictions emerge. At times, dancers forge work-based alliances and provide each other with the kind of support and working-class solidarity that I had been so desperate to find at the onset of my research and that I remember with (probably idealized) fondness. At other times, dancers position themselves in opposition to one another and embrace individualistic approaches to labour that are highly divisive. How do we make sense of this paradox without delegitimating the workers by resorting to variations of the "false consciousness" theme? Erik Olin Wright's concept of contradictory class location (1989a, 1989b) provides a point of entry that allows us to see how the complex labour location of dancers — as simultaneously employees and entrepreneurs — gets taken up within the labour site.

On the one hand, dancers are *workers* who need to fulfil a certain number of expectations at the labour site, including "hanging out" and doing "stages." As workers they embrace traditional working-class understandings in their collectively forged knowledges. Their acceptance of their shared relation to labour sometimes results in the recognition of common interests and culminates in collective action. These cooperative struggles for control focus on particular areas of the labour process that are specific to their position as workers, such as contesting managerial expectations of hustling drinks, decoratively gracing the floor and performing stage shows.

On the other hand, dancers work not for wages, as workers traditionally do under capitalism, but for access to a setting that allows them to "make their money." All or most of their income is derived from their labour as entrepreneurs. In this ideological context as private owners and sellers of a service, relations between dancers are competitive and individuals identify their interests oppositionally. Accordingly, they engage in divisive practices, including ratting, gossip and violence.

What we see being played out is the conflict in dancers' labour location: they are simultaneously working-class individuals who sell their labour to a capitalist, and petit-bourgeois who own the means of production. Their resistance to managerial authority and oppression in the labour site tends to be individualistic, or at best an ad-hoc collective response to a particularly threatening situation. Their contradictory class location effectively undermines class solidarity, a state of affairs that operates in the interests of management.

This conceptualization allows us to make sense of the contradictions in management strategies as well. On the one hand, it would appear that management would benefit from having traditional "workers." Management does discursively construct dancers as employees although, as we will see in the next chapter, dancers are defined as *inadequate* workers but workers nonetheless. On the other hand, managers continually foster individualism among dancers through favouritism and failing to intervene decisively in conflicts, and they also actively generate competition among dancers as a tactic to secure compliance. Circling back, it would appear that contradictions in class

location undermine the realization of class solidarity in this particular marginal labour site in ways that not only facilitate exploitation, but also shape the nature of that exploitation.

RECONFIGURING THE SERVICE ENCOUNTER

As we have already seen, there are two discrete elements to a stripper's labour. She enters into an agreement with an establishment, exchanging her labour for access to the appropriate setting and clientele. This allows her to undertake the second aspect of her labour, where she generates her income. Up to this point we have looked at the ways in which managerial authority is resisted and displaced. The next section explores how the expectations and behaviour of clients are resisted through action and discourse. In comparison with resistance to managerial authority and control, dancers' resistance to customers is necessarily more concealed, although no less real or strategic.

Describing "Reality": The Hidden Transcript

"Every subordinated group creates, out of its ordeal, a hidden transcript that represents a critique of power spoken behind the back of the dominant" (Scott, 1990:xii). The hidden transcript can be seen as an encoding of the world-view from the position of insiders. Transcripts are forged and confirmed collectively, so that it is in association with other workers that consciousness is transformed into knowledge and becomes a personal and political resource. The hidden (backstage) transcript does not remain at the level of discourse, but is realized in practice — it is the subtext from which the stripper as performer (in the everyday and in the Goffmanian sense) fashions her interactive script.

When a prospective customer enters the strip club, he sees a number of scantily dressed women who are prepared, for a price, to please him socially and/or sexually. Since he is financing the interaction, he imagines himself as agent. In all likelihood, his perception of the workers he sees is shaped by the dominant discourse about strippers. This public transcript, the "self-portrait of the dominant élites"

(Scott, 1990:18) essentially constructs men as dominant and in control, and strippers not merely as deviant, but as the epitome of disempowered and sexualized womanhood. The customer may be aware that it is a script, but it is one he accepts and legitimates through his actions.

It is perhaps precisely because the strip club makes explicit the public transcript of sexual relations that it is a potential site for subversion. Certainly within the environment of the club, a very different understanding operates, a "hidden transcript" about clients and stripper-patron interaction that is generated from the perspective of insiders: support staff, dancers and management. As noted earlier, strip-club patrons tend to fall into one of the following identifiable groups: regulars, the boys and loners. While the presence of the regulars and the boys is extremely important to maintaining the atmosphere and energy of the club, for the most part they do not represent a substantial source of income for the dancers. It is the loners who patronize clubs with the express or primary intent of enjoying private dances, who provide the bulk of the dancers' earnings and who are the principal subjects of the hidden transcript. While an individual dancer may have considerable affection for a particular patron, these individuals are exceptionalized: "I have this one customer.... He's okay *though*" [emphasis mine] (Ann). In short, even the anomalies affirm, rather than undermine, the prevailing (in-club) discourse.

There are two interrelated elements to the hidden transcript about these clients. First they are rendered "other" because of their perceived "deviance." Second, the encounter is redefined in terms that make the dancer the agent in the encounter. The following selection of quotes, while not exhaustive, illustrates the particular explanatory framework that emerges as dancers try to make sense of these clients and their behaviour:

> I don't know. They don't know anything about you. How can you know somebody? Like, I don't know, I never went to a bar and spent, I never had a guy stand and dance for me or pay someone to sit and talk to me. So I don't know what they're thinking (Diane).

Clients are infantilized:

If the customer thinks he can get away with it, with a slap on the wrist, they'll do it again. Definitely. Oh ya, if you say, "Okay, that's it, that's all, you're outta here," they'll go to another club and do it again. But this time they'll do it faster 'cause they know that girls are watching their back.... It's like a child, if you say, "Don't touch that," a child's gonna do it just to spite you 'cause that's the way their minds work. If you slap their hand and you say "no" and you take that thing away, they're not gonna touch it. So ya, like I said, if you slap this guy on the wrist and he goes to another club there he's gonna do it again. You gotta beat it into their heads that "Hey, this is my job, I don't have to put up with shit like you" (Debbie).

Of questionable intelligence:

I don't know, they must be pretty stupid to believe what we say and to come into a club and spend all kinds of money and get ah. What? (Jamie).

Desperate:

[Giggling] ... Ya, he was like talking, talking, talking, that guy he is like fifty-eight years old. He's looking for a girl, y'know, to take out on the weekend. A regular girl y'know, a girlfriend. But *anyone* will do [laughter], anyone (Tina).

Sometimes clients' behaviour is medicalized through the application of a disempowering discourse of addiction:

It's almost like they start going and they go by themselves and that's almost worse for them. Because that's all they get to know what to do. Well, I have guys tell me it's almost like an addiction for them. That they're not going to come back. Like guys have said, "Okay, that's it for me, I'm not coming back" ... "This is no good for me," y'know, "I just keep doing this, I keep spending my money, I've been doing this for years." And just things like that, y'know. And then they always come back (Diane).

Even if no particular "problem" is identified, the loner client is still assumed to be inadequate in some undefined way:

> I asked him, "Why?" He's not a bad-looking guy, he's in his early thirties and has a good job and dresses okay. He looks *normal* (Judy).

The particular construction of customers in the hidden transcript is revealing because it inverts the stereotypes and constructs the client as object. The latter point is somewhat ironic given that anti-pornography feminists have been arguing since the 1970s that objectification allows women to be transformed into "a thing to be used" (Dworkin, 1979:128). In the strip club the otherness inherent to objectification may indeed enable abuse or exploitation:

> You tell them little white lies. Me, I tell my customers, "Oh you know, fuck, I'm having a rough month, the repo man's gonna come and get my car." They'll pay my car payment, which is cool, 'cause now my car payment is money in my pocket. Ya (Debbie).

Of course if clients are somewhat pathetic, childlike objects to be processed, then the stripper is, almost by default, agent: "In the champagne room I'm in control — I'm the boss" (Debbie). Customers are not considered to be self-determining actors: "They're trying to figure out a nice way to get out of the champagne room. You know, 'cause some pretty girl is hitting on them" (Debbie); they are transformed into the stripper-entrepreneur's property (market) and inevitably referred to with possessive pronouns: *my customers*.

Constructing the clients as other also allows a dancer to insulate herself from the emotional demands of the labour. In this sense, when Alex remarked that she "disassociated myself from the people," we can understand this to be a strategy of resistance shaped and supported by the negative depersonalizing discursive construction of clients. Purposeful construction can then be extended as she situationally defines herself:

[People in the club] know me as one way and my friends know me as another. I'm a completely different person in the club, completely different person. I'm not a very — nice person. I could be called a slag. Ya. When I'm at work, I'm pretty nasty (Debbie).

PUTTING IT INTO PRACTICE: ACTUALIZING THE HIDDEN TRANSCRIPT

The discourse about clients and the nature of the dancer's work is constituted in the three principal sites of labour: the stage, the floor and the champagne room. These spaces become the physical sites where resistance against client control is made real through praxis. On-stage, a stripper establishes the interaction with the audience. She determines the actions and the pace of the show. While she might constitute a sexualized object in the audience's gaze, it is her own sexualized and managed construct. From a well-lit stage, the audience is almost invisible (though surprisingly audible in spite of the blaring music) and devoid of personality or importance. The hidden transcript's depersonalized conception of the audience as deviant or infantile helps the dancer maintain a positive self-image in the face of catcalls or judgements. She can always remind herself that their opinions are relevant *only* to the extent that they can be manipulated for her income. Far from being agents of her oppression, the men are transformed into mere consuming objects.

The stage show itself can also function as a "show" of resistance that embodies the depersonalizing discursive construction of clients, particularly when it is performed in a highly sarcastic manner and even taken to the point of absurdity as the dancer parodies the genre in which she is situated. Alex, who danced in the early 1980s, noted how she played with the audience:

I gotta charge out of what I was doing. Sometimes I would include the audience, y'know and stuff.... One night I went up there and I just thought, "What do I care, these guys are fuckin' asleep." So I put a bunch of toilet paper up my crotch, took my T-bar off and

there's, like, a pack of toilet paper there. "Oops," y'know. Some guy screams, "Your flag's showing!" I said, "*I surrender.*"

This strategy can be personally rewarding whether or not the audience appreciates the irony:

Van Halen, Alice Cooper — "I'm Eighteen It's My Body" ... all that stuff. "Only Women Bleed" for my floor show, that was an interesting one. "Only Women Bleed"[laughter]. Fuck ya. *I used to gross them right out!* Marianne Faithfull: *Why'd ya do it, she said, why'd you let her suck your cock?* I used to do that one for the fuckin' guys who were having lunch! (Alex).

With the introduction of table-dancing, customers became direct consumers of a dancer's services and they, rather than the establishment, became the primary source of her income. As a result, by the mid-1990s this stage-related form of resistance was largely limited to features. Today it is more common for dancers to resist customer expectations either by presenting an apathetic performance — "You figure why am I going to jump all over the place for all these people" (Rachel) — or by undermining audience expectations of nudity:

The other girls, they come to the stage just with the panties on. But me, I'm always dressed, for the first song I'm dressed. I have my, whatever, bra and panties and I have a dress. So I just pull up the dress up to here for the first song. I'm still covered and my slow song, I have a long nightgown and I just roll it up to here. And that's it. I have nothing underneath, but they can see anyways. They don't see my legs, they don't see nothing (Tina).

Because it would threaten a dancer's income, it is imperative that the customer does not become aware of the hidden transcript. However, when established boundaries are crossed, it might be "dramatically made public" (Scott 1990). At those moments a stripper will reveal herself as agent — the very antithesis of a sexual *object*:

It was the Chi Chi, I was up on-stage and I used to stand at the edge
of the stage with my legs open but my back to the audience and bend
over. So this fucking guy, a young guy too, he stood up and licked my
crotch right in front of the bar. I nearly died. I kicked him in the face.
My shoes were steel-heeled, they went in his mouth, out his cheek,
ripped his whole face wide open, put seventeen stitches on his face.
Oh, I wanted to kill him. Fuck I was mad (Sally).

The hidden transcript also permeates interaction on the floor as
dancers seek to maximize their income:

If there's a bunch of people sitting at a table, you pay ten bucks.
Everybody else pays two bucks. Why should I dance? Why should
I dance at a table for a bunch of fucking guys? I'm dancing for one
guy, six of his friends can watch for free? Fuck that. You're all
paying, oh sure, they all paid. Oh sure, sure they paid. And if they
didn't want to, well sorry. I'll be a bitch. I'm not dancing for ten
bucks for seven guys. For twenty, I'll think about it (Sally).

At other times disdain is communicated. When a customer
approaches a dancer, she might not respond enthusiastically: "I say,
'Ah, I'll be there in a minute after I eat, I just have to eat, okay?' 'I'll
see you after' and all this stuff. And they'll wait" (Kelly). On the floor
rumour and gossip are also used against customers. Patrons who have
been rude or are defined as cheap — "If they only ever take one dance,
why bother?" (Sarah)[91] — are ignored and find themselves unable to
procure social or sexual services as word of their conduct circulates.
Here too, the hidden transcript ceases to be expressly hidden when
the fiction of subservience is no longer expedient.

The third site of resistance is the champagne rooms. Like other
workers, dancers accept a level of apparent oppression that they
consider tolerable and financially worthwhile. As long as the
customer plays by the rules, the illusion of "sexual-woman-pleasing-
dominant-male" is maintained. Of course while the dancer carefully
orchestrates the interaction to protect herself, she nonetheless rarely
appears guarded — instead she fawns, giggles and listens "intently."

Yet, if the customer stops playing by the (or more accurately her) rules of the game, the script quickly evaporates and the stripper steps "out of character." Her response may well be verbal or physical aggression:

> If a customer touches me after I tell him not to, I grab them by the back [or] by the front of their scalp and I bang their head against the wall. I usually get in trouble, told to cool off, go home for the day. Stuff like that. If they'd keep their hands to themselves, ah, I wouldn't have to (Debbie).

At one level it is clear that out of "prudence, fear and the desire to curry favour, the performance of the powerless will be oriented to meet the expectations of the powerful" (Scott, 1990:2). At the same time, the hidden assessment of the customers not only positions the dancer to resist but also discursively reverses the power relations, so that the dancer might:

> Make them think you're just this poor little soul lost without them [laughter]. It's a good thing they're there or you don't know what you'd do. They're looking for somebody to save [laughing]. Ya, to save me from who? Kooks like you! (Rachel).

In short, strippers' engagement with and resistance to forces that would render them symbols, pornographed objects, challenge assumptions that they are simply victims of social and structural forces. The hidden transcript allows them to make sense of customers and becomes a resource that legitimates both passive and assertive strategies of resistance.

CHALLENGING GENDER SCRIPTS

Ironically, stripping, which appears to epitomize oppressive gender roles and women's subservient position, can also be a site of resistance to those very linguistic and cultural constructs. What we see is that class-culturally-informed approaches to sexuality and gender are supported by dancers' experiences and legitimated in the hidden transcript.

Strippers are therefore in a position to invert and manipulate the very relations and gendered scripts that would oppress them.

At one level, engaging in the skin trades is an explicit and highly graphic rejection of both the patriarchal control of women's sexuality that is realized through a divisive whore-Madonna discourse of respectability and morality (Jeffreys, 1985:60)and the negative sanctions imposed on sexually autonomous women. Dancers use a commodified representation of their sexuality for maximum personal gain in the market. Such non-shameful display and retention of agency in the commercial and social interaction constitute a transformation that challenges acquired gender roles. Like the waitress who inverts the symbols of servitude (Paules, 1991), the stripper inverts the sexual script and sees herself as controlling and manipulating her own and her client's sexuality for profit. In both cases, the inversion is a hidden transcript that is empowering; and in both, working women use public discourses to their own advantage.

There is more to it. For some, the use of sexuality to undermine men's power is individually rewarding in more than economic terms:

> I used to be overweight.... I lost the weight, and I wanted to pretty much get back at every man who ever used me. And I was told this was a good way to do it. And I went one night — tried it. I made a complete fool out of myself, but I loved it (Debbie).

Later in the interview Debbie reiterated: "Ya, like I said, it's payback and watching men cringe is, it gives me, it gives me a form of satisfaction." This notion of revenge resurfaced frequently:

> And you know what? Dancing too is my way of... being brave. I'm not afraid of saying to a customer or anybody, "You fuckin' assholes made me this way.... Like, look at me but you can't fuckin' have me." Fuckin' right! (Sally).

These quotes highlight how resistance has an origin in both material appropriation and the pattern of personal humiliation that characterizes that oppression (Scott, 1990:111). For others, their perspective is

based on an understanding of women's oppression and men's "nature" that comes close to radical feminism. Explaining her disdain for men in general: "Yuk! That's what I think of men — *yuk*," Tina explained:

> Nah, they're all the same [long pause]. They must have a life, no? They must have a wife, a girlfriend? Ya, at least I get paid for this. If I have a boyfriend who did the same and I am, I am home waiting.... For example, if I'm home expecting him, I have kids and I make the supper and wait.... And at the end of the week you know we're missing some money for this, for that and he went there [to the strip club].... I prefer to grab the money (Tina).

Taken in this way dancers are profiting not only from their customers but from a broader level of gender structure and the commodification of sexuality. We can perhaps best understand this resistance as an example of maximizing gain within real and perceived gender relations and expectations. Of course, employing subordination for personal gain does not challenge stereotypes or the legitimacy of the hierarchy, and may support the status quo. Nevertheless, it can be a personally empowering strategy (Scott, 1990:33). This is not false consciousness, but an accurate assessment of structural and institutional realities. Imbalances in economic and social power may mean that although individuals negotiate an imposed script, they retain agency to the extent that they exploit and employ those scripts to maximize advantage and subvert the social relations symbolized in the script (Scott, 1990:133). In other words, the strip club becomes the site where the hidden meets the public transcript, and in this collision, gender, sexuality and autonomy become contested terrain.

RESISTANCE OR COMPLICITY?

Nude entertainers appear to epitomize the objectified and controlled female — the owners and managers of strip clubs are overwhelmingly male and unlike the powerful male audience, the dancer is literally naked and symbolically disempowered. In fact, the relationship is

considerably more complex. The symbolism of subservience crumbles when the perspective of the worker is considered, or even when one observes the play without preconceptions about the power relations inherent in sexual displays. From the dancer's viewpoint, we must recast her passivity as part of her "arsenal of often subtle but undoubtedly effective tactics to moderate the exploitative elements of her occupation" (Paules, 1991:166).

Apparently, dancers resist the implications of their social and gender location and their status as sexualized objects through the manipulation of these dynamics to their advantage. The ability to deconstruct existing exploitative relations in more or less *hidden* transcripts, though personally empowering, is limited in terms of generating cohesive class consciousness or having an impact on public perception, precisely because it remains hidden. In fact, its very oppositional nature may inhibit the formulation of a politicized discourse and political action (Knights and Willmott, 1985:38). This provides us with our point of departure for the next chapter on stigma. Dancers subvert stigmatic scripts through inversion without challenging their fundamental tenets; as we will see, this confines them within a dichotomous discourse which, while individually expedient, continues to be oppressive.

7

Negotiating Stigma

While participation in the paid labour force is a taken-for-granted imperative for most Canadians, the nature of an individual's work is something they are presumed to have agency to choose. "Choosing" a labour-market location that is on the margins of legality, morality or propriety can have profound implications, as the stigma of a labour location is transferred to the worker (Polsky, 1969). For women working as strippers, this is compounded by the conflation of the skin and sex trades in the dominant discourse, a conflation that further vilifies strippers and personalizes the whore stigma.

The application of stigmatic designations changes an individual "from a whole and usual person to a tainted, discredited one." It is a special case in the typification of difference; that is one that is very much in the foreground of our attention and negatively evaluated (Goffman, 1963:3). At the same time it is not that straightforward: it is always mediated. We need to leave room for individuality, and explore how this complex dynamic operates at a structural and interactive level as a multi-level interplay between individuals, shifting subjectivities, socio-historic contexts and specific social and individual interactions. In this chapter we consider two substantive though necessarily interrelated processes: first, the ways that dancers understand and negotiate

stigma in their everyday lives and second, the multiple levels at which stigma operates in the labour site.

STIGMA IN EVERYDAY LIFE

Dancers recognize that stripping is a stigmatized occupation and are cognizant of both the existence of stigma and the particular sexual nature of the blemish:

> It's the reputation that goes with it. People — when you tell them what you do they go, "Oh — really!" ... To the outside world, there is no difference between a prostitute and an exotic dancer (Debbie).

It seems that the experience of stigma has changed over time and has increased with the public perception, solidified during the lap-dancing debates, that strip clubs are also sites of sex-trade work: "So it's, it's hard to say [that I am a stripper] the way it is. But ten years ago, I didn't mind at all. I would say it, it was my job" (Marie). Stigma is consistently identified as a disadvantage of the occupation:

> People sometimes look down on you or something because of that
> I find women are worse than men, about thinking like, "Oh, she's a *stripper*." Just like maybe women will be, "Oh, she looks like a stripper" or whatever, things like that. That's the only thing I don't like (Rachel).

Dancers are exasperated by such public perceptions. In particular they are critical of women for making uninformed stereotypical judgements:

> It's weird. I figure they [women] should at least go and have a drink in a strip bar or come in with their husbands and have somebody dance for them. [They could] even pretend [to be] bi to see ... what really goes on in those rooms and how we really are (Rachel).

For the workers, stigmatization is not an abstract concept, but a real dynamic with real implications for their lives. They contend with moral

righteousness and stereotypical assumptions not only in the public arena, but sometimes also in the private realm, when their intimate partners reproduce stigmatizing assumptions:

> [My partner] doesn't like the fact that I have champagne rooms and the club that I'm at — the reputation that it has. He, to this day, does not believe that I've not had a customer pay me to touch me in different ways. All girls do it as far as he's concerned (Debbie).

The occupation can intrude on romantic relationships:

> I did it [stripping] for a few years. And then, I started seeing a cop and he told me that because of his job I couldn't do that 'cause [of] the stereotypes and stuff (Diane).

As Sally explained:

> It is a very hard life as a dancer trying to be in relationships and you should know that yourself. You know, there is no understanding.... People in general who don't know and don't understand the dancing world will never be with a dancer for long-term. Until you quit dancing, then relationships will work. But in the business it doesn't work. There is no understanding.

The following story by Tina is quoted at length because it captures not only the fact of stigma, but also reflects the very shattering personal consequences engendered:

> I can't make a life to myself because of that.... I met somebody in December. I didn't work because I didn't feel like working and I [did] volunteer work. Okay, [when] people ask me if I was working, I say, "No." ... And I met a guy and he ask me for supper.... I wanted to say yes and no at the same time and finally I say "okay." So at the dinner he ask again, he said, "Ah, you told me that you're not working." I said, "As a matter of fact I'm working.... I'm doing *that*," [stripping].... He start to eat. He start to eat, [and] he say,

"*Really.*" You know, he said because he wanted to go out with me not for one night. He wanted to see me. So he said it's like, it's like, "un coup de mass dans le front" [it's like being hit with a hammer in the forehead]. Ya. So I said to him, "You're swinging the hammer back to me," you know. And then we talk, we talk, we talk. And at coffee time he said, "Maybe I could handle this, maybe I could handle this, I'm gonna try to — but the only thing, never ask me to go where you work." ... And I ask him after that, "What you gonna do with your family?" "What you gonna do with your friends?" "What you gonna tell them?" So he said, "Oh, that's no problem. You women, you have a sense of twisting the truth." You know like I could say I'm a barmaid or something like that to them. I said, "No way. If you don't intend to tell them, you don't accept what I do." That was the end of the relationship before it [even] started.

Stigma also intrudes on a range of social areas and economic exchanges, from housing — "some places don't rent to strippers" (Diane) — to finance — "it's hard to get credit in a bank" (Marie) — that are generally assumed to operate outside of moral considerations. Finally, at some level, stigma may be internalized so that definitions of self became alienating. Rachel's language when she discusses a date with a man she met at the club is revealing:

[We] hit the bars, took some pictures, stuff like that, y'know, of us in the bar playing pool.... We had a good time.... Then it makes you feel [like] that was cool, that they'd want to phone us up and ask us out instead of asking a *normal person* [emphasis mine].

Working as a stripper becomes *being* a stripper, an identity marker with very real implications in the lives of women in the industry, shaping the worker's experience of the wider world. What's more, it seems to be a "sticky" stigma that infects those around the dancer as well (Goffman, 1963:30), so that her family may be, or may perceive themselves to be, stigmatized. Certainly those who share her labour site are. It is also sticky in the sense that it endures even after her participation in the industry has ceased. The almost inevitable linguistic designa-

tion of ex-strippers in the media speaks to an understanding that participation in the trade legitimates continued assumptions of immorality. In this sense, it is even more lasting than Goffman suggests when he notes that "when such repair [to identity] is possible what often results is not the acquisition of fully normal status but a transformation of self from someone with a blemish to someone with a record of having a blemish removed" (Goffman, 1963:9).

Managing Stigma: Personal Identity

Identity takes on particular significance when stigma needs to be negotiated. Dancers as social actors are cognizant of prevailing discourses — as participants in stigmatized occupations they must "make sense" of the work in ways that do not threaten the self. From the outset, successful entry into the occupation requires that dancers transcend stereotypical assumptions about the industry:

> I'd never been in a strip joint before — a female strip joint before in my life. I had no idea what went on until the day I went into one to work. And, so I mean, I was raised with the persona that everyone [there] is a ho. So I went in there thinking, "Oh my god, I'm going to have to be a cheap floozy." And then I danced, and then I danced for a customer and I thought, "Well, is that all there is? This is easy" (Debbie).

The research revealed two distinct and contradictory approaches to managing stigmatized identity among dancers. The first is an individualized construction of the self-as-normative, through denial, distancing and differentiation. The second normalizes the occupation by discursive deconstruction. While the former approach remains problematic, both are valid strategies that reflect an authentic understanding and cannot be dismissed as "neutralization" (Sykes and Matza, 1957).

Dancers who adopt a relationally realized non-stigmatized personal identity do so through legitimization of the stigmatic designations applied to strippers generally. Although these women may acknowledge that they also sometimes contravene conventional morality and engage in dirty dancing, they assume moral superiority over other workers:

"Those lap-dancers ... will not dance for ten dollars. They refuse to. It's beneath them. Most of them sleep with the managers for, y'know, favours — support their habit" (Ann). Rather than challenging stereotypes, these dancers espouse an understanding that mirrors the dominant discourse. They assume that the occupation has implications for behaviour and moral status beyond the workplace that they want to avoid: "I will not associate with dancers socially. It's the lifestyle, the drugs, the drinking" (Debbie). Evoking all the clichés, they create "straw-strippers" who are then dismissed as "hookers," "sleazy" and "druggies."

It is in relation to these "straw-strippers" that these dancers define themselves as different, moral and, most explicitly, not prostitutes — "I'm not on sale.... I'm for show" (Debbie). They are careful to establish that "I am not a typical dancer.... I am a girl trying to, trying to make a living" (Debbie). These distinctions and distancing strategies are sometimes extended to a club or a specific group of colleagues:

> I like the Stag, because it's clean. Sometimes there are dirty dancers but either the managers get rid of them or the girls run them out. At the Stag, the girls aren't hoes. Well, I guess some of the freelancers will meet a guy after, but none of the house girls. The house girls are all really decent. We all have something happening in our lives, not just drugs (Sarah).

Like the morticians in William Thompson's 1991 study, these dancers are so concerned about not appearing to be "typical" strippers that they are ultimately much more confined by the stereotype than their more radical counterparts. The judgements of these "insiders," which replicate the dominant discourses and position their moral self-identity against that of the deviant "other," powerfully legitimate dominant understandings. Of course, stigmatizing something you engage in is emotionally difficult: "I'm ashamed of what I do" (Debbie). This kind of conditional moral identity also makes some dancers vulnerable to forms of emotional abuse that threaten to further undermine their sense of self. Sarah, discussing her relationship with her intimate partner, noted, "When we fight [and] he gets real mad ... he calls me a whore, a slut. I hate that."

There is also an interface between identity management and the experience of labour. For the most part, these dancers bring their stereotypes into the workplace and consequently tend to maintain more antagonistic workplace relations than their less judgemental co-workers. Furthermore, since they do not associate with other dancers socially, they are denied the support that can only be provided by insiders who truly understand the worker's situation.

A far more common approach to identity management, one that is generally embraced by career strippers[92] and by those who enter the occupation already "wise" (Goffman, 1963), is to counter dominant discourses about the industry and its workers. This orientation is very different from the one described above and does not involve the convoluted distancing strategies and othering of the former approach. Instead, these workers are able to transcend assumptions and construct an understanding grounded in experience. The result is the nuanced and sophisticated deconstruction employed by most dancers.

Part of this is a defiant stance that dares outsiders to judge: "I never cared what people think of me. 'Cause I consider, I know my worth and if they can't see it, well, too bad, they're losing out. That's how I see it" (Marie). This does not mean they do not engage with the dominant discourse in order to counter assumptions, but they do so in the name of the collective identity of strippers. Part of this involves normalizing the job and their reasons for participation: "Most of us are either dancing to, ah, for our kids and we have bills to pay" (Diane).

Since the stripper stigma is primarily perceived as a whore stigma, with its implicit subtext of female unworthiness and dishonour (Pheterson, 1990), considerable effort is put into countering this particular stereotype. Prostitution is (accurately) dismissed as marginal to the industry, and these workers clearly identify themselves and most other dancers as fundamentally respectable (and therefore not whores). In fairness, unlike most women, who have never been offered money for sex, dancers can speak to their "moral" parameters with considerable certainty:

> And sometimes you get old men saying, "Oh, I'll give you two thousand dollars, five thousand dollars, anything, just come home and sleep with me," and all this stuff. And it's like, "No!" I never

needed the money that bad, I guess. I'm not saying one day I'll never do it, maybe someday I will. [Is it difficult to turn down the money?] No, not at all. I don't find it hard at all not to sleep with them for money — especially when they're old and all wrinkly too [laughter]. That kind of eases your answer, y'know (Rachel).

The attempt to distance stripping from prostitution and from the dominant discourse regarding their occupational location is illustrated by workers' language. While workers will identify their job as "stripper," most refer to themselves and their colleagues as "dancers." Implicit in this is a rejection of the meaning embedded in the loaded term "strippers."[93] This is not an indication of self-delusion. Women who work in strip clubs are well aware of the erotic nature of the labour and the limited value placed on their *dancing* skills at the labour site. It does, however, speak to identity management.

The negotiations around naming can also result in some linguistic acrobatics that recast sex as dance, particularly by women who have worked as lap-dancers:

A twenty dollar dance ... involves a lot of touching between the legs. Some girls would let it go to the actual [finger] penetration. And then there [are] some girls [who] would do a fifty-dollar dance which involves a blow job. Some girls, some girls will, for twenty bucks, sit on you. Once.

The contradiction was not lost on some dancers:

But they don't register that, ah, "Oh, I do a hand job now and then," they don't classify themselves as prostitutes. But the minute there is a sexual [act], that *is* prostitution (Sally).

While dancers experience the whore stigma in deeply personal ways, illicit substances are part of a more general subtext of labour-site disrepute: a source of secondary stigma for the workers. The association of strip clubs and narcotics in the dominant discourse was nonetheless addressed by research participants:

The coke these days, the drugs, they don't do that much at all, these girls these days. I haven't seen a drug dealer in a bar in friggin' ages. Like I'd say two, three years now I've been working in bars where they don't even have drug dealers. Y'know, you used to work in a bar and there'd always be that guy. There'd always be this one drug dealer in the corner there waiting to make money off you and everything. And now I've been in bars they don't even have one.... Most of the girls these days, they don't do drugs anyways. They smoke up once in a while, or they'll drink (Rachel).

Marie, who started college fifteen years ago and had been thoroughly disenchanted by a number of things, including extensive drug use, spoke to the stereotype when she noted:

It's very hard to consider the bars as a major source of drug, of drug abuse. I would say they're all over.... Because first of all, people who say that, "Oh there's drugs in bars," they don't know what they're talking about because all they see is the outside of the bar.

The identification of these different approaches to managing personal identity once again highlights the importance of individual subjectivity. An individual's standpoint, her ideological, economic, social and personal position, shapes her world-view and consequently her experience of stigma. An unconventional take on stigma is not an indicator of self-delusion or loss of dignity, as some authors would have us believe (Kretzman, 1992; Thompson and Harred, 1992), but shows us that there is a wide range of possible responses to stigmatization. Different individual responses may not alter stigmatic designations in public and private discourses, but they may transform the dynamic from the experience of shame or embarrassment to the negotiation of consequences.

Managing Stigma: Social Identity

Regardless of an individual's approach to the management of personal identity, strippers are *discreditable* individuals, rather than individuals whose immediately apparent stigma renders them discredited. Accordingly they engage in information management to the extent

that they accept the legitimacy of the stigma or acknowledge the social implications of its application. The options for managing social identity range from "passing" to full disclosure; the latter transforms the process from the management of stigma to the management of uneasy social situations (Goffman, 1963:100).

Strategies of social-identity management can best be conceptualized as occurring on a continuum ranging from complete to almost no disclosure. Put another way, some strippers are "out" and wear the markers — "the make-up, the clothes, the walk, the talk" (Debbie) — of their occupational location (and since they overlap with the indicators of rough, working–class female sexuality, at least at one level, also their class location[94]) with pride, while others are so closeted that they carefully conceal their occupation from family and friends, conscientiously monitor their talk and body language and often work some distance from home in an effort to guard against disclosure. Most fall somewhere between these extremes. An individual's location on the continuum is not static. Once stripping is adopted as a career and the discourse deconstructed, less stigma management seems to be necessary, since occupational location can be integrated into both personal and social identity. Similarly, since former strippers are not *without* blemish but considered to have "corrected a particular blemish" (Goffman, 1963:9), the adoption of other occupational or social roles may require new strategies of social identity management.[95]

Regardless of the strategies of identity management employed, stigma remains important (Coleman, 1986:221). Dancers are still obliged to interact in social spheres where their livelihood is presumed to be a definitive identity. The use of stage names by most dancers serves a purpose in social-identity management. Even the most defiant deconstructors are sensitive to the fact that disclosure may require others, particularly parents, to engage in identity management:

> I think it's a great job. I think, anybody who thinks anything else just doesn't know. They still have this old mentality of it, y'know. This, um, always drunk or stoned or stoned out of your brains and you spend your money all the time. Or prostitutes. And they just think we're a bunch of low-lifes and it's not like that at all. So right

now I don't mind telling anybody at all. Except my parents. 'Cause they're kinda — God-fearing people. So I'd rather, my mother would probably commit suicide, or probably think she'd failed or something, or, "Where did I go wrong?" So I'd rather not just, I'd rather not put them through that, thinking they'd failed or anything, 'cause it's not that they failed. I've tried other stuff and I just don't like it (Rachel).

Keeping a certain aspect of one's life, whether it be sexual orientation or occupational location, hidden from others is challenging. When it entails the maintenance of another (non-deviant) identity, it can also be highly stressful (Cain, 1991:67). Individuals must monitor their talk and behaviour and create fictions to guard against disclosure and the loss of non-deviant identity: "I don't know if I can keep it a secret any longer. You know, the lies are catching up" (Debbie).

The existence of a discrediting hidden identity may also render an individual vulnerable, as information can be employed as a strategy of control:

Well, they [my parents] were supportive. Not all the time. Not when they discovered it. They found out through one of my boyfriends. He didn't want me to dance and he just opened my costume suitcase on the kitchen table and my parents freaked out. And they didn't speak to me for two months. But I hung in there and I said, "They'll come around eventually." And they did (Marie).

For a woman in an abusive relationship, the abuser's knowledge of a discrediting hidden identity can be a source of power over her: another avenue through which domination is realized. Similarly, occupational location and schedule requirements can also be used by the patriarchal state to control women. Many women fear losing their children:

I have to be real careful ... [because] Children's Aid has been around.... No, I don't think that they would take the kids, but I've had problems and they watch me (Kelly).

There may also be psychological and emotional implications of maintaining a hidden identity. Certainly mental-health practitioners have identified covertness, in individuals whose sexual orientation is same-sex, to be linked to a "range of social and personal problems such as low self-esteem, social insulation, awkwardness and a sense of powerlessness and incompetence" (Cain, 1991:67). People may also internalize the spoiled identity implicit in the stigma as Rachel did in distinguishing herself from "normal people." Finally, dancers who are extremely closeted deny themselves a positive reference group, lose the opportunity to collectively deconstruct stigma and cut themselves off from potential solidarity in the workplace and socially.

Stigma Matters: The Costs of Managing Stigma

To briefly summarize the discussion so far, stigmatization is experientially and concretely real for strippers. Women in the industry are conscious of stigma and employ various strategies to counteract the implications of participating in stigmatized labour, including personal-identity management effected by normalizing-the-self or normalizing-the-occupation and social-identity management. These strategies, while effective, can also be stressful and create new sets of predicaments, particularly when social and personal identities are incongruent.

They are problematic at another level of analysis as well. The strategies of denial, distancing and differentiation continue to not only support deviant designations but, at a minimum, operate in relation to existing dichotomized understandings. It is precisely stigma that renders the meanings and understandings of deviantized populations suspect. In order to change popular and academic discourses, it is first necessary to counteract stigma, to introduce legitimate accounts and to promote and ensure their acceptance. Efforts at stigma management frequently focus on forging individual or collective non-stigmatized identities, rather than explicitly challenging the morally stratified discourse that is the basis of the stigma in the first place. This is unfortunate. Without intellectually worked-up insider knowledge, particular conceptual constructs can continue to be presented as "truth," with all the consequences for power/knowledge entailed (Foucault, 1980). In real terms, this absence simplifies the

transformation of workers into symbols of degradation and impedes the codification of understanding that, as knowledge, becomes a personal and political resource for marginalized individuals and their advocates.

Furthermore, even dancers who actively deconstruct and resist stigmatic designations operate in relation to the whore-Madonna dichotomy. Implicitly, despite statements like "I have nothing against prostitutes" (Ann), they legitimate the othering of sex-trade workers by seeing that designation as inherently insulting: "Ya. That's like calling me a whore to my face. You can call me any name in the book — don't call me a slut, don't call me a whore. Anything else doesn't bother me" (Ann). The tension around the question of prostitution was, for me, disconcerting. At times dancers carefully deconstruct the stripper stigma, but in the process unproblematically reproduce the judgemental and morally loaded dominant discourse about sex-trade workers. In fairness, dancers are, to some extent, using the conceptual tools at hand to draw attention to the differences between the two labour processes. This is, of course, in part my argument stripped of its analytic framework. At the same time, this is also problematic as it unquestioningly reproduces regulatory discourses.

Feminists have long drawn our attention to the fact that patriarchy is fundamentally premised in the ideological and substantive appropriation of women's reproductive capabilities. Quite simply, the rule, lineage and immortality of the father can only exist if paternity can be assured. Women are, therefore, afforded both tangible and intangible rewards for their conformity to the dictates of female purity. Once female purity is accepted as valuable, it can create a wide range of effects, including the stigmatization of women who violate the constructed moral order. In this manner, sexuality becomes a gender-specific dimension used to define, describe and, because the ascribed statuses are decidedly value-laden, assess women. In patriarchal thought, male sexual behaviour is constructed as occurring on a continuum. In contrast, women's behaviour is polarized into two mutually exclusive categories. The benefits of being a "good girl" exist only in relation to the status and experience of "bad girls."[96] Since female sexuality is afforded primacy within characterization, the

designation of "whore" becomes an overriding definition. The division between "pure" and "fallen" women is important for the maintenance of male supremacy; by splintering the female element, men ensure that women do not join together to challenge patriarchal power (Jeffreys, 1985:60).

In short, not only do dancers' discourses *vis-à-vis* the sex trades inadvertently perpetuate the whore stigma, but they also obscure commonality between the occupations and hinder recognition of the fact that the whore stigma is inherently damaging to all women. In fairness, for women in the skin trades, the whore stigma is a reality that reverberates through their daily lives — experientially, it is a far cry from the concept that it is for most feminist theorists. Perhaps it is for this reason that deconstruction is problematic: like all women, skin-trade workers seek to derive the benefits afforded to "good girls" — however relative that "good" may be.

Stigma Matters But Some Things Matter More

To understand why dancers participate in work that requires stigma management, we have to step back to consider stigma as relative, and conceptualize it within the broader context of the lives and opportunities of working-class women. We need to factor stigma into our understanding of workers who are "making choices but not within the conditions of their choosing."

Stripping can be a monetarily rewarding occupation in comparison with many of the casual, part-time and poorly paid service sector jobs where working-class women are clustered (Duffy and Pupo, 1992). Economic resources have both real effect and symbolic meaning in consumerist societies, including signifying status, freedom and social position. Having money minimizes disadvantage and signifies a certain freedom from the stigma, degradation and "less than human status" (Waxmann, 1977:69) that is definitive of the experience of poverty in Western capitalist culture (Rubin, 1976; Sennett and Cobb, 1972).[97] For many dancers, multiple social and family obligations (not infrequently including being sole-support parents) combined with the decline of the social safety net precludes participation in traditional labour arrangements. For these women, the stigma of "disreputable" work may be

experienced as less oppressive than the stigma of not participating in the paid labour force, or the stigma of dependence on state transfer payments. Taken together, these points have several implications.

First, the negotiation of work and social life by workers in the industry, including coping with stigma, needs to be considered in relation to the other stigmas (not to mention real economic, social and personal problems) that poor women must contend with. Describing her entry into the occupation, Tina explained:

> I try it, I make my night, not a lot of dollar[s] because I was shy. I was straight, I didn't drink. And at three in the morning when I [got] home I cried because I say, "It's not okay to do that and this and that." And then I say, "Okay, go to sleep, you'll see tomorrow." The next day I say, "I have money to eat today, so, don't worry, be happy — go to work." So I make from '82 to '91 like that.

Similarly, one participant described her decision to strip in these terms: "Now we still don't have much, but my kids play hockey" (Kerri).[98] Her comment suggests that the ability to participate either directly or vicariously in reputable leisure activities may compensate for the stigma incurred by marginal labour location.

Second, the taint of occupational location is not restricted to exotic dancers. While there is a moral stigma attached to stripping, other occupations also carry stigmas. There is the stain of dirt when you are "in a bar washing the cigarette butts" (Marie), the sexualization of cocktail waitresses, or the mark of an inappropriate gender role. Tina explained:

> I was a janitor, y'know working with the tools.... The people living there, they're a pain. They call you up to have your... changing washroom ... instead of, you know, doing my make-up [laughing]. It's a different world.... And when I start dancing too, I was comparing [laughing]; there's no comparison. I am a woman, I want to have — femininity and the job to go with it. I was feeling not good in the other job.

Third, the stigma associated with the work is perhaps compensated for by the fact that it offers certain rewards that are rarely available to working-class women:

> You get to travel and meet all new people and just get more out of life. I think, I mean if you're gonna be stuck in a job that most people think is so bad at least you gotta make the best of it, and you gotta say to yourself, "Is it bad at all?" And it's true, in other jobs you're stuck behind a desk eight hours a day, you get two weeks vacation a year and you're miserable on top of it all. Most people who have jobs, they don't even like their jobs (Rachel).

Contradictions emerged in the interviews. All the respondents explained their participation in stripping in terms of economic motivators and labour opportunities. It would appear that this is in part shaped by a perceived need to *justify* participation in a deviant labour activity. Such explanations focus on the least deviant of desires in Western capitalism: financial security. At the same time, it is clear that the occupation affords other benefits — independence, autonomy, friendship, ego affirmation. Sally, who carefully maintained an explanation based on economic justification, described her re-entry into the field after visiting a strip club with her partner: "I said, 'I just want to get on-stage.' And she's, 'Ya, go, go' and she's coaxing me and I'm telling her, 'If I get on-stage that won't be my last show, 'cause I'll have dance fever again.'" I am suggesting that dancers' public claims of economic need are real, but that they are also, in part, a response to the stigma attached to stripping: to identify the job as pleasurable would render the dancer truly disreputable. Perhaps experientially stigma is factored into labour value, something that is acceptable provided it is adequately compensated. At the same time, dancers themselves are cognizant that enjoying the job is doubly deviant; this shapes their narratives since they are careful to discount this possibility, even when they evidently derive secondary benefits.

STIGMA ON THE JOB

Since moral regulation is realized at the labour site itself for strippers, it is important to consider the other, more structural, way stigma operates. Labour-site stigma is more nuanced than the stereotypical assumptions that shape the dominant discourse about strippers. As a result, its impact and the ways it is managed are complex. Three areas of inquiry emerged in the research. What effect does state moral regulation have on the labour site? How do customers, management and dancers operate within stigmatic assumptions that shape the labour process? How are these stigmatic designations resisted?

Moral Regulation: The State at Work

Stripping is not only a marginalized occupation, it is, as we have already seen, also one that is controlled through coercive and administrative action by arms of the state. The regulation of morality through criminal-justice intervention is perhaps the most telling way that the state legitimates the whore stigma. The reality of moral control is reinforced for workers in the industry by the periodic appearance of uniformed police who patrol the clubs. Dancers understand that their actions are monitored. Discussing a raid, Judy noted:

> The cops would go in and they were doing it months before. They were all going in plainclothes and stuff and getting dances and seeing what was going on and seeing what was being offered and everything. And then one night, they just went in and they busted everybody.

Dancers are well aware that whatever their own behaviour, simply being caught in a raid will have financial costs and, more significantly, social consequences if stigmatized identities are made public:

> When they raided Parmee's in Oshawa, every girl that was in the champagne room went to jail for ten hours. They paid a $2500 fine, the bar was charged $5000 per girl in the champagne room. The customers went to jail as well, their names were printed in the

paper, along with the girls' names. So those girls, their career is shattered. There's no anonymity for them (Debbie).

As a result, dancers' decisions regarding labour practices and labour sites are in part determined by how straight a particular bar is and how willing they are to risk the incursion of a permanent stigma through a criminal record:

> I haven't a lot of years in front of me.... I never had any record, never in my life, y'know, so you think more about those things. Before I didn't accept the risk, now I accept the risk (Tina).

Moral regulation reinforced by a threat of state sanction means that women not only protect but also police each other:

> I'm not doing time for nobody. If I see a girl lap-dancing, if I catch a girl doing a twenty-dollar dance, I'll tell. I'll tell the management. Oh ya, I'll mark the girl. I don't care. 'Cause if we were to get raided, I'd be going to jail for her (Diane).

Arguably, within the strip club the police, doormen, managers, support staff and other dancers all act as disciplinary agents who patrol moral and legal boundaries. Therefore, while the dancer is providing champagne-room dances in an apparently private space, she is actually under careful surveillance. She must continually monitor her own and her customers' behaviour in relation to this panopticonian gaze (Foucault, 1979).

Customers' Stigmatic Assumptions: "How Much, Honey?"

Customers operate within the dominant discourse. Many assume that strippers are sex-trade workers:

> Like 99% [of] the customers, oh yes, "You must have a price." Some guys go up to a thousand dollars. And they lay it on the table. I have stuffed eight one-hundred-dollar bills in a guy's glass and said, "Drink it," and split. Ya, they do, they do, a lot of them. No [it didn't

bother me], I take it as a compliment, because ... in a way it is and in a way the way society is, they're allowed to expect it (Marie).[99]

It would appear that these customers equate surface presentations of sexuality, with actual sexuality so that dancers are wrongly presumed to be highly promiscuous, if not prostitutes. Some dancers, (especially those who manage their identity outside the labour site by identifying themselves as moral and therefore as atypical strippers) also frequently project blame onto other dancers for customers' expectations: "'Cause there is, they know that there's a possibility of somebody in there actually biting. 'Cause there is. There's always a possibility that a customer will go home with a dancer" (Ann). Such perceptions become a further basis of antagonistic relations between dancers.

At the same time, regardless of how an individual dancer understands its source, she is required to cope with customers' anticipation of sexual fulfillment while she labours in an environment where she is presumed to be, but cannot be, sexually available. Dancers counter the taken-for-granted assumption of sexual licence by asserting their own boundaries or projecting immorality onto customers in their hidden transcript. The distinction between dancers and consumers can be supported through an appeal to the legitimating discourses of economic need or family obligation; unlike their hedonistic customers, who seek immoral pleasure, they are motivated by the legitimate and implicitly moral need for economic resources. Both of these approaches appeal to higher loyalties and condemn the condemners (Sykes and Matza, 1957).

As we saw in the previous chapter, dancers' hidden transcript generally remains hidden as dancers present themselves to customers as sexually available: "I guess we all basically pretend we don't have boyfriends, or pretend we don't live with anybody. All those things like that, you don't ever talk about that" (Rachel). Kerrie was even more explicit about the source of her success in spite of being older and uncomfortable with engaging in hustling: "When I first got here I wasn't making any money. One of the regulars here helped me out. He started a rumour that I was dirty.... Ya, then I was real busy." Stigmatic assumptions are a discourse with which dancers consciously engage in the interests of

making money: "The minute they start thinking that these chicks, all they want is our money and we'll never get them, you know this stuff, the less people are going to be in the bars" (Rachel).

In effect, although dancers are confronted by stigmatic designations that are imposed by clients, the associated implications of social powerlessness are resisted and agency asserted when dancers exploit stigmatic assumptions to make money and when they reverse the stigma by deeming customers morally suspect deviants. In this setting, a dancer has to cope with the behaviour and expectations of customers, but does not need to seriously engage with the assumptions of inferiority that are the subtext of stigma.

Dancers' ability to project stigma is supported by broader social perceptions of deviance. Although customers do not have to manage their public identity in the way that strippers do, strip clubs are not only stigmatized labour sites but, at least to a degree, stigmatized leisure sites. The behaviour of customers suggests that while they hardly equate their deviance with that of the strippers, they are nonetheless cognizant of the prevailing sentiment that frequenting strip bars constitutes morally suspect behaviour. Customers regularly establish their non-deviant intent by presenting their presence at the bar in terms of their desire "for a few beers" and carefully avoiding the stage area for a significant period before wandering to "perv row." Others shun the parking lot and leave their vehicles some distance away to avoid the appearance of association with the strip club. Under formal law, the police can of course charge strip-club consumers as well as the service providers under section 210 of the Canadian Criminal Code.[100] Dancers recognize that the stigma they share with customers affords them a measure of protection from having their stigmatic occupations revealed by customers outside the club:

I've danced for my father's boss. [Would he tell your parents?] Why would he say anything? I have more on him then he has on me. It would hurt him more to tell my father than it would hurt me — cause I'd go straight to his wife. That's understood. Just like any married man. I would never go up to a customer. Say I was in the library — I would never go up to a customer ... and say, "Hey, how's

it going?" They would be like, "Oh, where did you meet her?" You know. I would never (Debbie).

Management's Stigmatic Assumptions: Good Girls, Bad Workers

In the past, managers also often ascribed whore status to strippers. They presumed promiscuity, imposed sexual expectations on dancers and sanctioned those who refused to participate. Describing an out-of-town engagement in the late 1970s, Marie noted:

> The owner kept introducing [me to] his friends who had a lot of money — so I would go and sleep with his friends.... And since I like to do sewing in the dressing room and not chat and drink, that was really rough for him. He didn't like me. He even cut my contract short [by] two days. And the plane there was supposed to be paid [for], and it wasn't.

As the industry changed from public entertainment to a service industry, the nature of the relations between individual managers and workers changed as well. Today:

> Most managers, they either have their wives or their steady girl-friends. And they don't fuck around as much as back when, back when they had a different one each week. They'd book one and know that the other one wouldn't be booked till the next week 'cause he'd already slept with that one. So he couldn't get them all there in the same week 'cause that would be a big fiasco. So he'd space them out and stuff like that. And it was always just weird. But nowadays I think it's just more of a business. People are look-ing at it more like a business than just something they get pleasure out of. I find girls are keeping their money, spending it a lot less than they used to, a lot less [on] drugs (Rachel).

As Rachel notes, it is now "more of a business" for both dancers and management. In and of itself this shift in labour relations does not

appear to have removed the stigma from dancers, but it seems to have changed the attributes ascribed to workers by managers. Management still operates on the presumption that strippers, because they are strippers, possess "other undesirable traits as well" (Becker, 1963:33); however, the transformation within the industry from entertainment to service has influenced the way stigmatic designations get taken up at the work site.

Within the club, a specifically paternalistic discourse that infantilizes and delegitimizes dancers as *workers* is evident. For managers, administrative problems largely centre on the "unreliability of girls." Not only are dancers always referred to as girls — a rather obvious instance of infantilization — but the discourse resounds with sexist, patronizing assumptions: "No shit, managing a club is like having ten girlfriends on PMS" (Craig, manager). With regard to dirty dancing, narratives reflect an understanding of dancers as juvenile not only in terms of their competence as workers, but also in a perceived periodic inability to manage their sexuality:[101] "When there's no bouncer the girls they get carried away. You know what I mean? They get into all sorts of trouble" (Mike, manager). Defining dancers in this way legitimates a harsh managerial approach to labour relations: "If, if you're too nice to them, it doesn't work. You have to be a bit mean sometimes" (Craig, manager).

Reflecting on the experience of managing strip clubs, another manager noted:

> After about a week you think, "Well, the scenery is nice but everything else is...." Like you have to be like a father: "No, you cannot have sex in the champagne rooms," "Drugs are smoked upstairs, let me tell you again for the third time today." I've never had to deal with that anywhere else (Mike, manager).

If women workers are no longer presumed to be morally suspect because of sexuality, they are now morally suspect for their lack of work ethic. Despite the fact that the house girls and many of the regular freelancers who worked at his club were extremely reliable, took their jobs seriously and were quite professional, Mike nonetheless maintained:

Honestly, how many jobs do you get staff calling up and saying, "I
can't come in to work, I'm too tired," or "I got drunk last night" ...
or even, "I'm too high," they use that, "I'm too high," jeez. They are
irresponsible. Half of them only come in to work when they are
broke. Ya, they only work when they want to (Mike).

In short, the discourse of dancers as inadequate workers is realized
by way of control strategies and is played out according to gender
scripts. This tension — between dancers who perceive themselves as
entrepreneurs and managers who see them as their employees — gets
taken up in a construction where dancers are seen not as whores but
as deviant (women) workers who are unreliable, juvenile and unpro-
fessional. Ironically, these assumptions afford dancers an avenue to
resist labour practices and undermine managerial authority as they
use the stereotypes to further their own interests. Managers, confined
within their own particular understandings, do not appear to recog-
nize the extent to which the women are enacting a script in order to
manipulate: "I can't leave unless I whine, play sick, *play them good*,
what have you" (Debbie).

Unfortunately, when dancers use this particular tool in their own
interest they also inadvertently legitimate managerial assumptions.
Furthermore, it would appear that continual interaction in this envi-
ronment has an effect on dancers' own understanding as well. Dancers
sometimes accept the invalidating constructs as either personally or
collectively valid, and so deny themselves an "intellectually worked up
version of their point of view" (Goffman, 1963:25). Dancers, who are
capable of otherwise effectively deconstructing stigma, at times inad-
vertently support the in-club truisms: "Well, if we don't come in to
work they [management] know we're all bullshitting, that we drank
too much the night before and that we just don't feel like going in"
(Diane). It would appear that while dancers reject stigma, they never-
theless remain firmly embedded within certain designations and that
they sometimes, through projection and manipulation, also legitimate
stereotypes. This process further erodes solidarity and, in turn, restricts
dancers' ability to challenge the stigmatizing class and gender
discourses that render their behaviour suspect:

About the job? Mmm [long pause]. One thing, something I don't like, when you're having fun, and they don't like it when you're having fun.... The managers, sometimes the girls too. They'll say, "How come she's making so much money?" Even if you're just sitting with the guy talking, drinking, having fun, y'know. They always find some ulterior motive behind it.... I just find whenever I have too much fun, nobody likes it. And it's like, is [it] my fault I like my job? I like to party with people. So what if I'm getting paid for it? I'm still doing my job — dancing on-stage when it's my turn. I'm doing everything I'm supposed to be doing (Rachel).

The strip club is also a site where stigmatic designations intersect. Here contradictions abound. It is well established in the criminological literature that tattoos "mark" an individual as disreputable (Grumet, 1983; Layton, 1993; Sanders, 1989). Tattoos are assumed to denote the bearer's possession of other characteristics, such as being tough, cheap and unfeminine (Sanders, 1989). These judgements are still unquestioningly reproduced within the club despite the mainstreaming of tattoos in society generally. Explaining why three dancers were barred from the club, one manager carefully explained: "They were, with all those tattoos ... we don't want those kind of girls, we want nice girls." Since managers regularly refuse tattooed women employment, many dancers carefully conceal their body art and attempt to pass. Put another way, tattoos locate a woman as part of a rough working-class (McRobbie, 1991) — an apparently undesirable class location — in a way that provides a rationale for her further marginalization as a worker. In light of the particular industry dynamics, this limits her employment options and facilitates greater exploitation by managers.

Working with Stigma: Inverting, Subverting and Reproducing

Stigma in strip clubs shapes the labour process and the labour experience of participants. While there are a variety of stigmatic designations that are contextually determined, they are largely a variation on a theme and not qualitatively different from each other. Ultimately strippers are labelled deviant by the state, customers and management. This designation serves to reinforce otherness and legitimate

control. That stigmas are resisted, inverted and utilized by dancers does not render them any less real, but identifies stigma as negotiated terrain and highlights the ways tensions around stigma help shape the labour process.

In the context of the strip club, the ascription of moral stigma is to a degree reversed. Management shares with support staff and dancers an understanding of at least some of the customers as at best pathetic, at worst morally suspect. Mike, who himself frequented strip clubs in his leisure time, noted: "A strip club's not like other places. Like any other bar, you don't wonder about the customers. A guy comes into the strip club and you wonder, 'What does he want?' 'Is he okay?'" Because this inversion of moral stigma is still confined within a discourse of deviance, it implicitly reinforces the club as a stigmatized labour site; in effect it reproduces a moral/immoral dichotomy. Without a transcending of imposed definitions of the club that are fundamentally based on assumptions of morality, dancers continue to be caught in a loop. In the short term, inverting and projecting deviance onto customers is functional; it facilitates the extraction of maximum revenue from customers and legitimates the possibility of a (relatively) moral self-image. In the long term, because these understandings support a stigmatizing discourse, they reproduce the dancers' own marginalization.

8

Wrapping Up the Work

We end this journey where it began: with women hanging out, women dancing naked on-stage, women sitting at tables with men and women talking or dancing in champagne rooms. Women working: "It's my job. I happen to like my job. Sometimes I don't like my job" (Marie).

It would appear that work at the margins of legality, labour and "morality" is highly contradictory. There are contradictions in the ways dancers understand the business; in the ways they position themselves in relation to the industry; in the ways they experience their labour; in their relation to the labour site; in how they define themselves and negotiate identity; and in their relationships with each other. Of course we all experience contradiction and certainly many working-class women's relationship to labour is deeply contradictory. But on the margins, these contradictions are brought into sharp focus.

To freely adapt Dorothy Smith's (1987) wonderful analogy, these workers are not only *on* the margins, they live *in* the cracks or in the lines of fault between discourses: "It's confusing, you know. It's a very confusing job" (Debbie). Trying to make sense of confusing spaces necessitates new conceptual approaches. Dancers are neither naive nor lying when they tell us that they are "doing a job" (Marie), "playing a game" (Sally) or engaged in a "scam" (Alex); when they say the work is "fun" (Rachel), "depressing" (Diane),

"frustrating" (Debbie) and "not bad" (Jamie). They too are struggling to make sense within existing frames of reference that do not "fit," that fail to take the complexities of their lives into account and that dichotomize and categorize lived reality in alien and alienating ways. We need to deconstruct, invert and pervert these established ways of knowing so as to open up "new ways of seeing" (Smith, 1987:9).

This conclusion is divided into three parts. In the first we turn back to the transformation of the exotic-entertainment industry in the 1980s and 1990s and reconsider what this has meant for the way labour is organized and experienced. Next we look at the major theme of the book: stripping as work, but work unlike any other and briefly consider what that entails. Finally, and in accordance with the established feminist goal of improving the lives of women, we will consider possible policy implications.

LABOUR IN TRANSITION: RETHINKING CHANGE

This ethnographic study occurred at a particular historical moment, when strip clubs had relatively recently undergone a fundamental change from an entertainment to a service industry. This is a "moment" that illustrates not only that "class (still) matters" (Phillips, 1987) but also *how* it matters. Today, class continues to be a useful concept for understanding not only relations to labour; as well, the dynamic processes of class culture have a real impact on how we experience and negotiate our social and work worlds.

During the 1980s and 1990s, the Canadian consumer-service sector, where the majority of working-class women work, grew exponentially as capital expanded through the commodification of services at the same time as the manufacturing sector became increasingly peripheral. Throughout this period, in an exacerbation of the trends we witnessed for workers generally, working-class women lost their labour-market gains of the 1970s and became increasingly impoverished. The diminished social-welfare safety net in Canada further compounded the vulnerability, economic need and domestic responsibilities of this social stratum. As a result, workers were not only increasingly employed in

the service sector, but situated to embrace work in the growing non-standard labour market (casual and flexible self-account work) as an income-generating strategy that allowed them to fulfill their many personal and social obligations. Strip clubs' shift towards a service industry that relies on freelance workers is consistent with these general labour-market trends. While strip clubs may be marginal, they certainly do not operate outside of the broader Canadian economy. What is of particular interest is the way these shifts shape the labour process and workers' relation to that labour.

The transformation of the industry can be seen as a de-skilling strategy. Initially, by de-professionalizing the work, club owners were able to reduce labour costs and implement contractual arrangements whereby workers received minimal pay and were expected to supplement their income by providing table-dances to customers in a fee-for-service arrangement. Over time, strip clubs were able to further lower their labour costs by ending or drastically curtailing the schedule system and instead meeting their staffing needs with the free labour of freelance workers, who exchange labour and fees for access to the setting where they can pursue their trade. In practice, "You pay to work there" (Rachel).

While wages have decreased, the work load and labour expectations have increased substantially. In addition to providing visible erotic entertainment on the stage, workers are now expected to interact with and solicit customers for whom they provide a service. Furthermore, since dancers are providing a direct personal service in an erotic environment, the industry has increasingly become equated with prostitution in the dominant discourse.[102] All of these things speak to increased exploitation, decreasing quality of work life and greater stigma.

However, to categorically define these changes as inherently negative is too simplistic. Not only have there been positive outcomes for workers as a result of the above-noted shifts, but the changes have affected the industry in other subtle, but important, ways. Since they now represent a direct personal-service industry, today's strip clubs are becoming increasingly reliant on labour. With de-professionalization and lower labour costs, a new industry standard of continuous stages and lots of "girls" emerged. These changes meant new employment

opportunities as the demand for labour grew. They also conditioned the relationship between management and dancers in new ways that work to both the advantage and detriment of the women working in the club. On the one hand, the freelance system and the limited commitment to a particular labour site afford dancers greater levels of autonomy and allow them to determine, within particular confines, where, when, how and how much they work. Since the club no longer pays workers, but exchanges fees and labour-site access for free labour, management's ability to control labour has been somewhat eroded. This is exacerbated by individual managers' need for a stable work force and their subsequent hesitancy to alienate the dancers on whom they rely. Furthermore dancers are engaged in labour practices that allow them to embrace an identity of self-as-entrepreneur; this further facilitates resistance. On the other hand, dancers are positioned as both workers and entrepreneurs, and as a result of their contradictory class location, traditional class solidarity and alliances are destabilized and the ability to resist collectively undermined.

The new organization of labour has also changed labour expectations in another way. In the past, the nature of the entertainment-based industry compelled dancers to work full-time and travel as they worked "the circuit." These conditions effectively excluded from the trade many women workers who embraced other "respectable" social commitments: children, partners, education, other jobs. Today, dancers can opt to work as house girls or freelancers; work full-time, part-time or occasionally; and either never or only periodically go "on the road" in response to particular financial difficulties.

In real terms these conditions, coupled with the impoverishment of women workers in Canada generally, opened up the industry to reputable working-class women and women from middle-class families whose eroding economic position (coupled with ideological changes regarding the meaning of nudity) has rendered morally suspect labour increasingly tenable. Tina, a sole-support mother, started working as a stripper when she was:

> On welfare for seven months and it was hard and ... I saw those ads [in the newspaper]. And one day I decided to go, to try it. But it

was scary. I was twenty-nine years old and I didn't know what was
going on there.

Like Tina, these new workers need to overcome their own stereo-
typical assumptions about strip clubs; those who effectively decon-
struct the dominant discourses, however, sometimes remain in the
occupation for considerable periods of time. In turn, these new work-
ers bring with them their own class culture and have an impact on
the way social and labour relations are organized within the club.

What we see is a complex interplay between market economy
and labour structure. It is, at the same time, a dynamic process —
the labour process shapes the class origin of the available employee
base and then positions workers in a contradictory class location.
We see a destabilization of traditional class alliances as new prac-
tices have emerged.

The shift in the class origin of strip-club workers brings us back
to the importance of culture and stratifications within the working-
class. As employees are increasingly recruited from the reputable
working-class, bringing to the labour site their own moral demar-
cations of respectability, such stratifications have become embed-
ded in the industry structure itself. Today, the markers of rough
working-class culture — practices (partying, drugs), appearance
(cut-off jean shorts, tattoos), values (being "solid") and language
(talking tough) — are either absent from strip clubs or limited to
one token "rough bar."

There is a particular irony here. While the dominant discourse
increasingly defines stripping as immoral, clubs and workers are
becoming progressively more committed to respectability: "They think
of it as a business now, the newer generation. It's more like a business
instead of just the stereotyped thing that people used to do. The girls
are keeping their money [and there's] a lot less drugs" (Rachel). Young
women from the rough working-class who wear its markers with pride
are being marginalized within the industry. It is precisely these women,
whose employment options are restricted, who are the most exploited
population of workers.

STRIPPERS' WORK IS WOMEN'S WORK

This study examined the work strippers do as *work*; the traditional focus on sexuality and deviance was suspended and instead, insights from labour theory were used as a point of entry. At the same time I have argued that stripping is not work like any other, but a particular marginal labour, one that is sexualized and stigmatized. It was necessary, therefore, to "make sense" of all the nuances of the labour process and of what marginalization means to the workers. To do this, we need to attend to the interactively realized meaning of experiences that emerge from particular structural and material contexts, discursive patterns and everyday practices. This marriage of convenience among symbolic interactionism, neo-Marxism and discourse analysis furnishes us with a lens that reveals strippers to be active agents operating within the confines of oppressive labour and social relations.

When we "normalize" the labour of strippers and make links to the "reputable" work that other working-class women engage in, it becomes clear that far from being exceptional, the labour of dancers is organized in ways that are consistent with the trends we see for working-class women generally, both at the level of organization and at the level of process. When we look at the work that a stripper *does* we see that like her working-class sisters, she performs stressful and sometimes dangerous labour that requires the vigilant application of complex skills — skills that are rarely acknowledged. As a worker she is oppressed and exploited; and she resists. In the tradition of working-class women throughout history, within the confines of available options and structurally dictated constraints, she uses collective and individual action as well as discursive strategies to realize a measure of control over the labour and assert herself.

When we slip to another level of consideration and look at the sexual — the justification for marginality — a number of interesting things emerge. Strip clubs are unique "immoral" sexualized leisure sites. The eroticism is important for the clubs as it attracts male patrons who come to drink and watch attractive naked female bodies. A somewhat surprising finding was that for the dancers this eroticism has been transformed into context. In spite of the fact that the

labour is explicitly marked with the symbols of sexuality, that dancers self-consciously present a sexualized image and, more importantly, an image of sexual availability, this sexualization appears to be primarily about following gender scripts and providing the appropriate atmosphere in which the illusion of intimacy can be played out. Put another way, by and large sexuality is merely a superficial visual play that facilitates and legitimates the emotional labour through which dancers "make their money."

Today, more than ever, strippers engage in "women's work." Traditionally women have been expected to provide men with nurture, care and support. Dancers provide these services on the market on a fee-for-service basis. Suspending momentarily what it says about the state of alienation in advanced capitalist society that men are prepared to pay ten dollars for every four minutes (eighty-five dollars per hour if they take the flat rate)[103] they spend in the company of a woman, we can appreciate that this is fully consistent with the move of capital into the types of services traditionally performed in the home. In the context of intimate relations this empathetic support is not experienced as burdensome, but within the labour market it proves to be difficult, emotionally taxing labour that requires both surface and deep acting and the implementation of complex skills. Like so much of the labour women do, it is obscured, even to the participants, by the context in which it occurs and the taken-for-granted nature of the competencies. That is to say, not only is the labour structured so that work is interspersed with social interaction, but emotions do not "fit" into the language of work, so that while dancers are fully aware that "it's hard on your head after a while" (Diane), they nonetheless are sometimes not fully cognizant of this as *labour* activity.[104]

If I have done my job well and the voices of women working in strip clubs have been audible, it should be clear to the reader that the work women perform in strip clubs is *hard* work. In order to be able to practice her trade, a dancer has to periodically appear on-stage, dance and remove her clothes for a roomful (or worse, *not* a roomful) of men "for free." In order to "make her money," she has to present herself as an attractive, "sexy" woman, sell her service to an individual patron and

retain his attention by engaging in erotic and/or emotional labour while carefully maintaining physical and psychological boundaries. In the champagne room, her naked body may well be inches from her client (or she may, depending on the club, be sitting on his lap) but she is being continually monitored by the manager, the doorman, other dancers and the police. Like a rape victim if she is inappropriately touched, she is held responsible and sanctioned. All the while she has to cope with the particular stress of working in a leisure site as well as deal with the chaotic environment and the interpersonal conflicts that abound. When she leaves the labour site she continues to engage with the stigmatized nature of her occupation, managing her social and personal identity as well as coping with the stereotypical assumptions of her friends, intimate partners and the state agencies with which she interacts. While we can legitimately make links to more reputable labour sites for almost every aspect of the dancer's work, there are few jobs that require this combination of skills or necessitate that the worker operate in such a complex and emotionally taxing labour environment. Furthermore, the application of stigma means that the labour has far reaching costs in the worker's personal life.

At the same time, the implications of having a "job like no other" are not all bad. Unlike most workers who provide traditional women's work on the open market, a stripper can be well compensated for her labour. Not only does the job offer her degrees of flexibility and autonomy that are seldom available to working-class women, it also allows her to develop competencies that are useful outside the labour site — assertiveness, boundary maintenance and interpersonal skills. In addition, while her work may leave her frustrated and angry, it also affords her a broader vision, enhanced self-esteem, good body image, comfort with her sexuality and confidence — all worthwhile attributes and ones that many women continue to struggle to realize.

> [Dancing has] given me wisdom. It's given me strength. It's shown me the tough times and the good times. It's helped me a lot. It's helped me grow up (Sally).

MOVING ON: POLICY IMPLICATIONS

We have transcended the traditional focus on sexuality and deviance in this project and come to see that while strippers engage in difficult and sometimes dangerous work, within that context they use the tools at hand to realize a measure of autonomy and control. We can most certainly not define these women as victims in need of patronage or salvation. At the same time we can still consider what *realistic*[105] strategies might be useful in mitigating some of the more oppressive aspects of the labour process.

As we have seen, traditional labour organizing is not necessarily appropriate for this marginal, competitive, transient and stratified work. Dancers periodically resist collectively, but for the most part strategies are individualistic; workers define themselves as entrepreneurs and operate in their own interest. This approach, which is most effective for workers with considerable skill and organizational assets, is not only understandable but also conditioned by the contradictory class location of dancers. Unfortunately, because these strategies are divisive, erode worker solidarity and unintentionally support oppressive discourses, gains are frequently made by individuals at the expense of the collective. It is precisely the most vulnerable and exploited workers who lack sufficient assets for resistance, and who are consequently most detrimentally affected by the work and by the actions of their colleagues.

I was frequently frustrated during field work by the evident lack of sisterhood among the women I observed. At the same time, workers expressed enough annoyance (although took little action) about the exploitation of other dancers that I retain a measure of optimism. The most viable model appears to be the approach adopted by sex-trade workers. By forming associations such as COYOTE and Red Feather, sex-trade workers are asserting a collective voice to address problematic laws, myths and oppressive state practices that affect their ability to safely conduct their work. Though still marginalized, these organizations are increasingly assuming a political voice — especially since feminists have started to fight alongside rather than against them. At a minimum, these groups are being listened to, though admittedly not always *heard*.

Similar organizations are emerging in Toronto (Exotic Dancers Alliance of Ontario) and in Ottawa (Dancers Equal Rights Association) to champion the rights of dancers.[106] If empowered and supported, these organizations hold the promise of mitigating some of the most negative aspects of the job by providing a representative collective voice against stigmatizing discourses, oppressive state regulation, excessive fees and unsafe work environments. In addition, these organizations have the potential to offer women in the skin trade a measure of emotional support through their very existence, through specific practices,[107] and by forging of a discourse that supports rather than undermines the identity of workers.

A final note of caution regarding state intervention: we may complain about the lack of legislative protection afforded women working in the clubs; but there is a danger that as long as stripping remains marginalized and stigmatized, even allowing benevolent agencies a measure of control may result in additional, unintended oppression. To date, in a pattern that is consistent with marginal women's experience more generally,[108] strippers' interaction with the patriarchal state has resulted in reforms that frequently increase, rather than decrease, their oppression.

LAST WORDS

Dancers are a special breed of people, I guess — they really are (Sally).

It's relieving 'cause it's my side. It's not the stereotype. I am a girl trying to make a living (Debbie).

Endnotes

1. Given the importance of language, determining how to refer to women who work as skin-trade workers in strip clubs is somewhat problematic. On the one hand there are certainly political reasons to follow the precedent of sex-trade workers who have reclaimed "whore" (Roberts, 1992) and reclaim the term "stripper." On the other hand, most industry workers refer to themselves as exotic dancers or, more frequently, simply as dancers. In this book I took my cue from workers and while I use "exotic dancers," "dancers" and "strippers" interchangeably, my use of the latter is limited to occasions when specificity is called for. I trust the use of "dancers" will cause little confusion to the reader given the subject matter of the study; obviously the term refers to skin-trade workers in strip clubs.

2. This location has two implications *vis-à-vis* generalizability. Given the extent to which broader economic, social and labour context conditions the labour of women in clubs, labour practices may vary somewhat across the province. Furthermore, dancers are caught in a regularity web which includes provincial statutes. Consequently labour practices in some provinces may vary considerably. This being said, there is considerable evidence that the labour practices described are, with minor variations, increasingly common throughout North America.

3. This concept of discourse is central to the analysis. Discourses are understood here to be the conceptual frameworks that structure assumed "truths" — the "natural" understanding into which the articulators and recipients of social interaction "slip" (Penelope, 1990:203). We have to appreciate that discourses are not open to being constructed at will and are conversely constrained by the options that are imaginable. In other words, people can adapt, subvert and undermine, but are still working in relation to those discourses which permeate and have become the taken-for-granted truth.

4. See, for example, Dworkin (1979); Lederer (1980b).

5. There is considerable evidence that the claims made by the producers of *Snuff* constituted a publicity stunt and were not accurate

(Lacombe, 1994:29); that pornography was getting less violent (Segal, 1992:6); that correlations between depictions and acts of sexual aggression are unclear (Government of Canada, 1985:99); and that anti-pornography campaigns relied on questionable social-science research (McCormack, 1985).

6. The extent to which feminist concerns can be addressed within a capitalist and patriarchal state apparatus remains highly questionable. The application of feminist rhetoric to oppress sexual minorities in the 1992 Supreme Court of Canada *Regina v. Butler* decision and the 1985 introduction of the "communicating law" (section 213.1 of the Canadian Criminal Code) sustain concerns that the resulting reforms will address white, middle-class heterosexist morality through the oppression and suppression of sexual minorities and the curtailing of freedom of expression.

7. See, for example, the Canadian collection *Censorship*, edited by Varda Burstyn (1985).

8. See for example Hartley (1987); Scott (1987).

9. The term "skin trade worker," which refers to individuals who engage in labour that is defined in the public forum as visual sexuality or pornographic, not only focuses attention on labour but also reflects the distinction made between sex and skin trades by industry workers. While women who work as prostitutes and women who work as strippers are both the recipients of the applications of moral stigma, the labour processes are quite distinct and should not be conflated. This should not be seen as an implicit justification of the marginalization of sex-trade workers. They too are involved in a labour process, albeit one that is distinct from the work of exotic dancers. For some excellent work that deconstructs the sex trades, see Shaver (1996).

10. See, for example, the work of Susan Griffin (1981).

11. Token reference is often made to former pornographic-film actress Linda Lovelace, who claims "there was always a gun pointed to my head, even when no gun could be seen, there was a gun pointed at my head" (1980:62). Lovelace does not create an alternate discourse. Rather, she substantiates the suppositions of the moral majority that a "decent" woman must be forced, coerced or threatened into participating in pornography or prostitution.

12. Female consumers and participants of pornography are defined not only as victims of masculinist sexuality but also as experiencing a greater likelihood of suffering sexual assault, because they are supposedly less likely to avoid high-risk situations (Russell, 1988).

13. See, for example, Cole (1989); Price (1989).

14. "Sex radical" is a somewhat inadequate category that includes lesbians, gay men, feminist consumers of pornography and S/M participants — in fact, anyone whose sex/sexuality is outside moralistic, heterosexual norms and who is "defiant as well as deviant" (Califia, 1994).

15. See, for example, McClintock (1993); Califia (1994).

16. This comment was made by one of the industry workers at the "Challenging Our Images: The Politics of Pornography and Prostitution" conference held in Toronto on November 22, 1985.

17. While the industry continues to provide entertainment to patrons, it has undergone a profound transformation since the late 1980s, as we will see in the coming

chapters. Today dancers provide not only public entertainment but also private entertainment and emotional services on a fee-for-service basis.

18. This concept of normalization will emerge repeatedly throughout the book. My use of the term is premised on the understanding that what is "normal" is culturally constructed through a process of normalization that reflects and is embedded in, relations of power/knowledge (Wolfman, 1996:101). The "normal" evolves into taken-for-granted "truth" against which alternatives are deviant. My use of the term is somewhat subversive. Here we reconceptualize the "deviant" by accessing precisely those discourses, those knowledges, which are used to marginalize. In this way we not only immediately destabilize dichotomized understanding and highlight the problematic nature of normal/deviant designations, but create new analytic spaces and access useful theoretical lenses.

19. This literature represented one of the academic responses to the recognition of administrative criminology's limitations. At the same time Marxian critical analysis was emerging (Taylor et al.,1973). Unfortunately, to the best of my knowledge no such analysis of the skin trades was undertaken.

20. George Herbert Mead (1861–1931).

21. "Semi-skilled labourer" refers to jobs where the worker does not sell her skill base but rather sells the ability to learn non-transferable skills for the job (Rinehart, 1996:127).

22. While bearing the markers of the traditional petit bourgeoisie, this trend towards "own account workers" marked a reformulation of working-class labour that is "no more than a disguised form of casualisation wage-labour, often marked by dependency on capitalist employers through some sort of subcontracting system" (Bradley, 1996:49).

23. The term "stratification" best captures the fine gradations and fluidity to which I refer. Of course the Weberian association of the term renders its use somewhat problematic. While influenced by Weber, my usage reflects recent sociological developments and accords limited analytic attention to power and status, which were central to Weber's analysis (1946) [1921].

24. The liberal democratic state, while ideologically committed to a free-market economy, may regulate corporations, but consistently fails to acknowledge both economic and violent crimes perpetrated by capital against workers *as* crime (Reasons, 1986).

25. This includes the employment of housekeepers and/or child minders as well as the ability to purchase such things as convenience food, and the amount of time that must be invested in careful shopping.

26. Hughes (1999) distinguishes between self-employed employers who have employees and self-account workers who work alone. Within capitalism, this non-standard labour arrangement is consistent with producers' desire for a flexible work force. Not only do women in this sector experience a greater gender-based income disparity than their counterparts in the traditional labour market, they are also clustered in sales and service work and 75% work part-time (Hughes, 1999:2).

27. Exchange labour refers to informal-sector work and kin assistance.

28. Informal-sector employment is labour that is not contractually regulated and therefore is outside of the security afforded by legislative and government

control. It tends to involve small-scale, highly labour-intensive work such as the production of goods or services in the home, goods that are then sold on the open market (for example, piecework sewing) (Johnson and Johnson, 1982).

29. See Bourdieu (1984) for a discussion of the intersection between class and culture.

30. The work of E. P. Thompson (1966), Willis (1977), Dunk (1991) and McRobbie (1991) supports an understanding of class conflict in terms of expressive hegemonic and counterhegemonic cultural forms and practices. Unfortunately, expressive options are limited and defined by the far-reaching commodification that is the marker of modern capitalism, so that culture is frequently expressed in patterns of consumption (Crompton, 1993:171) and radicalism is "blunted by the inherently regressive features of the forms of expression they [working-class men] choose" (Dunk, 1991:160).

31. Beauty, the body and objectification are the focus of the ballet theatre as well as the strip club, but the former is revered as "culture" while the latter is demonized.

32. Tan lines are very important. On the one hand, the lighter flesh highlights the sexualized zones of a woman's body (her breasts and derriere). On the other, the existence of these lines reinforces the idea that the client is being given access to something illicit and normally hidden from view.

33. Quite clearly, North American ethnocentric ideals of beauty are powerful *political* discourses (Bordo, 1994) that reproduce and reflect social stratifications. As previously noted my research sheds little light on this important issue. At the same time Stella, a Montreal-based sex trade–worker advocacy group, has suggested that some clubs may limit the number of visible minority women they employ (Stella, 2000:29). Evidence emerging from the United States highlights the ways race intersects with gender discourses to the disadvantage of Afro-American women (Anderson, 1999; Funari, 2000).

34. Excerpts taken from the interviews are identified with a pseudonym following the quotes. Except in the case of dancers, the occupation is also identified. In the interests of protecting research participants, all identifiable names, places and events have been altered.

35. Most patrons do not check their coats but pay the admittance fee here. Some clubs always charge admission, while others do so only when they are offering special entertainment.

36. Laws, municipal and federal, notwithstanding.

37. The term may also originate in the cabarets of European countries, where B-girls are openly and legally employed. In these establishments, the purchase of a bottle of champagne customarily entitles the patron to enjoy the company (and, in exchange for monetary compensation, sometimes other favours) of his companion in a private and very comfortable, curtained-off area of the bar.

38. This division is somewhat different from Erickson and Tewksbury's (2000) six-category typology of strip-club patrons. The differences may in part be a result of divergent methodological approaches to the research. At the same time, my interest in patrons was secondary, while for the above-noted authors it was the primary focus of their study.

39. The gender-specific pronoun "he" is employed in this book to refer to managers. Similar licence is taken when referring to disc jockeys and doormen.

40. Within the club, nudity and the markers of sexuality are so pervasive that they go essentially unnoticed by participants. Ironically, or perhaps not, the very visibility of the erotic renders it invisible.

41. Why gratuities are particularly generous is open to question. Presumably it is a function of the fact that men earn, on the whole, higher incomes than women, and in a strip club most of the patrons are men. In addition it is possible that customers generally anticipate spending money in a strip club and some of this largess appears to spill over to bar staff.

42. For example, a waitress in a "straight" restaurant will strive to maintain good relations with the cooking staff. In practice, this might mean "sucking up" (offering drinks, friendliness, favours, etc.) and receiving, in exchange, assistance in correcting food-order mistakes.

43. While dancers rely on the doormen, they are also often annoyed when customers' acts of aggression are not treated with the seriousness they warrant.

44. Neophyte employees who have never before worked in a strip club are conspicuous in their demeanour, something that is inevitably commented on by dancers and support staff alike. In fact new recruits are rare, since a rotation of employees within the industry ensures that information regarding job openings circulates rapidly. The annoyance expressed by workers is not the result of the labour site, but is a function of the inevitable stereotypes one confronts when interacting with others outside the industry.

45. For a historical exploration of this process, see Bruckert and Dufresne (forthcoming).

46. In *R. v. Johnson* the Supreme Court ruled that "a performance is not rendered 'immoral' solely because it is performed in the nude so as to constitute an offence under section 163 [now section 174] of the Criminal Code" (SCC, 1973).

47. By 1981 nudity was defined as "total bareness" and was hence characterized by the complete absence of clothing (*R. v. Szunejko*).

48. In 1991, Patrick Mara and Allan East, respectively the owner and manager of Cheaters Bar in Toronto, were charged under section 167 of the Criminal Code with allowing an "indecent theatre performance." In 1994 Judge Hachborn of the Ontario Provincial Court, ruled that touching between patrons and exotic dancers was "innocuous behaviour" (Chidley, 1995). The ruling and comments were widely reported and condemned in the media (Bhabra, 1995; McGill 1996). The Ontario Court of Appeal overturned the ruling in 1996 and in March 1997 the Supreme Court of Canada upheld East's conviction. At the same time, the acquittal of Patrick Mara was reinstated on the grounds that he did not have the prerequisite *mens rea* that he did not "knowingly" permit the above-noted activities.

49. Notably he specified that it is harm to Canadian women generally and not harm caused to industry workers that was the basis of the courts decision.

50. In Canada, morality is, for the most part, a federal concern and regulated through, among other things, the Criminal Code and Customs. Commerce and labour, however, fall under the jurisdiction of the provinces, and to a much lesser degree, municipalities.

51. "Social problem" is being used here in the constructionist sense. See Spector and Kitsuse (1987).

52. At other times, strip clubs have been caught in the process of urban renewal as the traditionally working-class areas where they were located became gentrified.

53. Although newspaper articles during this period would occasionally quote a feminist who suggested the practice objectified women, this was clearly an add-on position.

54. It would appear that rates of crime in strip clubs were not exceptionably high during this period. For example, statistics from the Ottawa Police indicate that during the 1984 to 1991 interval, an average of between seven and ten police reports were filed annually in relation to activities in a typical strip club in Ottawa (City of Ottawa, 1991:21).

55. Traditionally this position was the domain of right-wing, pro-family, often church-affiliated interest groups like Canadians for Decency, established in 1974. As already noted, during the late 1970s and 1980s anti-pornography feminists joined with these groups in highly problematic alliances calling for the government to take action. Ultimately this empowered and legitimated the state and legal system by affording the state the opportunity to rhetorically address feminist issues while retaining the support of the anti-feminist right (Wilson, 1992:15) and setting up an increasingly repressive social control apparatus with more laws, more police and more powerful customs officers (see for example the recommendations of the Fraser Report, Government of Canada, 1985).

56. Criminologists link this "moral panic" to interest groups (in particular victims' rights organizations), media presentations and political opportunism (Kappler et al., 2000; Nelson and Fleras, 1995).

57. The Supreme Court refused to hear an appeal by Burlington and Markham against a lower court ruling and thereby confirmed that morality was outside municipal jurisdiction

58. The Supreme Court of Canada refused to hear an appeal challenging Oshawa's jurisdiction to retroactively restrict the location of strip clubs.

59. As of 2001 there is considerable disparity within the province. Some municipalities, like London and Kitchener, require clubs, but not attendants, to purchase licences. In municipalities that continue to licence dancers, costs can be quite high. In Windsor dancers must pay $225 plus administration and photo fees annually.

60. Similarly, Bill 146, "An Act to Amend the Municipal Act," which is before the Ontario Legislative Assembly at the time of publication, seeks to empower municipalities to decline exotic-entertainment licences to individuals with a criminal record for prostitution or organized-crime offences (Ontario, 2001). At the same time the definition of an exotic-entertainment parlour is expanded to refer to a "premise from which dates, escorts or nude or partially nude dancing is [sic] arranged for a fee" (Ontario, 2001). In other words individuals with prostitution-related offences are prohibited from the business at the same time as the proposed law conflates the trades.

61. Unlike licensing for exotic dancers, municipalities do enforce club licensing. Fees vary by municipality. For example, in 2001 an operator's licence in Toronto costs in excess of $3,000, while in Windsor it is $2,760.

62. Licensing provides a good example, since there is considerable provincial disparity in terms of how actively the women comply with the licensing requirements.

63. For example, in 1984 club owners across Ontario responded to the increasing regulation of and moral agitation surrounding strip clubs by uniting in the Burlesque Club Owners' Association.

64. In 1979 wages started at $275 per six-day week, but would quickly climb to $375 and could increase to $600.

65. Club owners defended the removal of salaries in part by pointing to the income potential afforded dancers by the newly introduced twenty-dollar lap-dancing.

66. The approach varies. As early as 1995, Toronto-area bars were implementing a "strip chip" system that required patrons to purchase five-dollar chips, for which the dancer was reimbursed four dollars (Bhabra, 1995:54).

67. These wages were in effect in 1999.

68. Cut-off blue jeans are of course associated with a particular rough, working-class presentation-of-self (McRobbie, 1991).

69. Note that these comments were made prior to the Pelletier ruling.

70. I did not witness this process, but the literature suggests that in some urban centres (particularly Toronto), clubs sometimes "hire" large numbers of migrant workers. These workers are reputed to (because of their economic need and vulnerability) undercut existing fee structures (Bhabra, 1995; McDonald et al., 2000). Certainly benefitting from ethnic and race stratification is not restricted to strip clubs, but is arguably characteristic of capital. See, for example, Luxton and Corman (2001) for an analysis of the intersection of race, class and gender in Hamilton's steel industry.

71. Bartky's (1988) analysis suggests that in modern society all women are alienated from their physical reality. Compliance with standards of make-up, hair dressing and body clothing renders the woman an ornament. Perhaps the epitome of Foucault's internalized panopticon is the woman who perpetually checks (and fixes) her appearance, ever conscious of herself as an observed object of others' gaze (Bartky, 1988:81). A woman's discipline of the body is seen in body language, especially in her careful movements as she postures and positions her body/object to take up limited space.

72. These include bringing their own towels to sit on or their own cleaning materials.

73. This approach is most effective with exceptionally attractive dancers whose eroticism is physical or visible. As a result, these women may use the stage as a self-promotion platform and tend to invest considerably more time and money in their appearance than other dancers: costumes, tanning and operations.

74. If a customer is not known to the dancer, she will rely on either a tip from a member of the support staff (about cash or conversational clues) or her own reading of indicators including dress, demeanour and body language. Unless there is evidence to the contrary, single men are assumed to be "looking" and are almost always targeted before those in groups. The most notable exception is, of course, members of stag parties.

75. Some customers appear to appreciate this approach. The role reversal absolves the patron of the need to approach a woman and positions him to refuse her sexual advances. This is an example of how complex and contradictory the dynamics can be. The woman is positioned as aggressor; the man is not only sought after but freed from the traditional expectation that men approach women.

76. Not "taking it personal" also requires dancers to distance themselves from the positive reactions of the audience. It is acknowledged within the industry that positive assessments must be similarly understood within the context of a scripted game.

77. See Sijuwade's work on counterfeit intimacy (1996) for a somewhat different consideration of this process. Sijuwade's "pure" interactionist analysis does not situate the labour of strippers within a broader context of gender, class or market trends.

78. "Fun" here must be understood in relation to Debbie's particular appreciation of the labour as providing, among other things, the opportunity to exploit men and realize "payback" for past injustices.

79. It is possible that capitalism is responding to the market and exploiting men's insecurity *vis-à-vis* the changing gender relations that have characterized the latter half of the twentieth century. With the erosion of male power that "is based on the compliance of women and the economic and emotional services which women provided" (Giddons, 1992:132), men struggle with the new expectations and their own need for intimacy (Giddons, 1992:180).

80. The driving service is also perceived as offering a level of protection when leaving the work site.

81. I am trying to distance the practice from deviance by pointing out commonality. Using drugs and alcohol in an environment where they are easily available can be compared to a nurse or intern getting colleagues to prescribe (or writing her prescription) for a desired mood-altering substance.

82. It would be misleading to construe the relationship between wages and labour processes as unmediated by exterior factors (Kessler-Harris, 1990:481). We need only reflect on the fact that danger, status, monotony and responsibility are all traditionally sites for labour negotiations.

83. This redefining of labour as semi-skilled is consistent with the trend towards de-skilling that Braverman (1974) identified as characteristic of twentieth-century capitalism. That de-skilling is ideologically and economically useful (for capitalists) is revealed when we realize that throughout the 1980s and 1990s, at the same time as skills were being denied, employers in mainstream sectors of the labour market were establishing inordinate educational requirements (Rinehart, 1996:78). It would appear that labour-dependent personal-service industries capitalize on existing age, gender and racial stratifications by hiring marginal workers, and then justify their low wages through reference to their marginal status (Reiter, 1991:148).

84. Here I am using Foucault's concept of power. Foucault argues that power is "not with a capital P" (Foucault, 1978), not a "proper noun" that can be imposed because it is possessed by an individual, institution or the state. Instead it is an element that permeates all social relationships and is exercised in social interaction. Power relations are both an effect and a condition of other social relations and processes.

85. Other notable exceptions include the 1933 establishment of the Burlesque Artists Association (BAA) (Zeidman, 1967:217) and the founding of the Canadian Association of Burlesque Entertainers (CABE) in 1982 (Johnson, 1987).

86. In addition, as already noted, dancers circulate among clubs, resulting in the formation of industry-wide understandings and truths.

87. In 2001, although bylaw L-241 was still active in Ottawa, it was largely ignored by dancers and by the city's bylaw officers alike.

88. This is a common strategy for working-class workers to employ (see Shapiro-Perl, 1984:203 for similar strategies employed by factory workers). In the club this puts support staff in an awkward intermediary position.

89. The dirty-dancing discourse is particularly effective because it operates in the interests of managers who are anxious to avoid state intervention. On the other hand, rumours of theft are an effective way to mobilize dancers.

90. The nature of the "favours" will depend on the particular labour situation, but can include circulating and performing onstage. It is not necessarily very subtle. For example, if very few dancers show up for a shift, staff will attempt to call in regular freelancers. Most will agree to come to the house's aid only after carefully negotiating financial and other concessions from management.

91. Once again strategies of resistance put support staff in an awkward position. I periodically took *pity* on the men and found myself trying to talk dancers into offering a private dance to patrons who were polite and respectful, but customarily only purchased one or two dances.

92. The term "career stripper" does not imply the absence of other labour ambitions but rather indicates a recognition of some commitment to the occupation.

93. In fairness, while the signifier "dancer" does not adequately reflect their labour, the term "stripper" is also hardly adequate given the multiple tasks that workers must perform on a daily basis.

94. Once again we see the intersection of strippers and disreputable working-class cultural symbols (McRobbie, 1991).

95. This is based, in part, on my personal experience of identity management in both professional and social spheres. For example, in discussing the sex or skin trades with colleagues, students or those with whom I interact but who do not know my labour trajectory, I carefully monitor my comments to ensure that I do not inadvertently "out" myself by sharing insider knowledge. In spite of my efforts I have occasionally been identified, but not threatened, by the "wise."

96. For further development of this argument see, for example, Roberts (1993).

97. The irony is that in a time when economic vulnerability continues to be a powerful instrument of compulsory heterosexuality, providing erotic entertainment for men is stigmatized but also affords some women independence from either particular men or the patriarchal state (Silver, 1993:79).

98. This statement speaks to an investment in respectability framed in relation to children. This is consistent with working-class parents' traditional willingness to make sacrifices so things are better for their children (Katz and Kemnitzer, 1984:212).

99. Marie's contention that she was not insulted was contradicted by her actions. Again we see the tension between an intellectually worked-up understanding and the deeply ingrained presumptions of morality that permeate Western patriarchal thought.

100. As with prostitution (Lowman, 1995), we see culpability assigned differently to consumers and service providers, and a considerable disparity in charging. Beyond that, of course, historically, the charging practices have explicitly targeted strippers. As previously noted, with the appearance of lap-dancing, prostitution laws are employed as a regulatory strategy.

101. Without pushing this too far, it is notable that Mike and other male managers and owners sometimes revert to a particular gender script and ascribe an element of sexuality to the exchange between customers and dancers. Despite being fully aware that dancers are at work and are not engaging in the pursuit of pleasure, the language continues to obscure the fact.

102. This is of course also a function of the lap-dancing debate, during which dancers' labour was fairly consistently constructed as sex work, not only in the media but also in state regulatory strategies.

103. These prices were in effect in 1999.

104. During field work and in interviews I was continually amazed when dancers expressed empathy for bartenders and waitresses who "work more [than strippers] … back and forth and back and forth, cleaning" (Tina). It seemed to me that the dancers had the more taxing job. It was only during analysis that it became clear to me that although dancers are well aware of the costs of their jobs, they did not conceptualize the emotional investment and expectations as *work*.

105. The "realistic" part is important, as the eradication of class and gender stratifications is desirable but unlikely in the near future. This may be just as well for women working in strip clubs: without gender scripts, strippers would likely be out of a job.

106. There is also Danzine, an American organization. This Oregon-based not-for-profit agency run by and for exotic dancers operates as an advocacy group and publishes a bimonthly magazine that addresses direct labour issues (health, safety and the circuit) and industry-related problems (drugs and financial planning). The organization offers counselling and other one-on-one services for dancers. A similar association in San Francisco, Exotic Dancers Alliance (EDA) is having considerable success in organizing dancers and serving as their advocate.

107. For example, sex-trade workers' organizations circulate bad-trick lists and undertake some counselling.

108. The examples here are innumerable. We need only to consider the individual implications for women of the state's intervention including mandatory charging of suspected wife abusers (Currie, 1990) and the "battered woman's syndrome" (Boyle, 1994) — to appreciate that we must be wary of unintended consequences of increased oppression. This argument is well developed by Carol Smart (1989).

Bibliography

Adami, Hugh. 1982. "Strippers Continue to Take It off, Despite Goulbourn's New Bylaw." *Ottawa Citizen* (November 3, 1982), 29.

Adelmann, Pamela. 1995. "Emotional Labour as a Potential Source of Job Stress" in Sauter, Steven; L. Murphy, eds., *Organizational Risk Factors for Job Stress.* Washington: American Psychological Association.

Adkins, Lisa. 1992. "Sexual Work and the Employment of Women in the Service Industries" in Savage, Mike, and A. Witz, eds., *Gender and Bureaucracy.* Oxford: Blackwell.

Allen, Robert. 1991. *Horrible Prettiness.* Chapel Hill: University of North Carolina Press.

Ample, Annie. 1988. *The Bare Facts: My Life as a Stripper.* Toronto: Key Porter Books.

Anderson, Gina. 1999. "Private Dancer." *Essence* 30, 3.

Aronowitz, Stanley. 1992. *Politics of Identity.* New York: Routledge.

Atkinson, Diana. 1995. *Highways and Dance Halls.* Toronto: Vintage Books.

Auerback, Stephen, and J. A. James. 1999. *The Annotated Municipal Act.* Scarborough: Carswell Publishing.

Ball, Donald. 1974. "An Abortion Clinic Ethnography" in Bryant, Clifton, ed., *Deviant Behavior.* Chicago: Rand McNally.

Barber, Pauline. 1992. "Conflicting Loyalties: Gender, Class and Equality Politics in Working Class Culture." *Canadian Woman Studies/les cahiers de la femme* 12, 3.

Bartky, Sandra Lee. 1988. *Femininity and Domination: Studies in the Phenomenology of Oppression.* New York: Routledge.

Becker, Howard. 1963. *Outsiders.* New York: The Free Press.

Bell, Laurie, ed. 1987. *Good Girls/ Bad Girls: Feminist and Sex Trade Workers Face to Face.* Toronto: Women's Press

Bhabra, H. S. 1995. "Ten Dollars a Dance." *Toronto Life* (May) Vol. 29, No. 8.

Billington, Michael. 1973. *The Modern Actor.* London: Hamish Hamilton.

Boles, Jacqueline, and A. Garbin. 1974. "Stripping for a Living: An Occupational Study of the Night Club Stripper" in Bryant, Clifton, ed., *Deviant Behavior.* Chicago: Rand McNally.

Bordo, Susan. 1994. "'Material Girl'": The Effacements of Postmodern Culture" in Goldstein, Laurence, ed., *The Female Body: Figures, Styles, Speculations.* Ann Arbor: University of Michigan Press.

Bourdieu, Pierre. 1984. *Distinction: A Social Critique of the Judgement of Taste.* London: Routledge.

Boyd, Monica, M. Mulvihill and J. Myles. 1991. "Gender, Power and Postindustrialism." *Canadian Review of Sociology and Anthropology* 28, 4.

Boyle, Christine. 1994. "The Battered Wife Syndrome and Self-Defence" in *Critical Readings in Criminology.* Scarborough: Prentice Hall.

Bradley, Harriet. 1996. *Fractured Identities: Changing Patterns of Inequality.* Cambridge: Polity Press.

Braverman, Harry. 1974. *Labour and Monopoly Capital: The Degradation of Work in the Twentieth Century.* New York: Monthly Review Press.

Bruckert, Chris, and M. Dufresne. Forthcoming. "Re-configuring the Margins: Tracing the Regulatory Context of Ottawa Strip Clubs." *Canadian Journal of Law and Society.*

Bryan, James. 1965. "Apprenticeship in Prostitution." *Social Problems* 12.

Burstyn, Varda, ed. 1985. *Women Against Censorship.* Vancouver: Douglas & McIntyre.

Cain, Roy. 1991. "Stigma Management and Gay Identity Development." *Social Work* 36, 1.

Califia, Pat. 1994. *Public Sex: The Culture of Radical Sex.* Pittsburgh: Cleis Press.

Campbell, Ken. 1989. "Getting Wired." *Toronto Life* (June) Vol. 23, No. 9.

Cavendish, Ruth. 1982. *Women on the Line.* London: Routledge & Kegan Paul.

Chindley, Joe. 1995. "A No to Dirty Dancing." *Maclean's* (July 17, 1995) Vol. 108, No. 29.

City of Ottawa. 1991. *Adult Entertainment Parlours: Recommendations.* Ottawa: Department of Planning and Development.

City of Ottawa. 1998. *Taxes, Parking and Permits.* http://city.ottawa.on.ca/ottawa/city.

Clement, Wallace. 1988. *The Challenge of Class Analysis.* Ottawa: Carleton University Press.

————, ed. 1997. *Understanding Canada: Building the New Canadian Political Economy.* Montreal: McGill-Queen's University Press.

Cockburn, Cynthia. 1986. "The Material of Male Power" in Feminist Review, ed., *Waged Work: A Reader.* London: Virago.

Cole, Susan. 1989. *Pornography and the Sex Crisis.* Toronto: Amanita.

Coleman, Lerita. 1986. "Stigma: An Enigma Demystified" in Ainlay, Stephen, G. Becker and Coleman L., eds., *The Dilemma of Difference.* New York: Plenum Press.

Connelly, P. M., and Martha MacDonald. 1989. "Class and Gender in Fishing Communities in Nova Scotia." *Studies in Political Economy* (30).

Cooke, Amber. 1987. "Stripping: Who Calls the Tune" in Bell, Laurie, ed., *Good Girls/Bad Girls: Sex-Trade Workers and Feminists Face to Face.* Toronto: Women's Press.

Corio, Ann, and J. DiMona. 1968. *This Was Burlesque.* New York: Grosset & Dunlap.

Corporation of the City of Ottawa. 1991. *Adult Entertainment Parlours: By-Law No L-6.* Ottawa: City of Ottawa.

Crompton, Rosemary. 1993. *Class and Stratifications: An Introduction to Current Debates.* Cambridge: Polity Press.

Currie, Dawn. 1990. "Battered Women and the State: From the Failure of Theory to a Theory of Failure." *Journal of Human Justice* 1, 2.

Danzine. Undated. *Danzine Homepage.* www.danzine.org.

DERA. Unpublished. *Mission Statement.* Ottawa: Dancers Equal Rights Association of Ottawa.

Dill, Bonnie. 1988. "Making Your Job Good Yourself: Domestic Service and the Construction of Personal Dignity" in Morgen, Sandra, and A. Bookman, eds., *Women and the Politics of Empowerment.* Philadelphia: Temple University Press.

Dragu, Margaret, and A. Harrison. 1988. *Revelations: Essays on Striptease and Sexuality.* London, Ontario: Nightwood Editions.

Duffy, Ann, and N. Pupo. 1992. *Part-Time Paradox: Connecting Gender, Work and Family.* Toronto: McClelland & Stewart.

Dunk, Thomas. 1991. *It's a Working Man's Town: Male Working Class Culture in Northwestern Ontario.* Montreal: McGill-Queen's University Press.

Du Wors, Richard. 1999. "The Justice Data Factfinder" in Roberts, Julian, ed., *Criminal Justice in Canada: A Reader.* Toronto: Harcourt Brace & Company.

Dworkin, Andrea. 1979. *Pornography: Men Possessing Women.* New York: Pedigree.

Dworkin, Andrea, and C. MacKinnon. 1988. *Pornography and Women's Equality.* Minneapolis: Organizing Against Pornography.

Edmonton. 1988. "Group Links Sex Assault to Strip Show." *Ottawa Citizen* (November 6, 1988) E4.

Enck, Graves, and J. Preston. 1988. "Counterfeit Intimacy: A Dramaturgical Analysis of an Erotic Performance." *Deviant Behavior* 9.

Erickson, David, and R. Tewksbury. 2000. "The 'Gentlemen' of the Club: A Typology of Strip Club Patrons." *Deviant Behavior* 21.

Exotic Dancers' Alliance (EDA). 2001. "Mission Statement." www.eda.sf.org.

Ferree, Myra. 1984. "Sacrifice, Satisfaction and Social Change: Employment and the Family" in Sacks, Karen, and D. Remy, eds., *My Troubles are Going to Have Trouble with Me: Everyday Trials and Triumphs of Women Workers.* New Jersey: Rutgers University Press.

———. 1990. "Between Two Worlds: German Feminist Approaches to Working-Class Women" in Nielsen, Joyce, ed., *Feminist Research Methods.* Boulder: Westview Press.

Forsyth, Craig, and T. Deshotels. 1997. "The Occupational Milieu of the Nude Dancer." *Deviant Behavior* 18.

———. 1998. "A Deviant Process: The Sojourn of the Stripper." *Sociological Spectrum* 181.

Foucault, Michel. 1978. *The History of Sexuality Vol. 1.* New York: Random House.

———. 1979. *Discipline and Punish.* New York: Vintage.

———. 1980. Gordon, Charles, ed., *Knowledge/Power.* New York: Pantheon.

Frankel, Linda. 1984. "Southern Textile Women: Generations of Survival and Struggle" in Sacks, Karen and D. Remy, eds., *My Troubles are Going to Have Trouble with Me: Everyday Trials and Triumphs of Women Workers.* New Jersey: Rutgers University Press.

Funari, Vicki, director. 2000 *Live Nude Girls Unite!* San Francisco: First Run Features.

Gaskell, Jane. 1986. "Conceptions of Skill and Work of Women: Some Historical and Political Issues" in Hamilton, Roberta and M. Barrett, eds., *The Politics of Diversity: Feminism, Marxism and Nationalism.* London: Verso.

Giddens, Anthony. 1992. *The Transformation of Intimacy: Sexuality, Love and Eroticism in Modern Societies*. Stanford: Stanford University Press.

Giddings, Paula. 1984. *When and Where I Enter: The Impact on Race and Sex in America*. New York: Bantam.

Goffman, Erving. 1959. *The Presentation of Self in Everyday Life*. New York: Doubleday.

———. 1963. *Stigma*. New Jersey: Prentice Hall.

Gornick, Vivian, and B. Moran, eds. 1971. *Women in Sexist Society*. New York: Basic Books.

Gouldner, Alvin. 1973. *For Sociology: Renewal and Critique of Sociology Today*. London: Allen Road.

Government of Canada. 1985. *Pornography and Prostitution: Report of the Special Committee on Prostitution and Pornography* (The Fraser Report). Canada: Supply and Service.

Government of Canada. 1998. Canadian Criminal Code (CCC). *Pocket Criminal Code*. Scarborough: Carswell.

Griffin, Susan. 1981. *Pornography and Silence*. New York: Harper and Row.

Grumet, Gerald. 1983. "Psychodynamic Implications of Tattoos." *American Journal of Orthopsychiatry* 53, 3.

Hartley, Nina. 1987. "Confessions of a Feminist Porn Star" in Delacoste, Frédérique and P. Alexander, eds., *Sex Work: Writings by Women in the Sex Industry*. Pittsburgh: Cleis Press.

Hearn, Jeff, and W. Parkin. 1995. *Sex at Work: The Power and Paradox of Organization Sexuality*, revised edition. New York: St. Martin's Press.

Henry, Frances, C. Tator, W. Mattis and T. Rees. 2000. *The Colour of Democracy: Racism in Canadian Society*, second edition. Toronto: Harcourt Canada.

Henry, William, and J. Sims. 1970. "Actors' Search for a Self." *Trans-Action* 7, 11.

Hochschild, Arlie. 1983. *The Managed Heart: Commercialization of Human Feeling*. Berkeley: University of California Press.

Houtman, Irene, and M. Kompier. 1995. "Risk Factors and Occupational Risk Groups for Work Stress in the Netherlands" in Sauter, Steven and L. Murphy, eds., *Organizational Risk Factors for Job Stress*. Washington: American Psychological Association.

Hughes, Karen. 1999. "Gender and Self Employment in Canada: Assessing Trends and Policy Implications" (Report no 4W04). Ottawa: CPRN.

Jaimet, Kate. 2000. "It's War on Lap Dancing." *Ottawa Citizen* (February 14, 2000) B5.

James, Jennifer. 1978. "The Prostitute As Victim" in Chapman, Jane, and M. Gates, eds., *The Victimization of Women*. Beverly Hills: Sage.

Jeffreys, Sheila. 1985. "Prostitution" in Rhodes, Dusty and S. McNeil, eds., *Women Against Violence Against Women*. London: Onlywomen Press.

Johnson, Laura, and R. Johnson. 1982. *The Seam Allowance: Industrial Sewing in Canada*. Toronto: Women's Press.

Johnson, Mary. 1987. "CABE and Strippers: A Delicate Union" in Bell, Laurie, ed., *Good Girls/Bad Girls: Feminists and Sex Trade Workers Face to Face*. Toronto: Women's Press.

Kappler, Victor, M. Blumberg and G. Potter. 2000. *The Mythology of Crime and Criminal Justice*, third edition. Prospect Heights: Waveland Press.

Katz, Naomi, and D. Kemnitzer. 1984. "Women and Work in Silicon Valley: Options and Futures" in Sacks, Karen and D. Remy, eds., *My Troubles are Going to Have Trouble With Me: Everyday Trials and Triumphs of Women Workers*. New Jersey: Rutgers.

Kay, Olga. 2000. "The Act Is Sick." *Ottawa Citizen* (February 2, 2000) E6.

Kessler-Harris, Alice. 1990. "The Just Price, the Free Market, and the Value of Women" in Hansen, Karen and I. Philipson, eds., *Women, Class and the Feminist Imagination: A Socialist Feminist Reader*. Philadelphia: Temple University Press.

Kinsman, Gary. 1996. "'Responsibility' as a Strategy of Governance: Regulating People Living with AIDS and Lesbians and Gay Men in Ontario" in *Economy and Society* 25.

Klein, Bonnie, director. 1982 *Not a Love Story*. Ottawa: Studio "D," National Film Board.

Knights, David, and H. Willmott. 1985. "Power and Identity in Theory and Practice." *Sociological Review* 33, 1.

Kretzman, Martin. 1992. "Bad Blood: The Moral Stigmatization of Paid Plasma Doners." *Journal of Contemporary Ethnography* 20, 4.

Lacombe, Dany. 1988. *Ideology and Public Policy: The Case Against Pornography*. Toronto: Garamond Press.

———. 1994. *Blue Politics: Pornography in the Age of Feminism*. Toronto: University of Toronto Press.

Lanar, Mary. 1974. "Prostitution as an Illegal Vocation" in Bryant, Clifton, ed., *Deviant Behavior*. Chicago: Rand McNally.

Langton, James. 1996. "Nice Girls Undress for Success." *Cosmopolitan* (July) Vol. 221, No. 3.

Laxdale, Vivienne. 1999. "Don't Call Them Bouncers." *Ottawa City Magazine* (October/November).

Layton, Monique. 1993. "Bad Boys and Tough Tattoos: A Social History of the Tattoo with Gangs, Sailors, and Street Corner Punks, 1950–1965." *Canadian Journal of Law and Society* 8, 2.

Lederer, Laura. 1980a. "Playboy Isn't Playing: An Interview with Bat-Ada" in Lederer, Laura, ed., *Take Back the Night: Women on Pornography*. New York: Bantam Books.

———, ed. 1980b. *Take Back the Night: Women on Pornography*. New York: Bantam Books.

Levi, Lennart, M. Frankenhauser and B. Gardell. 1986. "The Characteristics of the Workplace and the Nature of Its Social Demands" in Wolf, Steward and A. Finestone, eds., *Occupational Stress: Health and Performance at Work*. Littleton, Massachusetts: PSG Publishing.

Livingstone, D. W., and M. Luxton. 1989. "Gender Consciousness at Work: Modification of the Male Breadwinner Norm Among Steelworkers and Their Spouses." *Canadian Journal of Sociology and Anthropology* 26, 2.

Lovelace, Linda. 1980. *Ordeal*. London: Barkley Books.

Lowman, John. 1995. "Prostitution in Canada" in Jackson, Margaret, and C. Griffiths, eds., *Canadian Criminology*, second edition. Toronto: Harcourt Brace Jovanovich.

Luxton, Meg. 1990. "Two Hands for the Clock" in Luxton, Meg and H. Rosenburg, eds., *Through the Kitchen Window*. Toronto: Garamond Press.

Luxton, Meg, and J. Corman. 2001. *Getting By in Hard Times: Gendered Labour at Home and on the Job*. Toronto: University of Toronto Press.

Marks, Lynne. 1996. *Revivals and Roller Rinks: Religion, Leisure and Identity in Late-Nineteenth-Century Small Town Ontario*. Toronto: University of Toronto Press.

Maroney, Heather Jon, and M. Luxton. 1997. "Gender at Work: Canadian Feminist Political Economy Since 1988" in Clement, Wallace, ed., *Understanding Canada: Building the New Canadian Political Economy*. Montreal: McGill-Queen's University Press.

Marx, Karl. 1954 [1859]. *Capital, Vol 1*. Moscow: Foreign Languages Publishing House.

Marx, Karl, and F. Engels. 1976 [1864]. *The German Ideology*. Moscow: Progress Publishers.

Mattson, Heidi. 1995. *Ivy League Stripper*. New York: St. Martin's Press.

McCaghy, Charles, and J. Skipper. 1974. "Lesbian Behavior as an Adaptation to the Occupation of Stripping" in Bryant, Clifton, ed., *Deviant Behavior*. Chicago: Rand McNally.

McClintock, Anne. 1993. "Sex Workers and Sex Work." *Social Text 37*.

McCormack, Thelma. 1985. "Making Sense of the Research on Pornography" in Burstyn, Varda, ed., *Censorship*. Vancouver: Douglas & McIntyre.

McDonald, Lynn, B. Moore and N. Timoshkina. 2000. "Migrant Sex Workers from Eastern Europe and the Former Soviet Union: The Canadian Case." Ottawa: Status of Women.

McGill, Nichole. 1996. "More Than a Dance." *Ottawa Express* (February 15, 1996) 9.

McRobbie, Angela. 1991. *Feminism and Youth Culture*. Boston: Unwin Hyman.

Mead, George. 1934. *Mind, Self and Society*. Chicago: University of Chicago Press.

Miller, Gale. 1978. *Odd Jobs: The World of Deviant Work*. New Jersey: Prentice-Hall.

Miller, Jacquie. 1985. "Strip Bylaw Should Be Axed, Says Committee." *Ottawa Citizen* (November 15, 1985) C1.

Morse, David. 2000. "Lap Dancing Destroys Women." *Ottawa Citizen* (February 2, 2000).

Nakhaie, M. Reza, ed. 1999. *Debates on Social Inequity: Class, Gender and Ethnicity in Canada*. Toronto: Harcourt Canada.

Nelson, E. D., and A. Fleras. 1995. *Social Problems in Canada: Issues and Challenges*. Scarborough: Prentice-Hall.

Ontario County Court. 1969. *Regina v. Sequin 2 C.C.C.* 150.

Ontario Court of Appeal. 1996. *Regina v. Mara 105 C.C.C.* (3d) 147.

Ontario Government. 1973. "An Act to Amend the Liquor Licence Act" (Chapter 68, 69). *Statutes of the Province of Ontario*. Toronto: Thatcher.

———. 2001. "An Act to Amend the Municipal Act." Ontario: Legislative Assembly of Ontario.

Ontario Ministry of Labour. 1995. *Occupational Health and Safety Act*. Toronto: Ministry of Labour.

Ontario Provincial Court. 1972. *Regina v. Murphy 8 C.C.C.* (2d) 313.

———. 1981. *Regina v. Szunejko 6 W.C.B.* 326.

——. 1981. *Regina v. Diaz 60 C.C.C.* (2d) 39.

Ottawa Citizen editorial. 2000. "Lap dogs to the law." *The Ottawa Citizen* (January 31, 2000) D8.

Paules, Greta. 1991. *Dishing It Out: Power and Resistance Among Waitresses in a New Jersey Restaurant.* Philadelphia: Temple University Press.

Peistrup Hambrecht, Kate. 1999. "How Stripping Saved Her Life." *Cosmopolitan* (February) Vol. 226, No. 2.

Penelope, Julia. 1990. *Speaking Freely.* New York: Pergamon Press.

Penney, Jennifer. 1983. *Hard Earned Wages: Women Fighting for Better Work.* Toronto: The Women's Press.

Personal Narratives Group. 1989. *Interpreting Women's Lives.* Bloomington: Indiana University Press.

Pheterson, Gail. 1990. "The Category 'Prostitute' in Scientific Inquiry." *Journal of Sex Research* 17, 3.

Phillips, Anne. 1987. *Divided Loyalties: Dilemmas of Sex and Class.* London: Virago.

Phillips, Paul. 1997. "Labour in the New Canadian Political Economy" in Clement, Wallace, ed., *Understanding Canada: Building the New Canadian Political Economy.* Montreal: McGill-Queen's University Press.

Polsky, Ned. 1969. *Hustlers, Beats and Others.* Garden City: Anchor Press.

Porter, Marilyn. 1991. "Time, the Life Course and Work in Women's Lives." *Women's Studies International Forum* 14.

Price, Lisa. 1989. *Patterns of Violence in the Lives of Girls and Women: A Reading Guide.* Vancouver: Women's Research Centre.

Pringle, Rosemary. 1988. *Secretaries Talk: Sexuality, Power and Work.* London: Verso.

Reasons, Charles. 1986. "Your Money or Your Life: Workers' Health in Canada" in Brickey, Stephen and E. Comack, eds., *The Social Basis of Law: Critical Readings in the Sociology of Law.* Toronto: Garamond Press.

Reinharz, Shulamit. 1992. *Feminist Research Methods.* Oxford: Oxford University Press.

Reiter, Ester. 1991. *Making Fast Food: From the Frying Pan into the Fryer.* Kingston: McGill-Queen's University Press.

Rinehart, James. 1996. *The Tyranny of Work: Alienation and the Labour Process,* third edition. Toronto: Harcourt Brace.

Roberts, Nickie. 1992. *Whores in History.* London: Grafton.

Rose, Nikolas. 1999. *Powers of Freedom: Reframing Political Thought.* Cambridge: Cambridge University Press.

Rotenberg, Lori. 1974. "The Wayward Worker: Toronto's Prostitute at the Turn of the Century" in Actor, Janice, P. Goldsmith and B. Shepard, eds., *Women at Work 1850–1930*. Toronto: Canadian Women's Educational Press.

Rubin, Lillian. 1976. *Worlds of Pain*. New York: Basic Books.

Russell, Diana. 1988. "Pornography and Rape: A Causal Model." *Political Psychology* 9, 1.

Sacks, Karen. 1984. "Generations of Working-Class Families" in Sacks, Karen and D. Remy, eds., *My Troubles Are Going to Have Trouble with Me: Everyday Trials and Triumphs of Women Workers*. New Jersey: Rutgers University Press.

Salzinger, Leslie. 1991. "A Maid by Any Other Name" in Burnaway, Michael, ed., *Ethnography Unbound: Power and Resistance in the Modern Metropolis*. Berkeley: University of California Press.

Sanders, Clinton. 1989. *Customizing the Body: The Art and Culture of Tattooing*. Philadelphia: Temple University Press.

Schlosser, Eric. 1997. "The Business of Pornography." *U.S. News* (February) Vol. 122, No. 5.

Scott, James. 1985. *Weapons of the Weak: Everyday Forms of Peasant Resistance*. New Haven: Yale University Press.

———. 1990. *Domination and the Arts of Resistance: Hidden Transcripts*. New Haven: Yale University Press.

Scott, Valerie. 1987. "Working Girls" in Bell, Laurie, ed., *Good Girls/Bad Girls: Feminists and Sex Trade Workers Face to Face*. Toronto: Women's Press.

Scullion, Erin. 1992. "Stripped of Their Rights?" *Ottawa City Magazine* (May/June).

Segal, Lynne. 1992. "Introduction" in Segal, Lynne and M. McIntosh. *Sex Exposed: Sexuality and the Pornography Debate*. New Jersey: Rutgers University Press.

Sennett, Richard, and J. Cobb. 1972. *The Hidden Injuries of Class*. New York: Vintage Books.

Shadd, Adrienne. 1991. "Institutionalized Racism and Canadian History: Notes of a Black Canadian" in McKague, Osmond, ed., *Racism in Canada*. Saskatoon: Fifth House.

Shapiro-Perl, Nina. 1984. "Resistance Strategies: The Routine Struggle for Bread and Roses" in Sacks, Karen, and D. Remy, eds., *My Troubles Are Going to Have Trouble with Me*. New Jersey: Rutgers University Press.

Shaver, Fran. 1996. "Prostitution, Mythes et Préjugé." *Recherche Sociale: Bulletin du Conseil Québécois de la recherche sociale* 3, 3.

Shostak, Arthur. 1980. *Blue Collar Stress.* Menlo Park: Addison-Wesley Publishing Company.

Sijuwade, Philip. 1996. "Counterfeit Intimacy." *International Journal of Sociology of the Family* 26.

Silver, Rachel. 1993. *The Girl in Scarlet Heels.* London: Century.

Smart, Carol. 1989. *Feminism and the Power of Law.* London: Routledge.

Smith, Dorothy. 1987. *The Everyday World as Problematic: A Feminist Sociology.* Boston: Northeastern University Press.

Smith, George. 1990. "Political Activist as Ethnographer." *Social Problems* 17, 4.

Snowdon, Lynn. 1994. *Nine Lives.* New York: W.W. Norton.

Spector, Malcolm, and J. Kitsuse. 1987. *Constructing Social Problems.* New York: Aldine De Gruyter.

Spender, Dale. 1982. *Invisible Women: The Schooling Scandal.* London: Writers and Readers.

Spradley, James, and B. Mann. 1975. *The Cocktail Waitress: Women's Work in a Man's World.* New York: Alfred A. Knopf.

Statistics Canada. 2000. *Women in Canada: A Gender-based Statistical Report.* Ottawa: Ministry of Industry.

Stella. 2000. "Proud and Sexy with Solidarity." *ConStellation* 6, 1.

Sternbach, David. 1995. "Musicians: A Neglected Working Population in Crisis" in Sauter, Steven, and L. Murphy, eds., *Organizational Risk Factors for Job Stress.* Washington: American Psychological Association.

Sundahl, Debi. 1987. "Stripper" in Delacoste, Frédérique and P. Alexander, eds., *Sex Work: Writings by Women in the Sex Industry.* Pittsburgh: Cleis Press.

Supreme Court of Canada. 1973. *R. v. Johnson* 13 C.C.C. (2d) 402.

——. 1992. *Regina v. Butler* 70 C.C.C. (3d) 129.

——. 1993. *Regina v. Tremblay* 84 C.C.C. (3d) 97.

——. 1997. *Regina v. Mara* 2 R.C.S. 630.

——. 1999. *Regina v. Pelletier* www.gc.scc (December 13, 1999).

Sykes, Gresham, and D. Matza. 1957. "Techniques of Neutralization." *American Sociological Review* 22.

Tatoe, Charlotte. 1974. "Cross My Palm with Silver" in Bryant, Clifton, ed., *Deviant Behavior.* Chicago: Rand McNally.

Tattersall, Andrew, and E. Farmer. 1995 The Regulation of Word Demands and Stress" in Sauter, Steven and L. Murphy, eds., *Organizational Risk Factors for Job Stress.* Washington: American Psychological Association.

Taylor, Ian, P. Walton and J. Young. 1973. *The New Criminology: For a Social Theory of Deviance.* London: Routledge & Kegan Paul.

Thompson, E. P. 1966. *The Making of the English Working Class.* New York: Pantheon Books.

Thompson, William. 1991. "Handling the Stigma of Handling the Dead: Morticians and Funeral Directors." *Deviant Behavior* 12.

Thompson, William, and J. Harred. 1992. "Topless Dancers: Managing Stigma in a Deviant Occupation." *Deviant Behavior* 13.

Tolson, Anne. 1990. "Gloucester Holds Strip Clubs to Bare Minimum — One." *Ottawa Citizen* (February 21, 1990) B7.

Tracey, Lindalee. 1997. *Growing Up Naked.* Vancouver: Douglas & McIntyre.

Wallace, James. 1995. "Ottawa to Probe Lap-Dance Beefs." *Toronto Sun* (August 4, 1995).

Waxmann, Chaim. 1977. *The Stigma of Poverty: A Critique of Poverty Theories and Policies.* New York: Pergamon Press.

Weber, Max. 1946 [1921]. "Class, Status, Party." Reprinted in Gerth, H. and C. W. Miles, eds., *From Marx to Weber: Essays in Sociology.* New York: Oxford University Press.

Westwood, Sallie. 1984. *All Day Every Day: Factory and Family in the Making of Women's Lives.* London: Pluto Press.

Willis, Paul. 1977. *Learning to Labour.* Westmead: Saxon House.

Wilson, Elizabeth. 1992. "Feminist Fundamentalism: The Shifting Politics of Sex and Censorship" in Segal, Lynne and M. McIntosh, eds., *Sex Exposed: Sexuality and the Pornography Debate.* New Jersey: Rutgers University Press.

Wolfman, Oscar. 1996. "Homophobia in/as Education." *Alternate Routes* 13.

Wright, Erik Olin. 1989a. "A General Framework for the Analysis of Class Structure" in Wright, Erik Olin, ed., *The Debate on Classes.* London: Vers.

——. (1989b) "Rethinking Once Again the Concept of Class Structure" in Wright, Erik Olin, ed., *The Debate on Classes.* London: Verso.

Zeidman, Irving. 1967. *The American Burlesque Show.* New York: Hawthorn.

DR. CHRIS BRUCKERT is Assistant Professor in the Department of Criminology at the University of Ottawa. Bruckert's focus in teaching includes women as offenders, women as victims, social policy and prisons. Her research interests are: brothel/massage parlour employment from the perspective of labour, and ethnographic studies of the prison release and reintegration process.

AGMV Marquis

MEMBER OF SCABRINI MEDIA

Quebec, Canada
2002